EVERYDAY
MONET

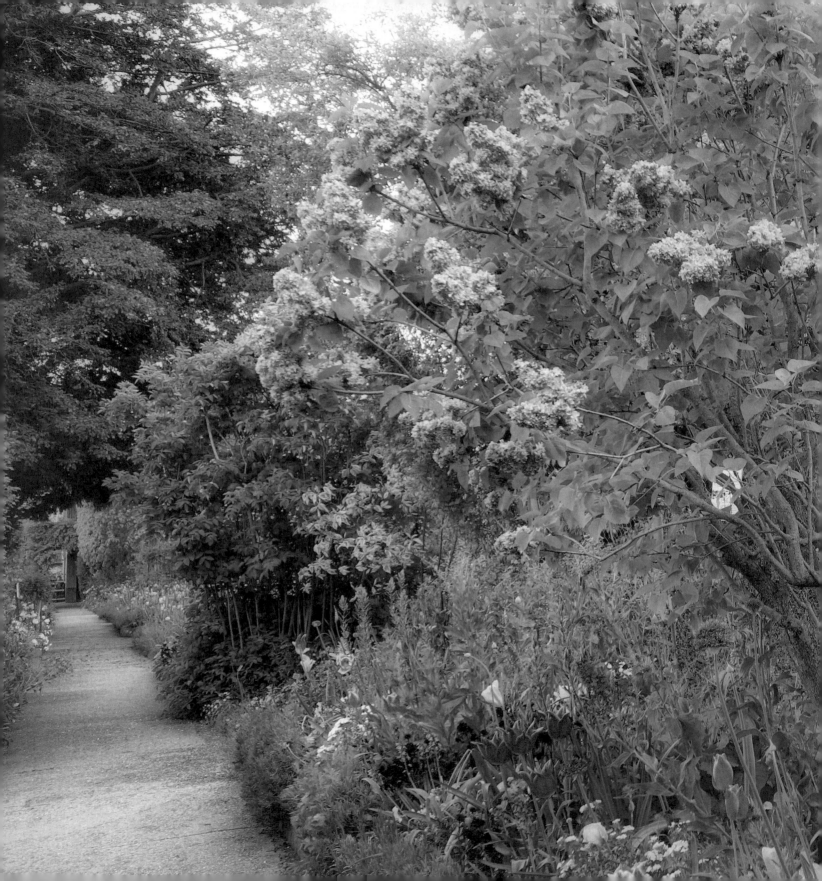

EVERYDAY MONET

A GIVERNY-INSPIRED GARDENING AND LIFESTYLE GUIDE TO LIVING YOUR BEST IMPRESSIONIST LIFE

AILEEN BORDMAN

TEXT AND PRIMARY PHOTOGRAPHY

DEY ST.

An Imprint of WILLIAM MORROW

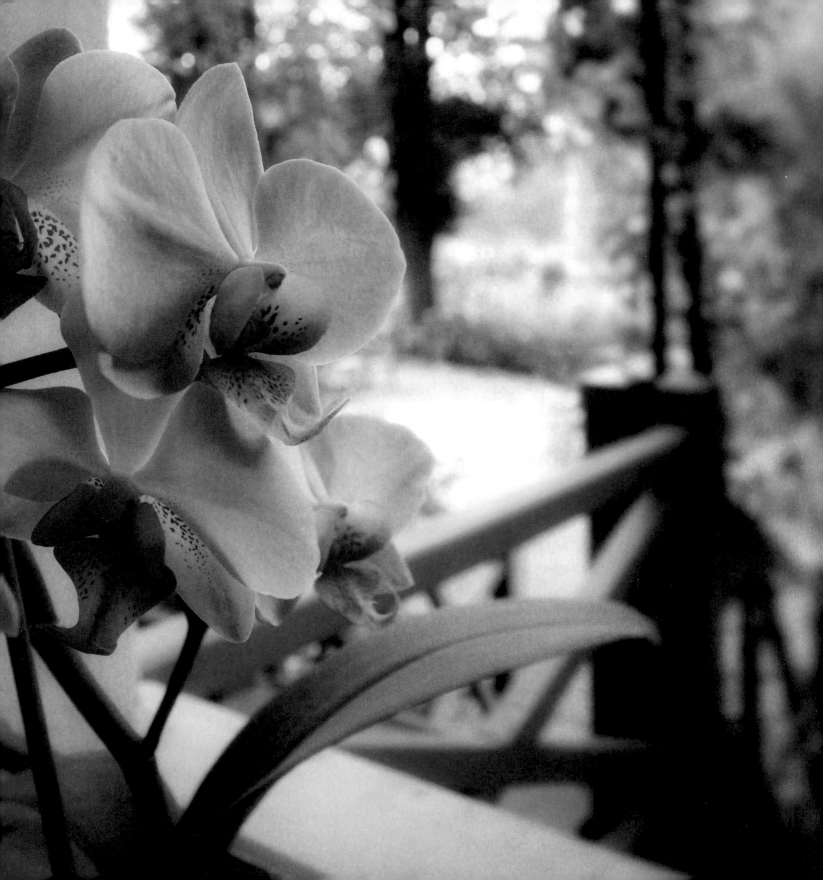

I DEDICATE THIS BOOK
TO ALL WHO SEEK, CREATE,
AND PRESERVE BEAUTY.
AND TO MY MOTHER, WHO HAS
ENCOURAGED ME TO CARRY THE
BATON OF STEWARDSHIP.

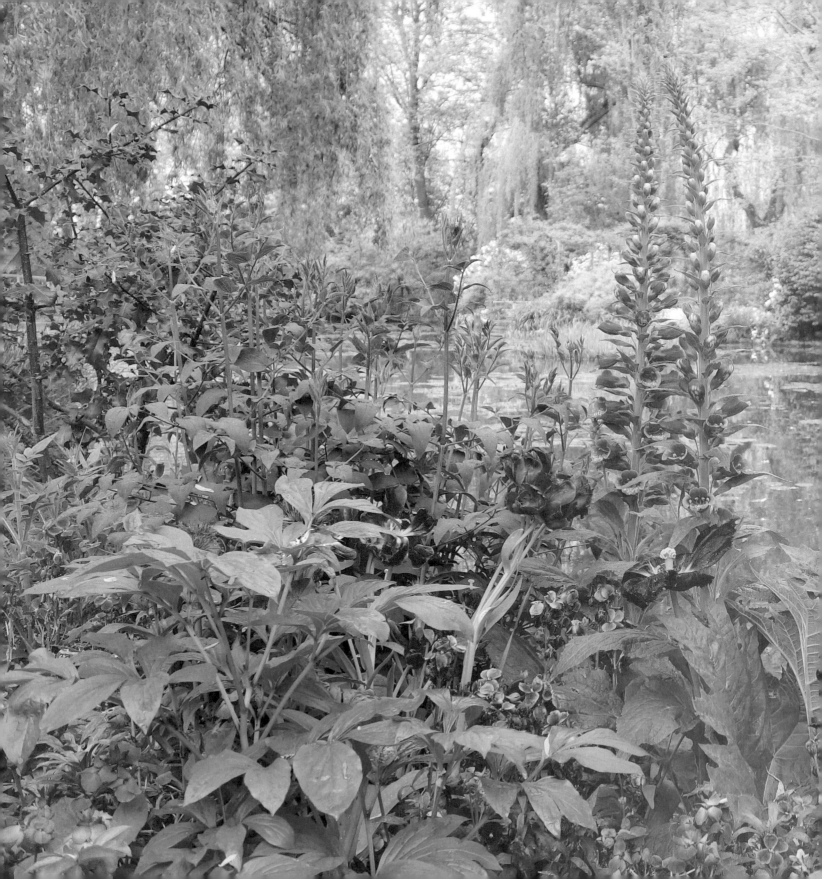

contents

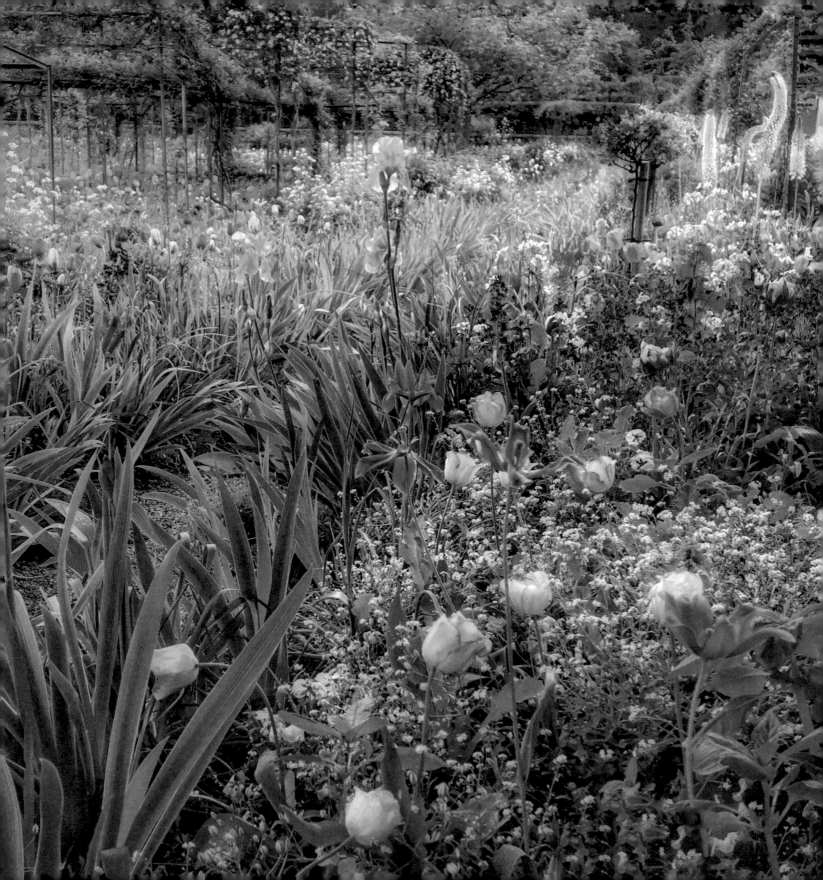

foreword

In 1980, after considerable dedication and work, I became an American representative and volunteer at Monet's garden at Giverny. After Monet passed away in 1926, the garden slowly lost its luster. My efforts, along with those of the curator at Giverny, Monsieur Gérald Van der Kemp; his wife, Florence; and a dedicated staff, including the head gardener, Monsieur Gilbert Vahé, helped to open up Giverny once again to the world. I believe it was my destiny to help preserve the beauty Monet created within his special home and in the glorious garden.

Since the restoration was completed, more than twenty million people have visited the beautiful home and garden. I am so grateful for the many accolades I've received for my work. Most recently, I was thrilled to learn that the French government has honored me with the Chevalier Ordre des Arts et des Lettres, one of the highest honors afforded to those who have enriched and preserved French culture. Meryl Streep, a prior recipient of the award, graced me with her nomination. Of course, my greatest reward is the happiness the garden has brought to so many people around the world.

I am very proud of all that has been accomplished at Giverny, and honored that my work and vision continue now and into the future. It makes me so happy that my daughter, Aileen Bordman, has joined my effort to preserve Giverny. Through the text and beautiful photography of *Everyday Monet*, Aileen has created a stunning and informative guide to bringing Claude Monet into any home—which is a beautiful idea. Even if you can't hang a Monet painting in your home or travel to Giverny to see its splendor in person, you can experience the garden and home through the wonderful pages of this book. I think that Monet would be very pleased with the dedication to keeping his garden and spirit alive. This book will bring the beauty of impressionism home.

With my deep devotion to Monet's garden at Giverny!

HELEN RAPPEL BORDMAN, AN AMERICAN STEWARD AT GIVERNY

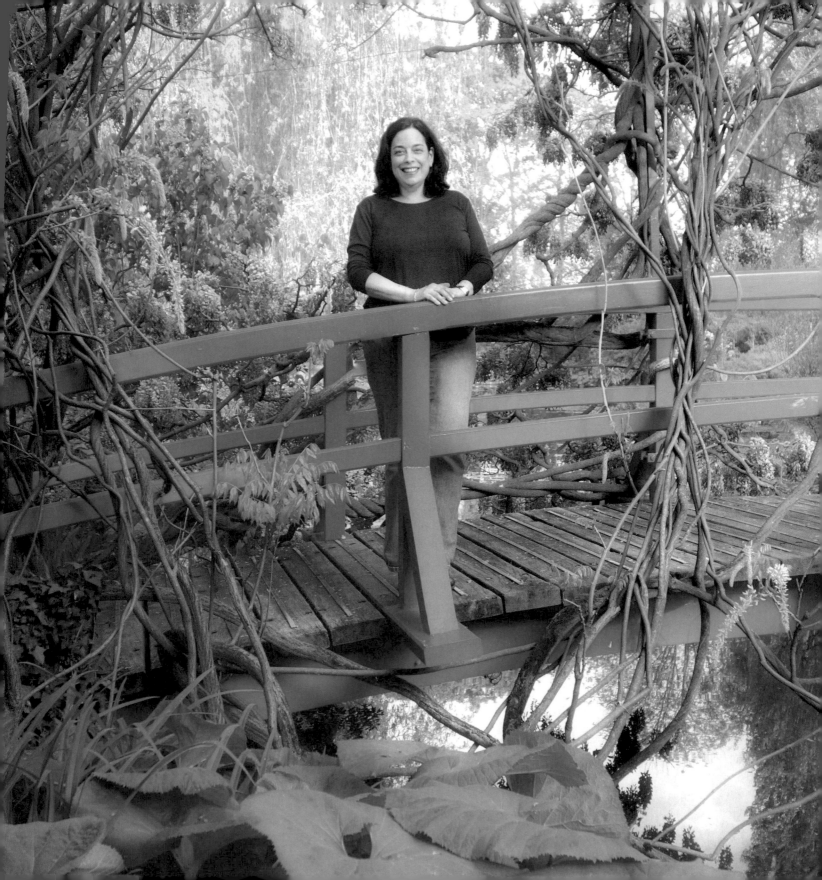

inspiration

From the moment I opened a gift from my mother when I was twenty-three years old—a small fragrant envelope laced with the sweet scent of lavender from the garden at Giverny—my fate was sealed. This was the beginning of my journey filled with beauty, creativity, stewardship, transformation, and preservation. My mission to share the magical world of Claude Monet had just begun.

Over the course of time, the lavender, now a dried and precious keepsake, became a reminder of my unique connection and legacy with respect to Claude Monet. Little did I know that my journey would include becoming a first-time filmmaker and author, as well as befriending the director of Monet's home and garden.

What I was always certain of was that I was carrying a baton. I was on a mission to bring the beauty I witnessed firsthand at Monet's home and garden to others. My role as a steward, a preserver for future generations, is one I take very seriously. I am eager to share Monet's world with you and be your guide as you bring home the beauty he created.

Over the decades, I would send little gift packets of seeds from Giverny to people all over the world. I realize now I was acting in the spirit of Johnny Appleseed. I was encouraging others to plant and, thereby, transport Monet's garden to their own homes. I received thank-you notes from every recipient, describing with passion where they had planted the cherished seeds. Their cutting houses, flowerpots, window boxes, terraces, backyards, and rooftops now held Giverny and captured the aesthetic the master had created.

In the same spirit, *Everyday Monet* is my gift to you—for you to plant your own seeds that sprout and send Monet's spirit throughout your life and home.

AILEEN BORDMAN

MONET, MY MOTHER, AND ME

one

"Once settled, I hope to produce masterpieces, because I like the countryside very much." —CLAUDE MONET

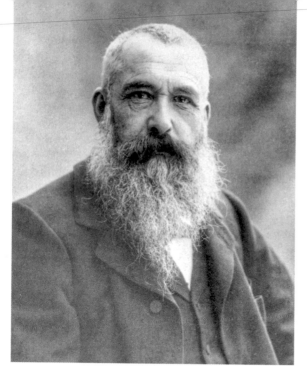

Claude Monet (1899). Photographer: Gaspard-Félix Tournachon, aka Nadar.

MONET

"I hope that something will come out of so much effort." —CLAUDE MONET

Claude Monet left us a living legacy not only in his paintings, but also in his home and garden at Giverny.

Born in Paris, France, on November 14, 1840, Monet would become one of the most important artists to ever hold a brush. As the father of impressionism, Monet created art that is cherished in the world's greatest museums and private collections. If Monet had only been a painter, with his work revered among the greats including Van Gogh, Picasso, Renoir, and Rembrandt, that would have been a magnificent accomplishment. But Monet's talents stretched beyond canvas over a wooden frame. He embodied the title of Renaissance man—his passions and talents extended to art, home and garden design, travel, food, and entertaining. We have him to thank for so much beauty we see in decorated halls across the globe.

MY MOTHER—HELEN RAPPEL BORDMAN

"I came to Giverny as a young woman and hope that my decades of work and dedication, which I continue, contribute to preserving the beautiful legacy Monet created." —HELEN RAPPEL BORDMAN

My mother, Helen Rappel Bordman, is one of the handful of Americans responsible for the renaissance of Monet's home and garden at Giverny. Of the myriad of her contributions, one of her most influential acts included founding the volunteer program at Monet's home and garden, which has aided in helping to restore Monet's home to its original glory.

My mother's journey started with a recommendation from the curator of the 1978 Metropolitan Museum of Art Monet exhibit, Charles Moffett. Moffett had suggested to the esteemed publisher and philanthropist Lila Acheson Wallace that

These are two of my mother's works in particular. They are an homage to Giverny.

Monet's home and garden be restored, and she gave the first large contribution toward the restoration. In 1977, after urging from Lila, the restoration began with Gérald Van der Kemp at the helm. Van der Kemp had previously restored the Hall of Mirrors at Versailles and had a great deal of restoration experience—he even hid the *Mona Lisa* under his bed during World War II, protecting it from the Nazis. While all these people were coming together to begin the restoration, my mother, too, joined the charge, and Claude Monet's home and garden at Giverny were restored for all to enjoy.

Since those very early restoration days my mother has helped to raise millions of dollars to grow, maintain, and operate Fondation Claude Monet in Giverny. Additionally, my mother led in the development and launch of the ever-expanding volunteer program at the garden, which has included artists, photographers, gardeners, and historians drawn from a pool of current students.

These volunteers learn everything there is to know about the home and garden and help to create a welcoming environment for the many visitors. Through the years, guests at the garden have included diplomats and celebrities, including Prince Charles, Rex Harrison, Gregory Peck, Audrey Hepburn, Ginger Rogers, Tony Bennett, Laura Bush, Leslie Caron, Louis Jordan, Barbra Streisand, Kirk Douglas, Meryl Streep, Bette Midler, Pierce Brosnan, and Hillary Clinton. Of course, the most important guests are all the adults and children who come from near and far, from every country in every continent in the world.

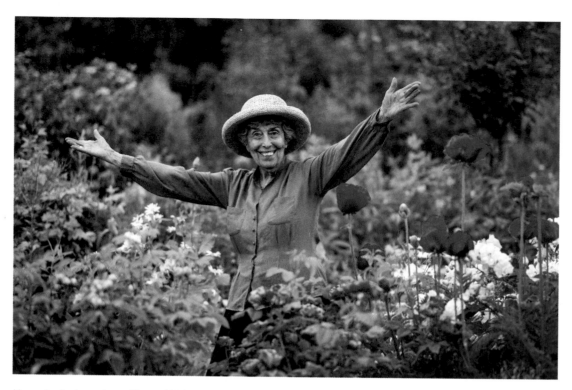

My mother in the garden at Giverny (2017).

The Fondation Claude Monet recently honored my mother with a plaque for all her work at Giverny. It hangs at the entrance of her residence, not far from the office of Monsieur Vahé, the head gardener at Giverny. He is a dear friend of my mother's, and through her, I have learned a great deal from him about Monet and Giverny over the years.

Since the opening of the garden to the public in 1980 my mother's mission has been to preserve the magnificent beauty of Monet's world and share that beauty with all who make the pilgrimage each year.

I am extremely proud of all that my mother has accomplished over the past four decades. As mentioned, she's even received the Chevalier Ordre des Arts et des Lettres award from the French government for her work. She has opened my eyes to the beauty of Giverny and through her and Monsieur Vahé and everyone who has passed through Giverny, I have grown inspired to pass along Monet's vision of beauty to those who cannot make the trip themselves.

AND ME

I sometimes joke that Monet is on my shoulder, winking.

As I put pen to paper I've realized that I could write for hours on end, pages on end, about Claude Monet—his artistry, his interests, his style, his garden, everything. Since 1980 and even more significantly in the past two decades, I have been immersed in the magical world of Monet. Although his art was created over a century ago, he has left a living legacy that stays with us through the decades.

The first time I stepped into the garden at Giverny, it was early morning, and the clouds were darkening. I felt the droplets come down; there was just enough rain to provide a veil of mist draping above the softening ground. I heard the patter of the rain, like the string section of the most stunning orchestra. I smelled the sweet scent of dew, unique to Normandy, where the rain falls hard and fast.

Instantly, I fell in love. I had entered a world that I knew I had to share in every way possible. Although at the time I was an investment banker on Wall Street, I immediately felt my calling. Paired with the knowledge of my mother's work and the work of so many others, I started to spread Monet's art and inspiration through my documentary, *Monet's Palate*; a cookbook; and a Facebook page. With a great deal of help and support, I'm so humbled and inspired to do everything I can to share the joy and beauty of Giverny, which I felt from the very first droplet on that misty day.

So, in the pages that follow, please journey with Monet, my mother, and me to the beauty and wonder of Giverny. We will be your guides and help you bring the beauty home, every day.

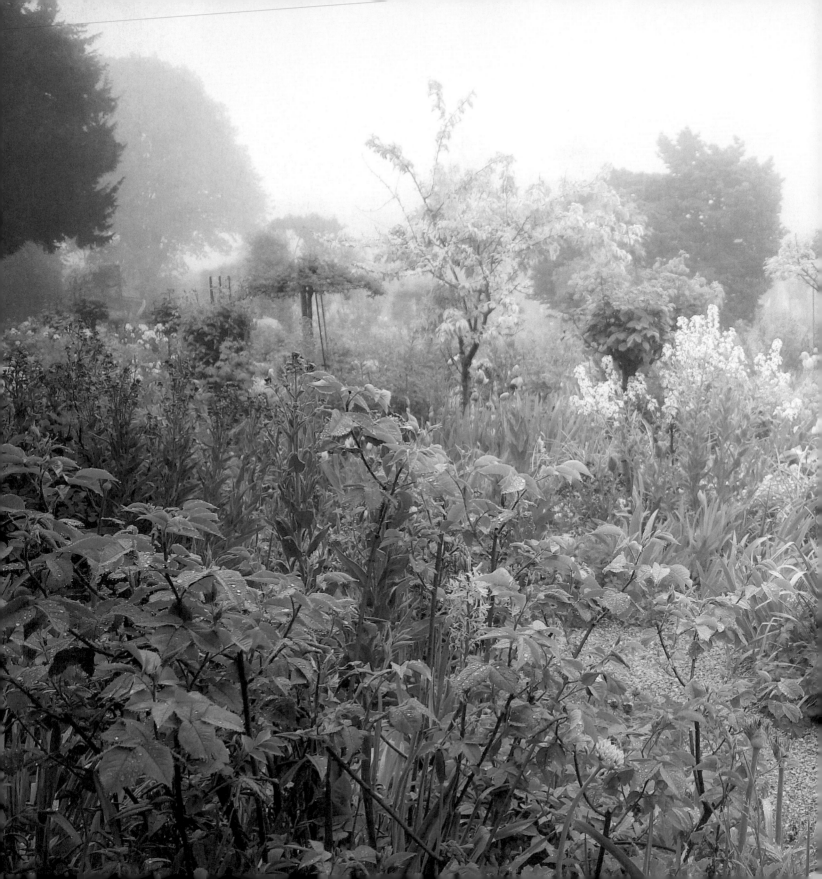

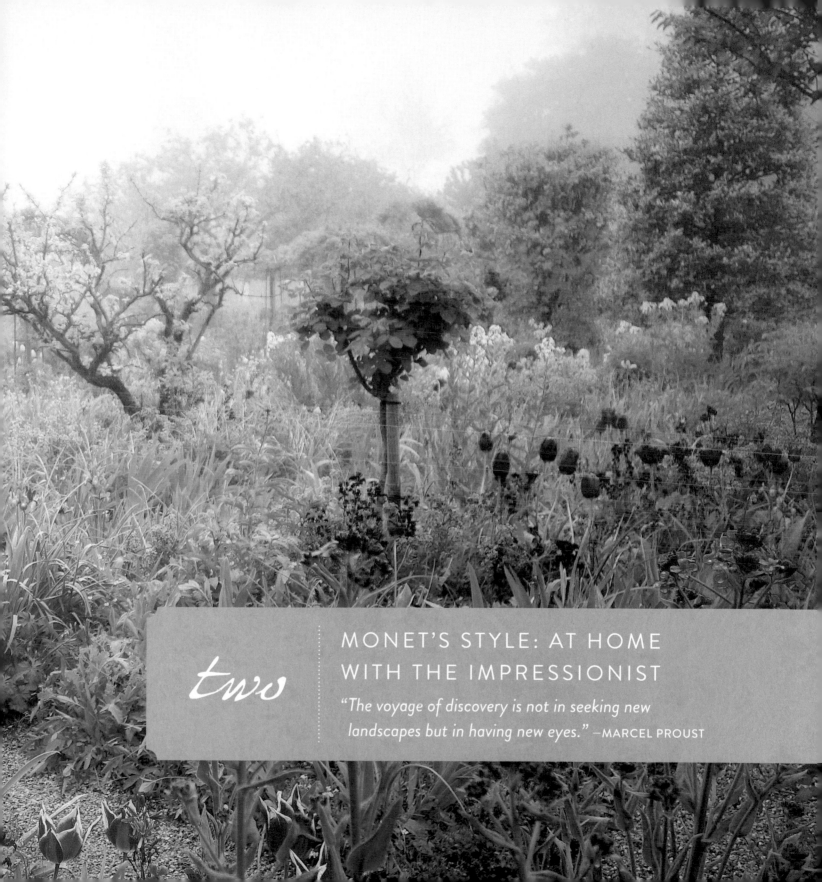

MONET'S STYLE: AT HOME WITH THE IMPRESSIONIST

two

"The voyage of discovery is not in seeking new landscapes but in having new eyes." —MARCEL PROUST

THE ESSENCE

Just imagine Monet's home and garden as a gigantic blank canvas with moving parts that change seasonally. His style and zest for life have always inspired me.

We can easily tap into and benefit from the master's touch. Color and light caress the objects and furnishings throughout his home. There is nothing too sharp in Monet's home; there are simply lots of flowing curves for the eye to see. It's all so visceral, and when you walk through Monet's front door, you realize this is not a journey or visit . . . it's a pilgrimage.

Monet's art and prowess with respect to style were astounding, capturing nature in ways that had never been done. In France in the 1860s, taking a palette into the outdoors was revolutionary—which is exactly what Monet did. Monet had always been a man searching for perfection, and there is no doubt that he was, and should forever be, considered a Renaissance man. No one else in Normandy was as eclectic as Monet; he knew how to bring the same beauty and innovation to his home, as he did to the world of art and impressionism. Monet's key design inspirations came from his art and included all aspects of color, light, and texture. Whether it was for the next magnificent subject to paint, the most delicious meal, an exotic orchid, or a Japanese woodcut, he scoured the world. In addition, frequent trips to paint in other countries and other parts of France exposed him to so many cultures and styles.

We are so fortunate to have been left the keys to the treasure box Monet created. It holds a magical trove of beauty and inspiration that allows others to add their own voices into the chorus he started. After all, wasn't it Monet who broke with the art of his time by looking out the window of the Louvre and opening the museum's window to paint what he saw outside?

Every aspect of Monet's *everyday life* was intertwined, and his style of living is one that informs our own style of living today—and I promise that including just one aspect of Monet's style into your home's interior or exterior will bring joy.

I want to immerse you and give you the tools to apply Monet's style, including his preferred colors, textures, and inspirations. These tools are just a starting point. It is like giving you a recipe for chocolate brownies with walnuts, but if you dislike walnuts you can omit them. I am giving you a road map, but please don't refrain from getting off the road and inputting your own passion and creativity. Trust me, Monet would approve.

In the pages that follow, I will help inspire some simple design ideas that tie your home and outside space to Giverny. A touch of lace, containers or frames painted per Monet's palette, or orchids, a passion of Claude's, placed in just the right space bring Giverny home.

We are not trying to re-create a Monet world, as the Smithsonian did for Julia Child with a replica of her kitchen. Instead, we are going to pull beautiful threads from Monet's style and weave them into your home. Please think of this chapter as a tour of Monet's inspirations, ways he incorporated them into his home, and some accessible ideas for bringing Monet's style into your world.

NORMANDY

It's impossible to discuss Monet's style without visiting his beloved Normandy. His art and soul were rooted in this region of France. As I travel to lecture about Monet and Normandy, I often explain that other regions in Europe have been celebrated in films such as *A Year in Provence* and *Under the Tuscan Sun*, but now here comes Normandy in all its splendor. This is a region of natural beauty, bucolic and majestic architecture, and

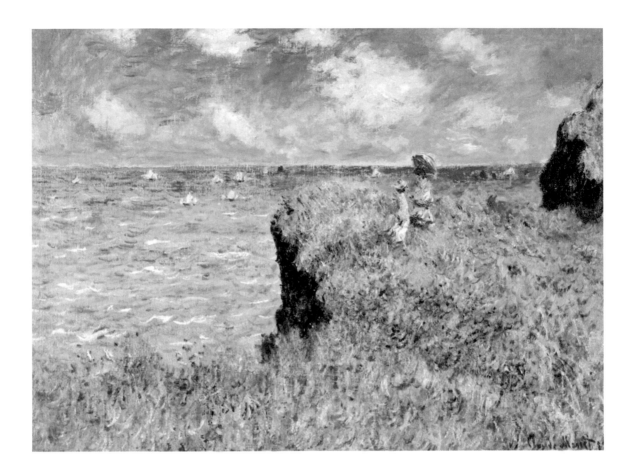

cuisine that challenges every region in France with its table. I am pleased to be able to shine a light on this often-overlooked region of France—clearly, it was not overlooked by Claude Monet.

Normandy begins just north of Paris, France, and follows the serpentine path of the breathtaking Seine River. The region continues all the way to the French seacoast. It embraces the English Channel and includes significant locales like Honfleur and Mont Saint Michel.

Monet and other landscape artists were attracted to the light, rolling hills, and abundant waterways of Normandy. The lushness of the region and the bounty of the sunlit vegetation made it the perfect subject for impressionism. As you can see in the painting above, the captivating channel with waves and curves, buttressed against the plush grassy cliffs, creates a sense of peace and solitude—a feeling that Monet craved. And I imagine we all would like to be standing on that serene cliff.

LE MOULIN DE FOURGES

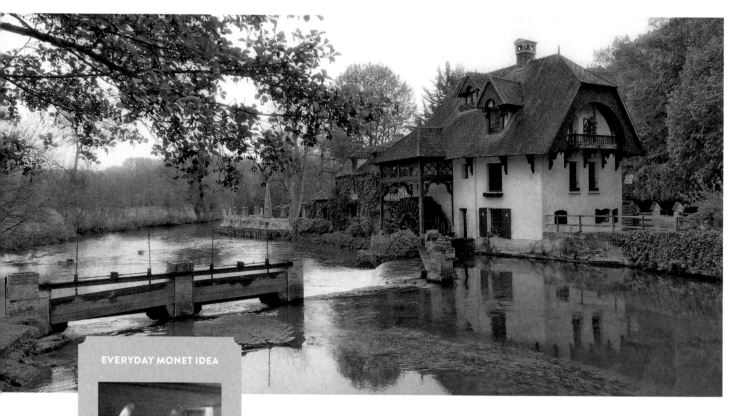

Consider bringing home some of those wonderful Normandy cheeses, like Camembert, from those very Norman cows. Serve them as Monet would have eaten them with some hearty bread and wine.

A two-hundred-year-old grist mill called Le Moulin de Fourges is located about ten minutes from Claude Monet's home. It is a wonderful example of Norman architecture and the English influence in the region that pervaded Monet's formal garden, interior elements, and many of his culinary preferences. I wish you could see the gentle movement of the mill as it scoops up the water, slowly rotating, allowing the now aerated frothiness of the water to be released. It is quiet near the mill, and there are flocks of ducks and a pasture with cows nearby.

Imagine this: Monet, with his easel propped, and nearby a basket filled with crusty bread, ruby apples from his own apple trees, Normandy sweet butter, and wine. The light reflects perfectly off the water. There are trickles of rain, and as the droplets land they hit the water with a circular motion—and that's just the kind of movement Monet captures in his paintings. Once the light is no longer to his liking, Monet will take a break from painting to spread the bread with butter and enjoy some wine—a perfect afternoon.

CHÂTEAU DE LA ROCHE-GUYON

The Château de La Roche-Guyon, located approximately a half hour from Giverny, was built by England's King Richard the Lionheart. It is a stunning example of ancient English architecture that is still in existence. From the tower, you can even see the beaches at Normandy.

Whenever I see this castle, I think of Camelot. Monet was like the French knight leaving the castle on the hill to become king of Giverny. When looking around Giverny, one can see there are similar influences to the garden design of the château. These types of English architectural structures exist throughout Normandy, and Monet was influenced greatly by them.

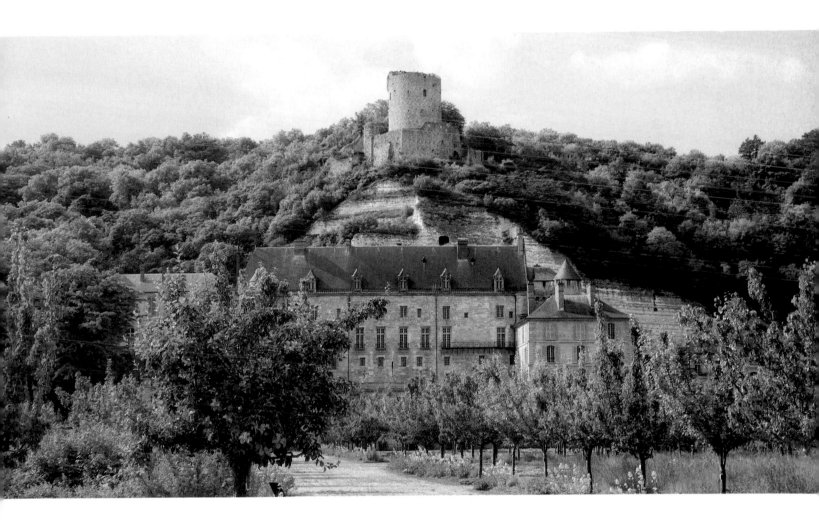

THERE'S NO PLACE LIKE HOME

"If I were settled somewhere permanently, I could at least paint and put a brave face on it. I'm going to go out until I have found a place and a house that suits." —CLAUDE MONET

Monet started the renovation—or better stated, the creation—of his Giverny oasis in 1883. His first wife, Camille, had already passed away, and so he moved there with their two sons, Michael and Michel, along with Alice Hoschedé and her six children. Ernest, Alice's husband and a patron, never lived with Monet and Alice at Giverny. When Ernest passed away, Alice and Monet got married (a soap opera from another day).

The farmhouse at Giverny, when Monet moved, was formerly a cider press, thereby referred to as *le pressior*. The home was near running water and shifting light, the two ingredients Monet required with respect to impressionism and his passion for gardens.

Living in Giverny influenced Monet's art and everyday way of life. In fact, most of the paintings we are familiar with today were created at or nearby Giverny. The series of water lilies, for example, were from Giverny and were finally finished after 1916.

Giverny was, and still is in many parts, medieval in its appearance and history. It has the feeling of the 1940s theatrical musical *Brigadoon*. One need only visit the timbered structures of Giverny today to feel as if you have been carried away to another place and time.

Monet broke in so many ways with a traditional Normandy interior design in styling his home. Of course, he was really bringing in vogue elements of style and grace that were already sweeping Europe and Paris. The fact that his home was not in a huge city, but happened to be located in a tiny village of Normandy, is what was so special.

GIVERNY AND MONET

Monet had visited, lived, and painted throughout France, including Paris, Argenteuil, Le Havre, Saint-Adresse, Louveciennes, and Vétheuil. Each of these locales garnered Monet's attention because of their beauty, subjects, and access to natural water sources—predominantly the Seine River and its tributaries.

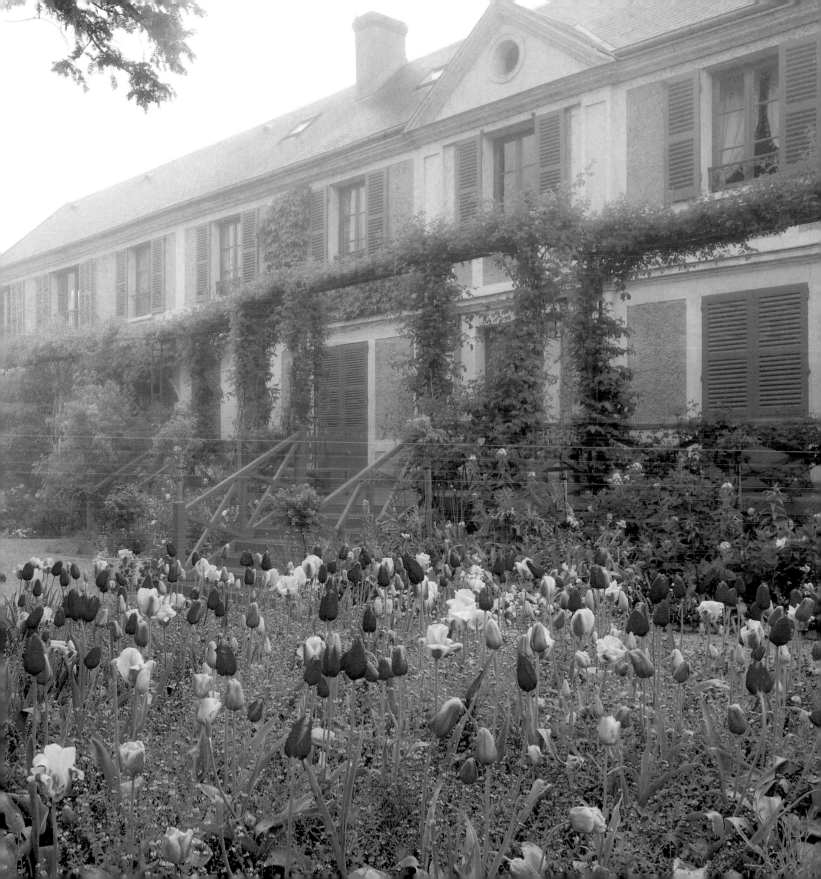

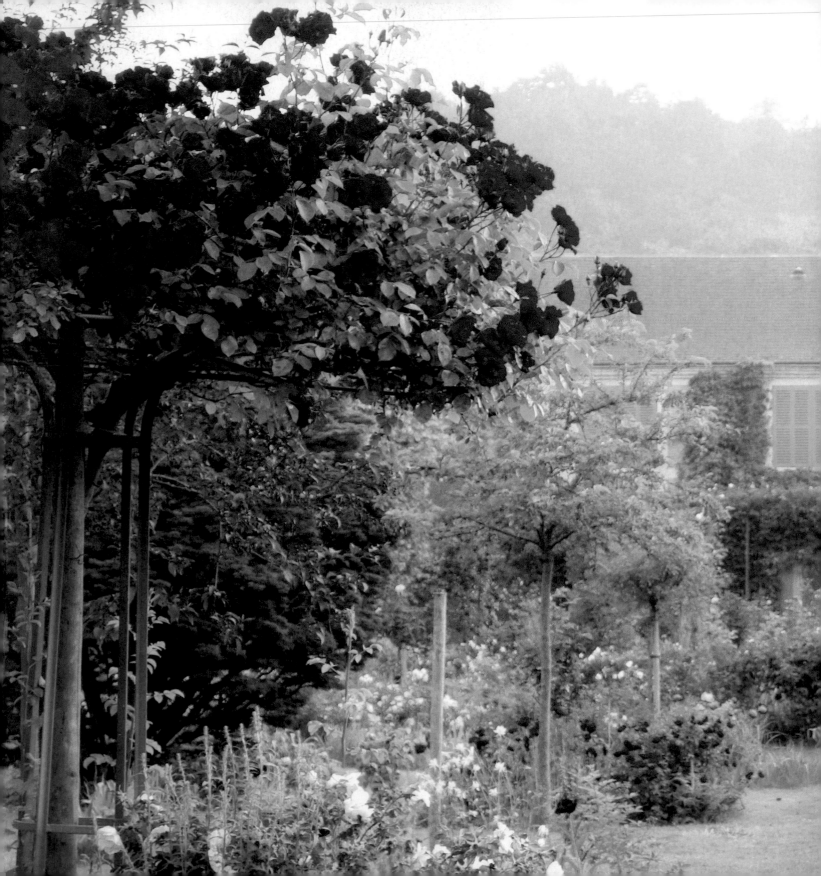

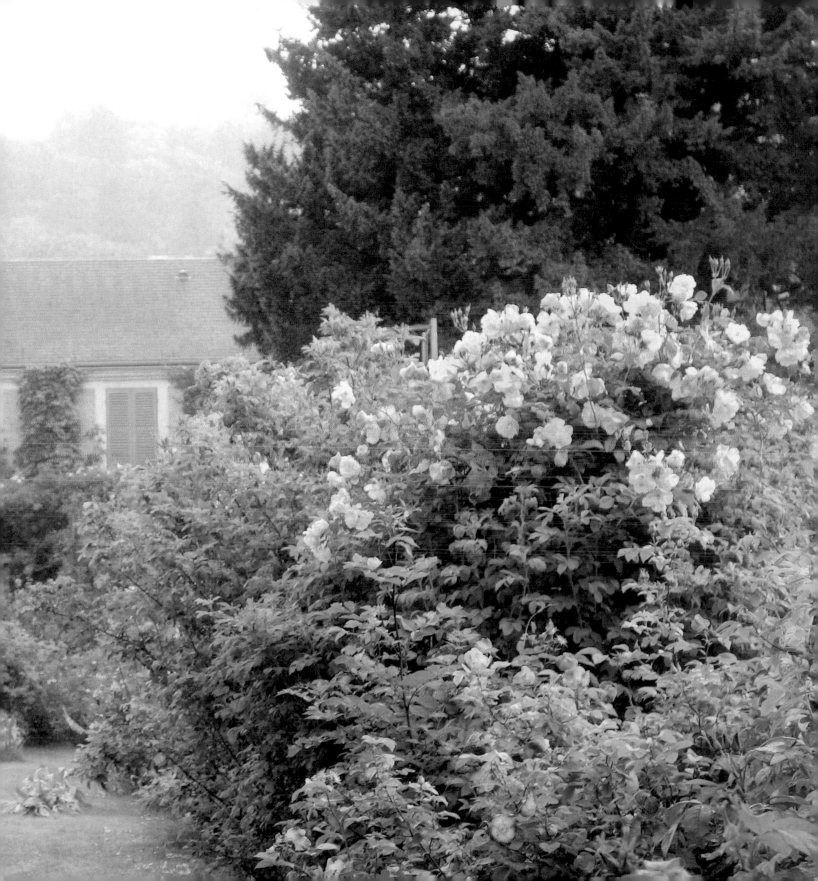

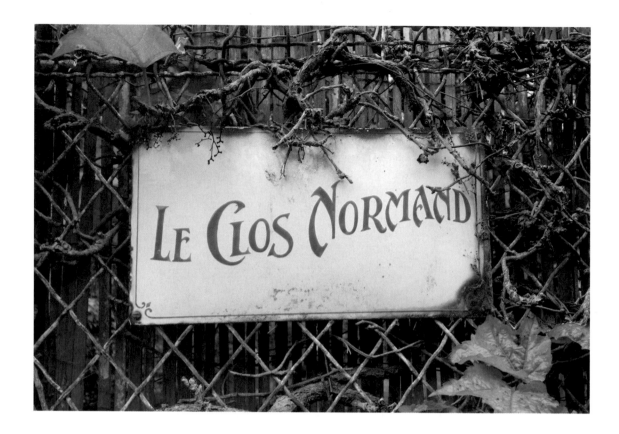

Monet was forty-two years old when he set out to find his one and only home. It was destined to become his place to create, imagine, and experiment with all the physical beauty he thrived upon.

Where someone chooses to live, and in Monet's case where he chose to build his oasis, speaks volumes. The fact that Monet chose Normandy for its architecture, cuisine, and way of life says a lot about Monet's tasteful and relaxed lifestyle. He could have chosen Paris and been in the mix with other artists of the salons, but with his art and family, he was destined for a country life. Monet used Giverny as his home base, and from there would make his many outings to paint. Monet traveled to the Riviera, London, Venice, Holland, Norway, and Rouen.

Opposite, on the left, is the view from my mother's window overlooking rue Claude Monet. Monet's house and studio is at the left in the image. The home was of the Norman style, with its pink stucco and green shutters peeking out among the vines.

This particular day was a cloudy one; it's Normandy, where it rains frequently. Monet's artwork benefited from the ever-present morning mist.

Below, on the right, is my mother's courtyard at Giverny. It displays an intimate view of not only Norman architecture, but also Monet's everyday world. He would buy bread that was baked in the oven of this bucolic structure. My mother saw the wood-burning oven before the restoration and described it as being shaped like a half-moon, the baking surface flat and made of stone. I can almost smell the bread baking and imagine the scent wafting through Monet's windows.

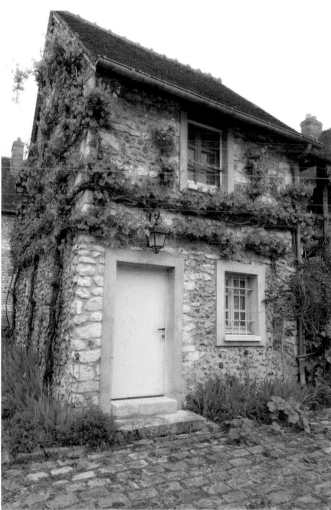

EN PLEIN AIR

The impressionists, especially Claude Monet, took their style of life quite seriously and made sure to stop and smell the roses. In the world of the impressionists, everything was relaxed and impromptu . . . not like the religious or the photo-realistic art of the past. Clearly, it was far more attractive for Monet, Pissarro, Renoir, and Cézanne to linger with a glass of wine amid the apple trees than be confined to a studio.

Monet's thirst for leaving his studio deepened as years went by. He painted so many outdoor canvases that celebrated color and light, and he brought the same sensibility into his sanctuary. The photo below shows the studio at the Hôtel Baudy, just a short walking distance from Monet's home. He would congregate here with his fellow artists and enjoy good food and drink.

It's because Monet went outside and strolled the wheat, poppy, and sunflower fields that he understood the lines, shapes, contours, and vastness of a landscape. As he visited the seacoast, meandered along riverbanks, and traveled outside of France, he took in each unique environment. All these outdoor experiences broadened his design sensibility and understanding of natural light and color, which he brought back to Giverny.

What better way to connect with Monet's everyday world than to spend more time outdoors, *en plein air*—whether it's visiting your local countryside, taking a walk in a park, spending time at the seashore, riding a bicycle, or reading a book. Spending time outdoors connects you with your environment and can make a difficult day joyful. Chapter 6, "Entertaining with Claude Monet," includes a wonderful guide to picnics, a favorite pastime of Monet. So grab some sandwiches, a book, and a blanket and enjoy the fresh air Monet cherished.

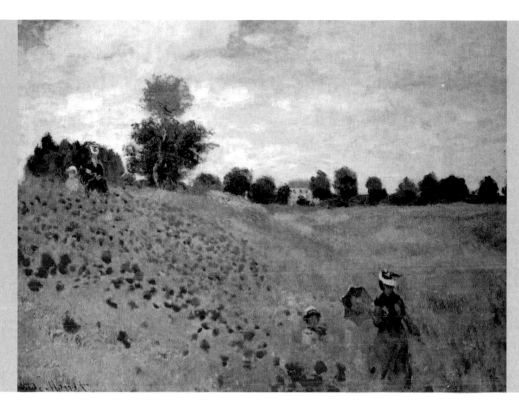

MONET'S PALETTE

"Color is my day-long obsession, joy, and torment." —CLAUDE MONET

It is impossible to discuss Monet's passion for his living space, both interior and exterior, without first discussing his color palette. Colors were the key components to Monet's world. It is a palette rich with contrast, light, depth, and originality. Monet's palette is like no other, and it was the basis not only for his masterpieces, but also for his style more generally. Oil paint in tubes and the box easel were each invented during Monet's time, and both inventions allowed him to not only open a window, but to go outside and paint right there in nature, in the light.

COLOR HIS WORLD

"The point is to know how to use the colors, the choice of which is, when all's said and done, a matter of habit. Anyway, I use flake white, cadmium yellow, vermilion, deep madder, cobalt blue, emerald green, and that's all." —**CLAUDE MONET**

Below is Monet's actual palette! I have applied examples of the key interior and exterior colors used in his home design. The palette itself is held at the Musée Marmottan, Paris, France, and measures twenty-four inches by seventeen inches. In 2012, it was displayed at the New York Botanical Garden, which presented Monet's colors, garden, and style, as a magnificent tribute to Giverny.

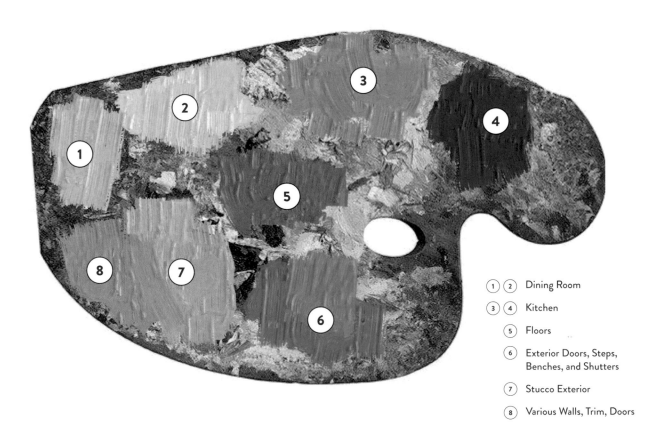

(1)(2) Dining Room
(3)(4) Kitchen
(5) Floors
(6) Exterior Doors, Steps, Benches, and Shutters
(7) Stucco Exterior
(8) Various Walls, Trim, Doors

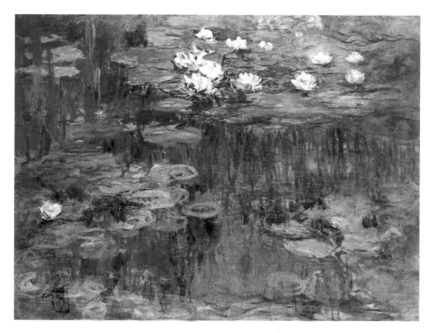

It cannot be an accident that the powder rose pink and emerald green exterior of Monet's home mirror the palette of his magnificent *Water Lilies*. Just remarkable!

During Monet's time and the birth of impressionist art, there was a French chemist named Michel Chevreul. In 1839, Chevreul's forward-thinking book, titled *The Principles of Harmony and Contrast of Color*, was published.

Chevreul's study of how we perceive color has directed designers and artists alike. Chevreul's focus on which colors were complementary and worked in harmony—when colors are placed next to each other—was groundbreaking at the time. The advent of the color wheel, with which we are all so familiar, started with his work—and today still guides painters, designers, and style.

The concept of contrast and harmony was a great influence on Monet and other impressionists. Tubes of red, yellow, and blue, the primary colors that can create all others, became their constant companions. One of the most special features of color is that we actually experience colors, and they can have a direct effect on our mood and our preferences.

When Monet was painting, his palette of colors was limited, but his prowess in mixing to achieve the many colors that he saw was brilliant. Although earlier works include black, he never used it in later years. Instead, he relied on his gift to mimic light and shadow.

Monet used a color palette that reflected the natural world he cherished: a blue sky, the glow of sunlight, the greens of the garden. Similarly, inside his home, Monet's color palette was all about everyday life: the yellow of the sun for the dining room, the blue of the sky for the kitchen, the pink and green of the exterior that shout water lily hues. The truth is, nature and Monet's natural environment were at the center of everything he did in art and life. For the master of *en plein air*, these color combinations, although sometimes contrary to the color wheel, work perfectly as Monet's style.

THE IRIS GARDEN

Hanging a copy of a Monet painting is an easy and wonderful way to bring his world into your home. His art evokes so many themes, colors, venues, and beauty. I regularly hear from people, sending me messages, sharing how much it means to them to have a copy of a Monet painting.

I want you to go beyond the art to the color palette Monet uses in a specific painting. Referencing the colors in one of his paintings, rather than just including the image itself, is a great way to incorporate a bit of Monet's style in your home. This is the perfect opportunity to draw upon his lifelong obsession with color, bringing in aspects of his design perspective.

Just by eyeing one area of a painting—as I show in the example here of Monet's *Iris Garden*—you can distinguish many of the colors already. All hardware and paint shops have wonderful color charts that can help you identify the colors as well. Then, once you've identified those colors, you can incorporate them into your space in any number of ways.

MATERIALS TO IDENTIFY
THE COLOR PALETTE

You can use a photograph of a Monet painting, a photo from this book, or any photo relating to Monet, Giverny, Monet's art, Normandy, or Monet's garden.

Or try a current photo program or app, such as Photoshop, Colorsnap Visualizer, Colorsmart by BEHR, or the Pantone Color System. The BEHR and Pantone are both free and available online.

There are many more programs today included in most photography and art applications that enable you to pinpoint a specific color of a photo or painting. Each program has its own system, but here are the usage basics for pinpointing the Monet color you are searching for in the various programs:

Scan or upload the photo or artwork you are interested in extracting from.

Open the photo via the app and follow the directions.

Using your cursor, touch on the area where the color you're interested in is located.

Move the cursor around until the display homes in on the correct color.

In the case of Pantone and BEHR, the application will give you the corresponding number to a paint that matches.

Using any program at all, you can easily take the example of *The Iris Garden* here and match its colors to a color chart. Then, use the colors to style your space and home. In addition, you can do the same with a flower you love; make sure it is fresh and take it to your local paint or hardware store and have fun trying to match the flower's color with a corresponding paint chip.

After you have found your color, that's when the fun begins. Paint a picture frame, an entire room, a window box, a wooden chair . . . the ideas are endless. At the end of the day, you will have a little bit of Giverny and Monet's art as part of your everyday life.

HOME

Now that you have traveled through Normandy and have arrived at Giverny, this is the perfect opportunity to take you on a tour of Monet's home, keeping in mind the color palette and the inspirations we have just explored.

If not for my mother, and the others who acted as stewards, I would not be able to take you on this inspired tour of Monet's inner sanctum. As you turn the pages, note the remarkable use of color at Monet's home. Through the decades, the emerald green used on the home's shutters, exterior steps, benches, and the Japanese bridges has been different hues, as has the various pink stucco. That iconic green and pink, the eclectic collection of items and furnishings, the traditional Normandy architecture—all this made up Monet's home.

Through the painstaking research done by the curator, Monsieur Gérald Van der Kemp, Monet's primary design palette was revealed. In fact, during the restoration, layers of paint were stripped away to reveal a surprising pinkish lavender. Monet used it on various walls, trim, and doors in his home.

From the first moment I saw the lavender paint on the doors, my thoughts immediately went to the natural lavender canopy of wisteria that floats over the main emerald bridge. Once again, natural elements connect Monet's garden to his home.

EVERYDAY MONET IDEA

Lavender is such an exquisite color—so soothing, so evocative of the irises and Japanese poppies in Monet's garden. His use of lavender paint on doors seems like a natural choice—it is a welcoming color that moves us from one room to another. To re-create this look in your home, use the palette I provided on page 24; the lavender is marked number eight. Measure the dimensions of an interior door or doors you would like to paint. Take the color palette to your local paint store and have them match the color. Share with them that you want to paint an interior door (give them its dimensions) and they will guide you with respect to how much paint you should purchase. If you hire a painter, they will help you with all the steps. A lavender door is in your future!

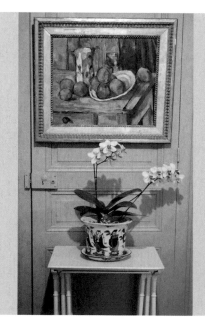

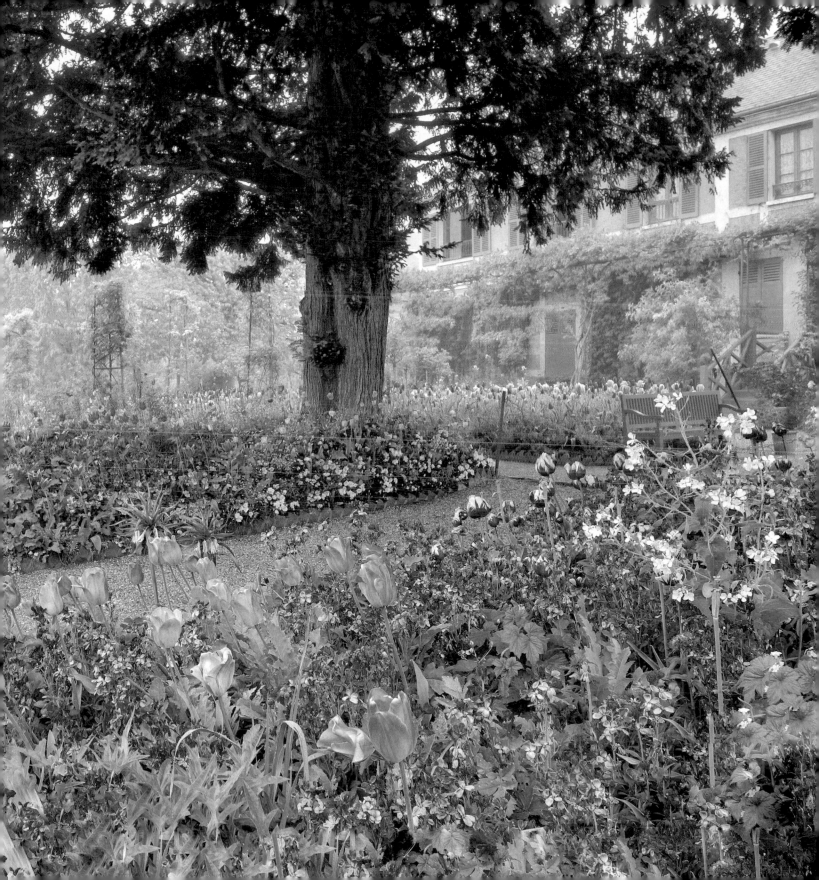

JAPONISM/JAPONAISERIE

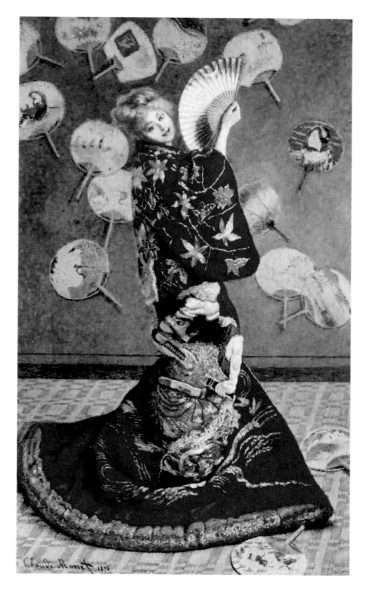

The painting on the left is of Monet's first wife, the love of his life, Camille, posed and draped in a traditional Japanese kimono. The painting is romantic and beautiful, truly demonstrating Monet's passion for Japanese style. I recently learned that Camille enjoyed dressing up for this painting and that it was a wonderful experience to create this work together.

The era of Japonism/Japonaiserie was in vogue in Europe and sweeping France at the time. With the opening up of trade, first through Holland and then through the rest of Europe, the refined designs and beauty of the current Japanese and Chinese styles were embraced completely. Monet's circle of friends were especially fond of the Japanese style. Everything about it, including the colors, lines, art, design, garden, and general temperament, agreed with Monet. He brought Japonism into his living space and it's an important aspect of style in Monet's life.

To this day, there is a strong link between the people of Japan and Monet's world at Giverny. It is a reciprocity steeped in mutual admiration. Each year a large number of visitors from Japan visit Monet's home and garden. It is delightful to see their faces as they enjoy Monet's nods to style inspired by their culture. Although Monet never visited Japan himself, he had many Japanese guests visit with him at Giverny. Happily, we have living and preserved testament to his taste.

Many years ago, to show their appreciation, the people of Japan held a ceremony honoring the head gardener, Monsieur Vahé. And Monet's home at Giverny gave special permission to the Japanese, allowing the only authorized replica of the home and garden—Monet's Garden, Marmottan in Kitagawa Village—to be built.

JAPANESE WOODCUTS

"Me, Monet and Rodin are enthusiastic about them." —**CAMILLE PISSARRO**

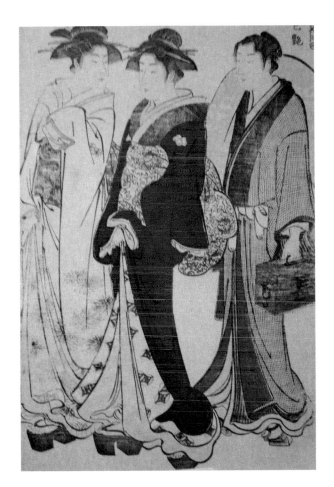 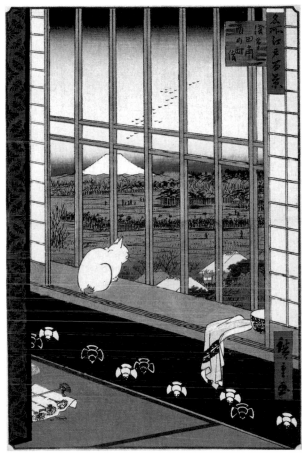

Monet's home contains a massive and cherished collection of original Japanese woodcut prints. The dining room alone has dozens of woodcuts adorning the walls, and most feature women and men dressed in traditional Japanese costumes. Other prints hang in a very intimate way on the stairwell walls as you make your way up the winding wooden staircase. Monet adored Japanese woodcut prints and the Japanese motif overall, as witnessed by the garden's green Japanese arched bridge.

It is so easy to purchase an inexpensive reproduction of a Japanese woodcut print. Here is one called *Chrysanthemums and the Bee*, by Hokusai Iitsu Hitsu. I put mine in an old wooden frame, and from the moment I hung it on the wall, Monet's love of Japanese woodcuts has been in my home, to pass by every day.

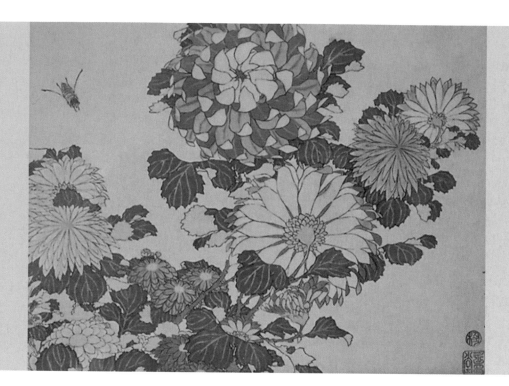

Monet collected a total of 243 prints, of which 211 are on display on a rotating basis throughout the home. The major ukiyo-e artists in the collection are Katsushika Hokusai, Andō Hiroshige, and Kitagawa Utamaro. Supposedly, Monet originally saw the prints in a grocery store in Holland that was using them to wrap up purchases. Another theory is that he was introduced to the woodcuts by the American artist James Whistler. It just so happens that at the same time Monet was amassing his collection, another American, Frank Lloyd Wright, was also passionately acquiring these treasures—according to my friend Melissa Galt, Wright's great-granddaughter, the collecting was inveterate.

I have passed through the walls of prints so many times through the years. Recently, I lingered in front of a number of prints, taking in their beauty, simplicity, and colors. I understand how Monet, Wright, Whistler, and so many others couldn't own just one. But then again, 243 might be considered excessive.

Monet's brushstrokes and lines were influenced by the ukiyo-e woodcut prints that were the first to include color. Color! Like Monet, the ukiyo-e woodcut artists would repeat the same subject at different times of the day and light. We are truly fortunate to have Monet's cherished collection as an inspiration for style in our everyday life. Plus, as an important body of Japanese art, they are now being protected by the Fondation Claude Monet, Giverny.

LIGHT

"It would be interesting to study the same motif at different times of day and to discover the effect of the light which changed the appearance and coloration of the building, from hour to hour, in such a subtle manner." —**CLAUDE MONET**

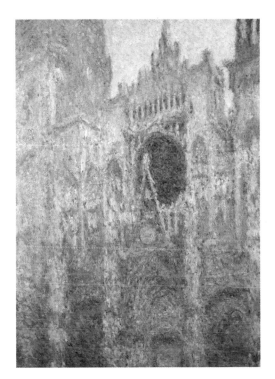 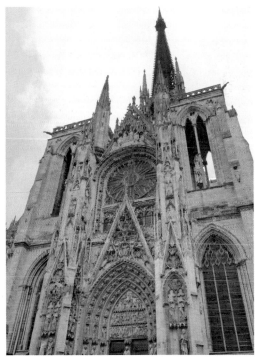

In 1882, Monet finally acted on his desire and started his series of the Cathedral at Rouen. The architecture of the cathedral was different from many of the natural subjects Monet was drawn to. I find it very interesting that the color scheme in the painting above (left) mimics Monet's yellow dining room as it peers out from the frame of the blue kitchen's doorway.

Monet would eventually paint thirty canvases in this series of the cathedral, all at different times of day from a small space he rented, capturing the different light effects. This was much more a study of light than any of Monet's other series of paintings. Monet's ability to use and showcase varying light was a true talent—not everyone could paint the same subject at different times of day, catching the special light of the hour or season like Monet.

I have stood in front of the space Monet rented to create this series. When I took the photograph, I couldn't believe the amount of light and how ancient the church appeared in the photo. The majesty of the cathedral, and the realization that Monet captured the light better than anyone, was overwhelming.

(Interestingly, the maker of the lenses that were in Monet's eyeglasses, Zeiss, make a great camera lens today—and it's the lens in my camera. The Zeiss lens is known for its sensitivity to light. In fact, those very lenses, a gift from a Professor Jacques Mawas, helped Monet to see in his very last year.)

SCENT

Monet's style is really about appealing to all the senses. Claude Monet created a magical world of beauty, light, color, and fragrance! A wonderland where fragrant roses, lilies, tulips, daffodils, irises, lavender, herbs, and every other imaginable flower nestled together in sweet-scented harmony.

The love of Monet's life, his wife Camille, would keep her perfumes in tiny bottles topped with silver. This was a time of La Belle Époque, the time of great imagination and excitement that first took over Paris, and then the world. Perfume was a symbol of that great period, and it brought the aroma of the garden into the house.

I have always been drawn to this painting of Camille Monet sitting on a sofa. It was not painted at Giverny. The painting was done in 1871 in London; as mentioned, Camille never lived at Giverny. The style of the chaise is a precursor to the wonderful style that Monet brought into the Giverny home. The English connection in this particular painting feels like the inspiration for much of the style and decor of the home.

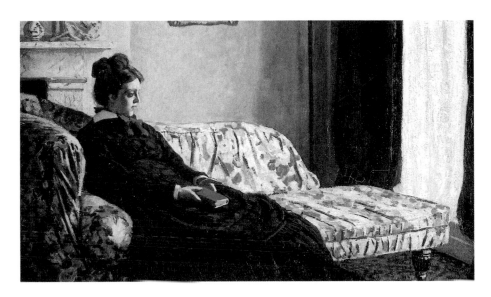

EVERYDAY MONET IDEA

The list of scents representative of Monet's period and garden is vast and can easily be introduced into your home with a scented candle. You can also take a small drop of a scented oil, perhaps lilac, and place just a touch at the top of a lamp bulb. When you turn on the light, it will release the scent. A lavender candle can be a wonderful connector, and it is a lovely visual element, bringing Monet's love of warmth, light, and fragrance into any room. Buy a good-quality candle. Those that are of lesser quality do not maintain their scent—the scented oil will separate from the paraffin—and though you will still get light from the wick, you will get very little scent as the candle burns. Choosing a great, beautiful candle really does go a long way to bring Monet's love of light and warmth into your home.

RATTAN, LACE, AND COMFORT

The bamboo that flourishes at Monet's water garden is a perfect example of how Monet's interior style and outside design of the garden come together as one. The use of bamboo, which can be fashioned into wicker, and rattan, a vine that grows like a tree and is as strong as wood, is replete throughout Monet's design. In the pages that follow, take note of the various chairs and tables included in the interior style photos of the home.

VIGNETTES Á LA MONET

Here are some easy ways to bring Monet's preferences for rattan, lace, and comfort into your home.

VIGNETTES

The term *vignette* is often confused with *tablescape*. A tablescape is how to arrange creative place settings and centerpieces at a breakfast, lunch, or dinner table. They are generally themed for a holiday like Christmas, an occasion such as a birthday, or a season like fall. A vignette, on the other hand, is much more in keeping with Monet's style. It is a staged arrangement of well-chosen items that take into account color, shape, size, and height. The items as a grouping, staged together, should convey a certain sensibility or message—and in this case you will be conveying the beauty and joy of Giverny.

We have all taken framed photos, books, decorative bowls, perhaps some candlesticks or a family keepsake and arranged them on a shelf, entry table, sideboard, or mantelpiece. It is our way of displaying and conveying our own personal decorative possessions with rhyme and reason—and you can do the same incorporating Monet's aesthetic as well.

A vignette can transport Monet's style to any part of your home and it is so easy to create. The vignette must be placed on a flat surface, for example, a windowsill, table, buffet, bookshelf, console table, or ottoman. The following two vignettes include different aspects of Monet's style; each is an example that you can follow or change depending on your own taste.

MATERIALS

Select a cleared, flat, and stable surface made of wood, glass, rattan, marble, or ceramic, and choose a grouping of items from this suggested list that sings Giverny:

Lace	Fruit	Monet's color palette
Rattan	Bowls	Flowers
Wicker	Candlesticks	Plant

Note: The most exquisite vignettes include various-size items, different heights, and a fabric layer.

1. Decide on your space. Make sure it is clear of any other items so you have a blank canvas.
2. Decide on the objects you would like to display from the list. Choose varying heights, shapes, and textures, if possible.
3. If you have decided on a fabric layer for the vignette, lay it down first, and center it on the surface.
4. Start the vignette by placing the taller items toward the center, with shorter items going out from the taller items.
5. The most visually appealing vignettes have either one prominent piece or three to five pieces of varying shapes and heights.

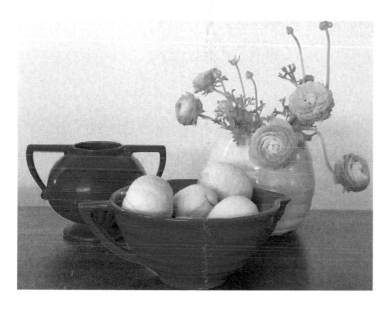

VIGNETTE EXAMPLE #1

The vignette here is a twenty-first-century twist on blues and yellows, an homage to Monet's dining room and kitchen. The stylist, Deborah Ritchken, used items already in her home and created a still life for the senses. I could imagine this on a buffet or an entry table in your home. Included in this vignette are fresh lemons from her tree and exquisite sunshine *Ranunculus asiaticus* (Persian buttercup).

VIGNETTE EXAMPLE #2

This vignette includes many of the style elements we've already discussed in this chapter. Paige Dixon, the noted floral arranger, combined Monet's fondness for lace and rattan perfectly. The wicker is a very suitable element and the lace a perfect layer. The tall vase makes a wonderful vessel for the fresh water lilies, with soft colors reminiscent of Monet's early water lily paintings. Simple elegance delivers the beauty of Giverny.

THE DINING ROOM

"It was a sunny room, lemon yellow walls decorated simply with Japanese prints that Monet told us he'd bought in packets a while ago, for just a few francs when visiting Holland. He told us to sit at the table. He'd pour drinks, watch us help ourselves to the dishes. 'But you're not eating!' With a meaningful look in our direction, Monet awaited our compliments, which we offered unstintingly." —**JACQUES SALOMON HADAMARD**

When I see Monet's yellow dining room (opposite) in the very early morning, before visitors are allowed in, I appreciate taking in the nuances of color and light. From butterscotch to saffron in the morning, and by midday, with the light streaming in from the double French doors, it is as if I am enveloped by lemon meringue. Of course, with sunset, all is washed in copper and gold. If I didn't know better, I would imagine Monet to have mixed threads of saffron, specs of gold, and lemon peel into the paint before applying the color across the walls. Monet was taken with surface paints, so much so that he used them on furniture as well, which was not the fashion at the time. Each element in the space interacted throughout the day as the light filtering through the windows changed.

THE DINING ROOM CAT

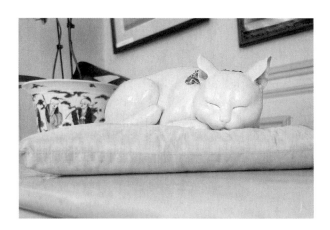

This is the precious ivory-white porcelain cat that was gifted to Claude Monet by friends from Japan. The cat has had its place on the dining room side table since the restoration. It supposedly dates back to the Meiji period in Japan, which lasted from 1868 to 1912. I often look at the cat, with its milk-white glaze, resting serenely on the luxurious blush silk pillow. Claude Monet loved cats, and to this day, there has always been a cat at play in the garden.

Just as Monet did, I am certain that many of you have already included a cat or dog as part of your family too.

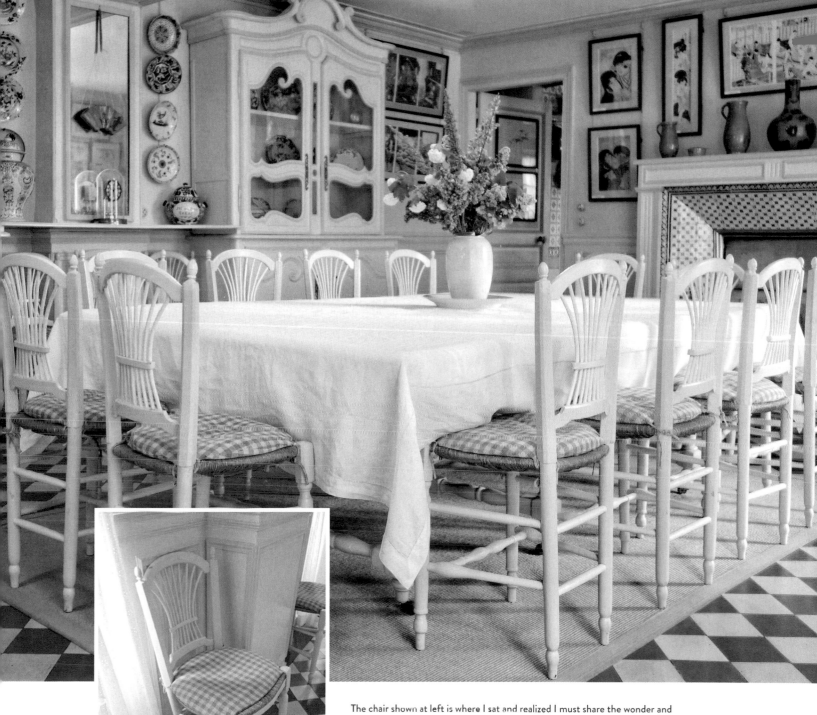

The chair shown at left is where I sat and realized I must share the wonder and beauty Monet created at Giverny. I digested the light, colors, ambiance, and beauty. My hope is that for a moment you will feel as if you are sitting here too. Can you feel the alabaster light on your shoulders? Close your eyes for just a moment and let me take you there.

THE CLOCK

The clock that sits in the Giverny dining room is one of the most exquisite clocks I have ever seen, and my annual visit to Giverny is never complete without checking my watch against its time. It was made in Germany by the Hettich Clock Company, located in the lush Black Forest, just over the French border. The shape fits perfectly with the lines of the room and creates an attractive reflection in the mirror it sits in front of, no matter where you stand.

Claude Monet was obsessed with punctuality, and a true keeper of time. In fact, if you were his guest and arrived late for dinner or lunch, that might have been your very last invitation.

EVERYDAY MONET IDEA

Do you have a favorite clock? One that you may have hidden away somewhere? Display it, and make sure it is set correctly; we wouldn't want Monet upset.

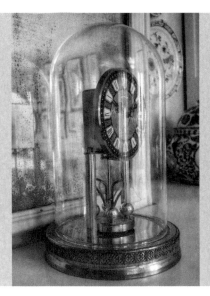
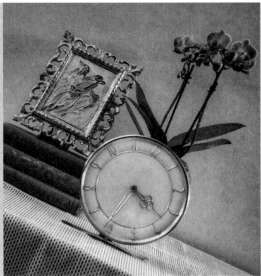

Monet was a gracious host and exuberant entertainer. The Chinese- and Japanese-influenced still life of a tea service, seen on the right, is one that Monet practiced often in real life, serving warm and comforting tea to guests. Often, he served this spread after a spectacular dinner in the dining room. In my interpretation below, I have taken some of Monet's favorite elements of lace and wicker to pay tribute to this lovely painting, and of course, you can too. Tea anyone?

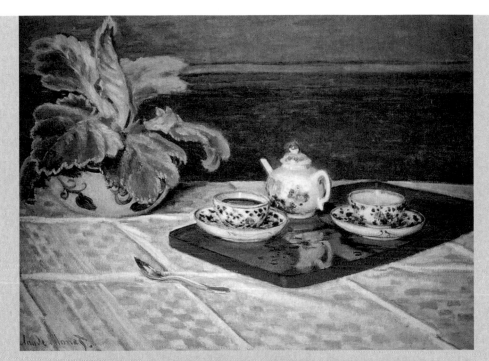

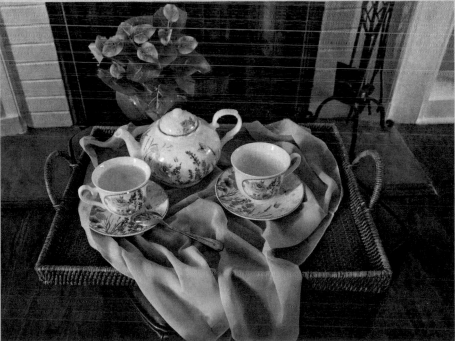

MONET'S KITCHEN

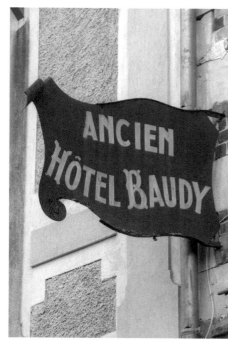

When I asked my mother about her very early days at Giverny, one of my first questions was "Where did you eat?" It seemed like a very basic question, and I imagined her taking meals at the Hôtel Baudy up the road, or at the studio, where Monsieur and Madame Van der Kemp resided. I can assure you I was shocked when she nonchalantly stated, "Well, here in Monet's kitchen, of course."

The kitchen, *cuisine*, is truly breathtaking, with light streaming in and bouncing off the abundance of copper pots and Rouen tiles. Monet took great interest in the layout, equipment, and design of his kitchen—his Norman French–style kitchen includes a large taupe marble sink, a stove, and hexagon terra-cotta flooring. This is the hearth of the home.

The heavy steel stove was produced in Paris by Mon Briffault, a company that also produced professional stoves for the greatest restaurants of the time. Monet always insisted on having the most current appliances and kitchen gadgets. He truly was a foodie, long before that phrase was ever coined.

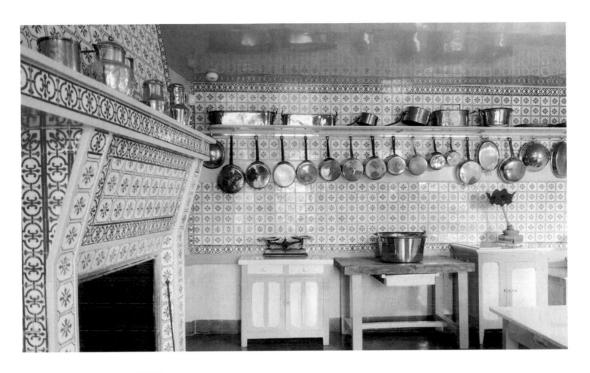

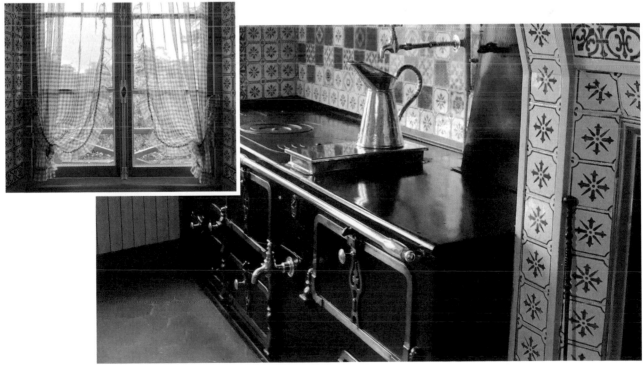

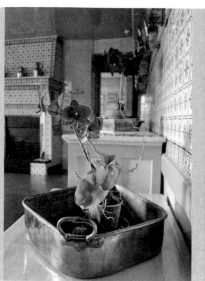
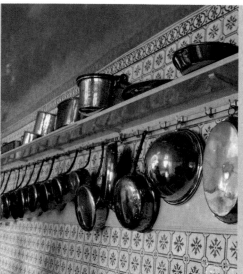

EVERYDAY MONET IDEA

There are so many ways to bring Monet's affinity for copper, and specifically for copper kitchen items, into your life. The most obvious is to buy your own copper pan. If you don't care to have a new pan, look at a tag sale or online for an inexpensive used copper pan. In place of a copper pan, you can find so many different items made of copper, including vases, candlesticks, planters, inkwells, and trays.

The door off the hallway near the kitchen leads to the cellar, which held his wines, seasonal fruits, and root vegetables. During the winter, Monet stored his favorite banana ice cream in the cellar, which he served at every Christmas meal.

Marguerite, Monet's cook, managed everything in the kitchen, making sure every meal was prepared and every evening of entertaining went smoothly. I imagine Marguerite at the stove, tasting the Sunday soup for seasoning while Monet paced the dining room. He demanded the soup be served hot. Marguerite's husband, Paul, was also Monet's butler, and he helped around the home. Paul served the meals and had to adhere to Monet's strict guidance. Monet was quite the perfectionist and was particular about everything—not only his art—and his passion for food ran deep.

The kitchen is and will always be my favorite space in Monet's home. Although it does not have the same glow of the other rooms, especially the dining room, its shades of blue present the feeling that the sky is all around you. The reflections of the copper pans change and twinkle with the sun—it is stunning, and I wish I could bring the exact pans into my own home.

IT'S NOT DELFT

With Monet's visits to Amsterdam and his love of tulips, it is easy to see why he may have chosen tiles for his *cuisine* that shout Holland. Visitors often assume the blue-and-

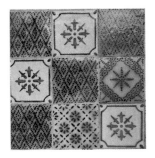

white beauties are the famed Dutch Delft tile. The Dutch were the first to import this style of pottery from Italy and soon adopted the blue-and-white motif popular in China.

But in fact, these very tiles in Monet's kitchen are French and were handmade in Rouen. France eventually became a leader in establishing the art of hard paste porcelain. How lucky for Monet that Rouen became a famed center for this style of glazed ceramic. They bring to mind the beauty of Normandy and are used as a backdrop throughout the kitchen.

TWO ROOMS WITH A VIEW

I always enjoy seeing the glow of the dining room shining as I stand at an angle looking from the kitchen. Similarly, the dreamy deep sky blues of the kitchen, which peek through the common passage to the dining room, are enchanting. Monet used this same French palette when he designed his formal yellow porcelain dinnerware. The dining room floral arrangement always sits upon a large dinner plate from Monet's service.

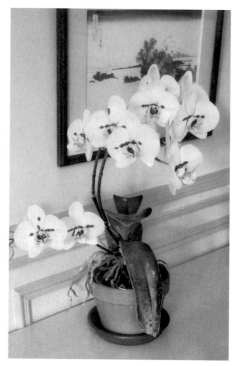

EVERYDAY MONET IDEA

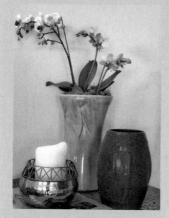

As you have seen thus far, orchids are a main feature of Monet's style at Giverny. Having an orchid is a beautiful and easy way to decorate your home like Monet did. In addition, this is another easy way to replicate the Japanese aesthetic that Monet so enjoyed. The orchid pictured is a *Phalaenopsis*, which is a common genus that requires very little light and water. Take note of the little copper bowl, just another nod to Monet's style.

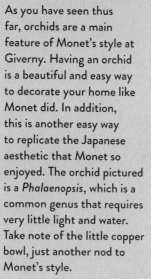

As mentioned earlier, Monet spent a good deal of time in Rouen, which is just forty-six miles north of Giverny. During one of his visits to paint the cathedral, he met Monsieur Varenne, who at the time was the director of the Rouen Botanical Garden. Monsieur Varenne led Monet on a tour of the garden's greenhouse. Monet became enthralled with the exquisite orchids, so Monsieur Varenne gifted them to Monet, along with a begonia. During Monet's era, the orchid symbolized the beauty and grace of a woman. Without hesitation, Monet took to these orchids like frogs to water lilies. Today, Monsieur Vahé, the head gardener, has made sure to source these beauties from the greenhouse, just as Monet did.

To this day there is a fresh rotation of *Vanda* orchids throughout the home. *Vanda* orchids were rare at Monet's time, but today they are very accessible. The addition of the orchids ties the home to the outside garden. In addition, they fit with Monet's affinity for the style in Japan, where they are highly celebrated.

THE SALON

"Begin at the beginning," the King said, very gravely, *"and go on till you come to the end: then stop."* —**LEWIS CARROLL**

Each time I enter the salon and see the clock, I am instantly reminded of the animated film *Alice in Wonderland*. The two playful shades of blue on the painted furniture, again so unusual for the period, along with the massive bookcase help make this room delightful. Monet kept a lot of his treasured books in this case. They included his books on botany—one grouping included his twenty-three-volume set of *La Flora des Jardins d'Europe*, which focused heavily on those flowers native to France and Europe. In addition, his interest in orchids made its way onto his bookshelves. In the early 1980s, when my mother would grab a book from the shelves, often it was a first edition signed to Monet by the author. I asked if she remembered some of the authors she discovered

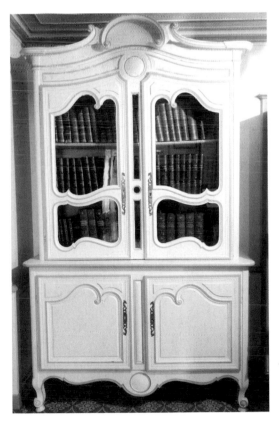

on the shelves, and she gladly shared the following list with me: Charles Dickens, Victor Hugo, Guy de Maupassant, Edgar Allan Poe, Flaubert, Ibsen, Alexander Dumas, Balzac, Rudyard Kipling, Tolstoy, Marcel Proust, Henrik Ibsen, George Sand, and Émile Zola. Hugo was her favorite to look at before bed. The book was inscribed by Victor Hugo to his dear friend Monet. My mouth dropped.

Of course, the salon was and still is adorned with its own generous collection of woodcuts. The room is darker and not as well lit as the others, but it still has a very warm and welcoming appeal. There is just one set of French doors in the room; they lead out to the veranda, which is a wonderful spot for some tea or coffee. Right off the blue room is an area where Alice would do embroidery and there was a phonograph, in the style of the early Edison players. Monet adored music and was known to break out into song. I imagine that after a whisky at the Hôtel Baudy up the road, followed by a liqueur when home in the blue room, he was ready to give the phonograph a whirl.

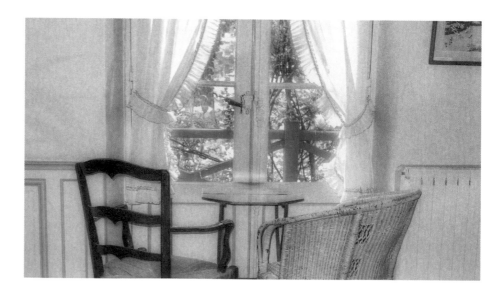

Imagine sitting at this table in Monet's library, with an early morning view, while enjoying a cup of tea or coffee.

THE STUDIO SITTING ROOM

"This is where Monet brings the work he's done during the day." —**GUSTAVE GEFFROY**

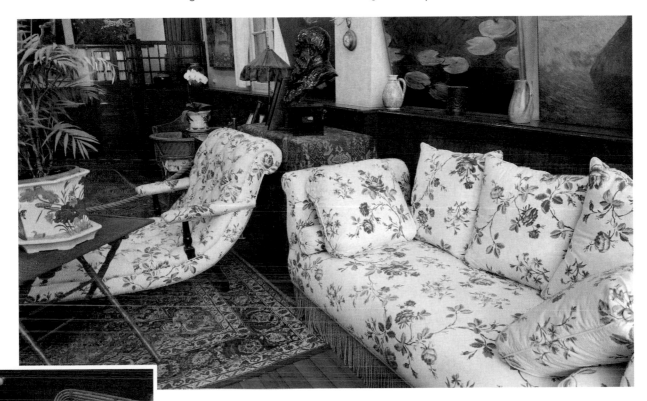

I guess it should come as no surprise that Monet was very precise about what indoor space would work as an art studio. At Giverny, he ultimately renovated and designed three distinct studios, each with a different feel, light effect, and purpose. His very first studio, pictured here, was the first change he made to the design of his home. He transformed the room from a place to store paintings to a place to paint, entertain, and display his art for sale.

This room was full of warmth and upholstered comfort. Monet would sit back, smoking his favorite brand of Caporal cigarettes, delighting in the view of his garden. The large windows streamed light upon every inch of the room, along the comfy rattan chairs and the table, where the family played cards and games, had tea, and lounged. The use of floral fabrics and rattan furnishings through the room evoke a similar style to the bamboo water garden and rose topiaries.

THE DESK

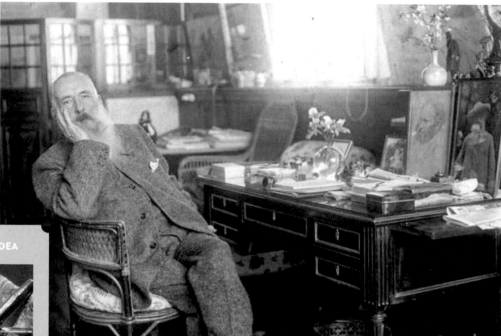

Claude Monet at his desk (1916). Photographer: Henri Meurisse.

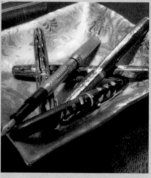
I have always been intrigued by the above photograph of Monet taken in 1913 at his studio. I love seeing his heavy wood desk, strewn with papers, even his own photograph framed. This is the very desk from which the prolific corresponder would have written to many people, including Renoir, Sisley, Pissarro, Degas, Butler, Boudin, Clémenceau, and his agent Durand-Ruel. The window above his desk extends out, looking upon the front of the house. Depending on the season, the rotation of tulips to roses brings sweet scents.

The artwork on the walls of Giverny today are replicas and are hung as Monet would have when patrons came to view those works for sale. Of course, Monet's work around the turn of the century became coveted. The salons in Paris, where he exhibited his art, were becoming successful and he was earning a handsome living for the time, especially for a painter.

I must share a story from my parents' dear friend Jean-Marie Toulgouat, Claude Monet's step-great-grandson, Alice's great-grandson. When Jean was a little boy, he would often play in the attic. There, he found wonderful paper that

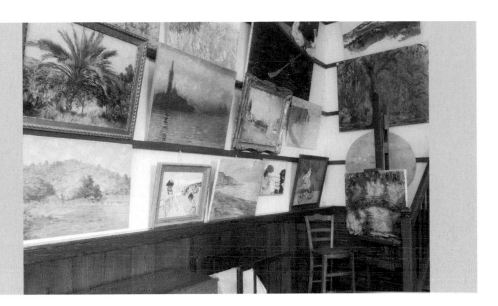

EVERYDAY MONET IDEA

Clearly, everyone cannot own a Monet painting, but we can all own a poster or reproduction. Consider hanging a print—or several, as Monet did here—of a Monet painting in your own home.

he used to fashion the sails of wooden boats he would create and play with in nearby streams. It turns out that these were rolled-up paintings by Monet, most unfinished. He laughed when he told my parents this story, finding humor in realizing how rich he would be today if he still had those papers.

UPSTAIRS

There is one stairway that leads from the main hallway off the main entrance to the upstairs quarters. I often think of the beautiful wooden banister, with its curves and turns. I imagine Monet holding on to the railing, looking at his woodcuts displayed at the top. I look at the banister and think about Monet holding tight toward the end of his life while his eyesight grew poorer. I think about Prince Charles running down the stairs before dinner in Monet's dining room.

Then I think of my mother, who was only forty-nine years old when she ran up the stairs in her high heels (which she still wears), making her way to her bedroom, thinking *How did I get here?* Through the years, the multitude of guests who climbed those stairs to visit with Monet included the statesmen, writers, and artists of his time. Since the renovation the names are too many to list, but among them are Ginger Rogers, Louis Jourdan, Audrey Hepburn, Kirk Douglas, Gregory Peck, Meryl Streep, Charles Trenet, Rex Harrison, Hillary Clinton, Laura Bush, Tony Bennett, and other dignitaries, politicians, artists, and musicians. It's just a banister . . . well, not really!

BLANCHE'S BEDROOM

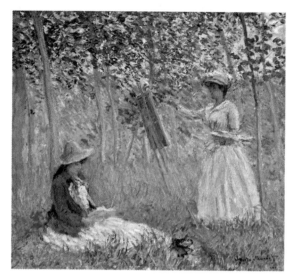 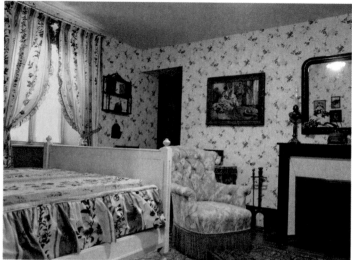

Who is Blanche? Blanche Hoschedé-Monet was Alice's daughter and Monet's stepdaughter. She lived at Giverny until her death in 1947. Blanche was a painter, and a good one. Her work has been exhibited worldwide, and above left is a lovely example of one of her paintings. Monet recognized her interest in painting and praised her work, along with giving her some pointers. I think she captured the style and feel of Giverny very well!

Blanche's old bedroom is the very bedroom that my mother, Helen Rappel Bordman, slept in during her early years at Giverny. It was decorated and opened to the public for the first time in 2014, and therefore, there are few published photos of the room that exist (top right).

This is such an elegant room with its Persian rug and delightful floral bed set. The floral design of the wallpaper brings the garden into the room, no matter the time of day or season. While Blanche lived in the room, she could see the area of the garden called *le clos normand* from her window. Between the wallpaper and bedding, the room was very English with its many roses.

ALICE'S BEDROOM

With a lovely view of both sides of the home, Alice's bedroom seems spartan when compared to other rooms in the home. It is decorated in a traditional Normandy style

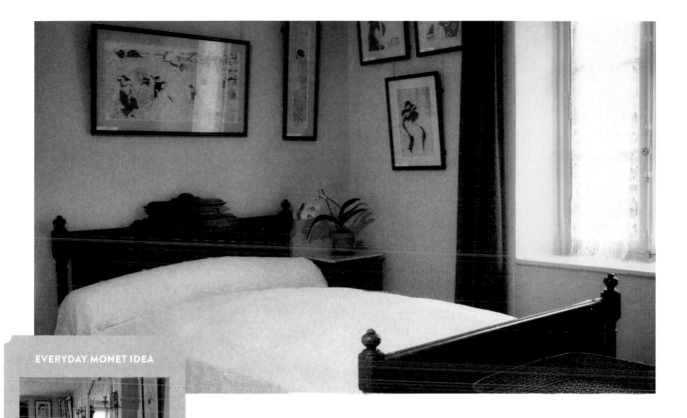

I implore you to take note of the orchids, lace, rattan, and woodcuts in both Blanche's and Alice's bedrooms. There is a theme, and if you just introduce one of these design elements to your bedroom, you have the simplest examples of Monet's style that you can enjoy every day.

with strong English influences. But there is also the wonderful presence of the Japanese woodcuts and, in keeping with Monet's style, touches of lace, blue, rattan, and an orchid.

The woodcuts in this room for the most part depict women, some Japanese and some European, all wearing nineteenth-century dress. Pictured left, the Louis XVI sconces are a touch of elegance in a very Normandy-styled bedroom. The elegant floral porcelain, with the glass-covered domes are rather new contributions to the room and have not always been there.

Alice left decorating to Monet. *Pourquoi pas!* Why not! I imagine Alice found this charming room an oasis; with eight children and a household to run, she was never lacking in things to do.

CLAUDE MONET'S BEDROOM

Claude Monet's bedroom is fit for the master. Each time I visit his most inner sanctum, I am impressed with the decor and the light. He had wonderful views from his window, including the main walkway through the garden dubbed the Grand Allée. It should come as no surprise that Monet renovated this part of the house with plenty of space

EVERYDAY MONET IDEA

Monet's bedroom was all about art. It was a place to showcase the work created by many other artists, whom I listed, that Monet coveted. Consider if you haven't already, a painting in your bedroom—whether it's Monet's or one of the many other impressionists who inspired Monet and whose paintings he had up on his walls. Choose one that you truly enjoy.

for his art collection, cherished photos, and possessions. The room included a Louis XVI flourish, in this case a frame for his mirror and an exquisite candelabra. There is a door leading from a shared closet into Alice's bedroom.

Surprisingly, Monet's bedroom was one of the few rooms open to visitors. He would invite friends and guests to see his art collection displayed in his room. The collection included paintings by Cézanne, Signac, Morisot, Renoir, Delacroix, and Pissarro. In addition, there were two small bronze Rodin statues. Just imagine having your artwork collected by Claude Monet.

A ROOM WITH A VIEW

Monet's inspiration and style were all reciprocal, as the garden inspired the home design, and the home inspired the garden. Take, for example, the use of the same emerald-hued green on the shutters, as well as on the benches and bridges. Monet enjoyed the view from the large green-framed window of his bedroom.

Impressionism! The home and garden were an extension of each other. I thought it would be lovely to share some of the views Monet, his family, and his guests enjoyed from various windows in the home. The center photograph on the opposite page offers a view of the main garden path, what is known as the Grand Allée, or grand boulevard. Are you feeling the impressionism?

NOW BRING MONET'S STYLE HOME

I am sure you have many ideas of your own just from looking at the paintings and photos throughout this chapter. If you adore Monet's paintings and just cannot get enough of seeing them at a museum, trust me, you can bring that love into your home. Even if for some reason you don't think the paintings themselves fit with the decor of your home, there are still easy ways to connect your home with Giverny. You can create a small space with something as simple as a scented floral candle that ties the beauty of Giverny to your home.

Just including a color, a fabric, a Japanese print, or a wicker tray can transport you. Try placing some dried lavender in your entry hall, or painting your shutters and windowsills an accent color from Monet's palette. Bowls of fresh apples, pears, or bananas placed in a decorative bowl with a Japanese motif would be superb. All these are so simple, yet they can transport you to Giverny. The most obvious way would be to do as Tony Bennett did after one of his visits to Giverny with my mother and paint a room the same color as Monet's home.

The ideas presented may require some effort and time, but if you have a passion for Monet, they are well worth it. I promise, they will help bring Monet's style—his garden and home at Giverny—to your home.

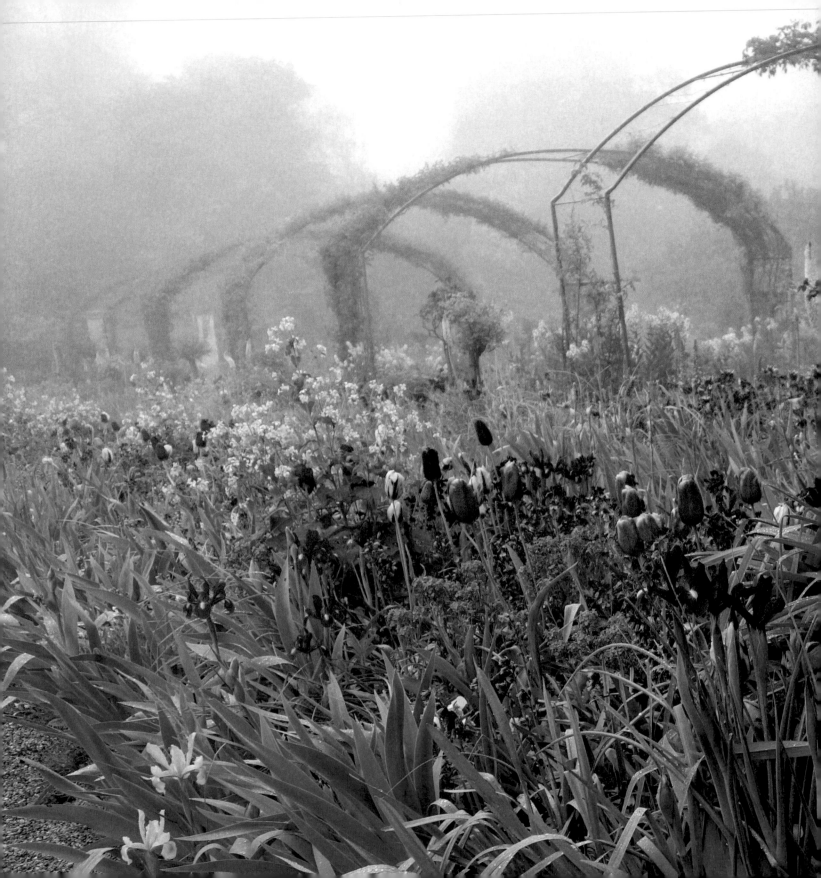

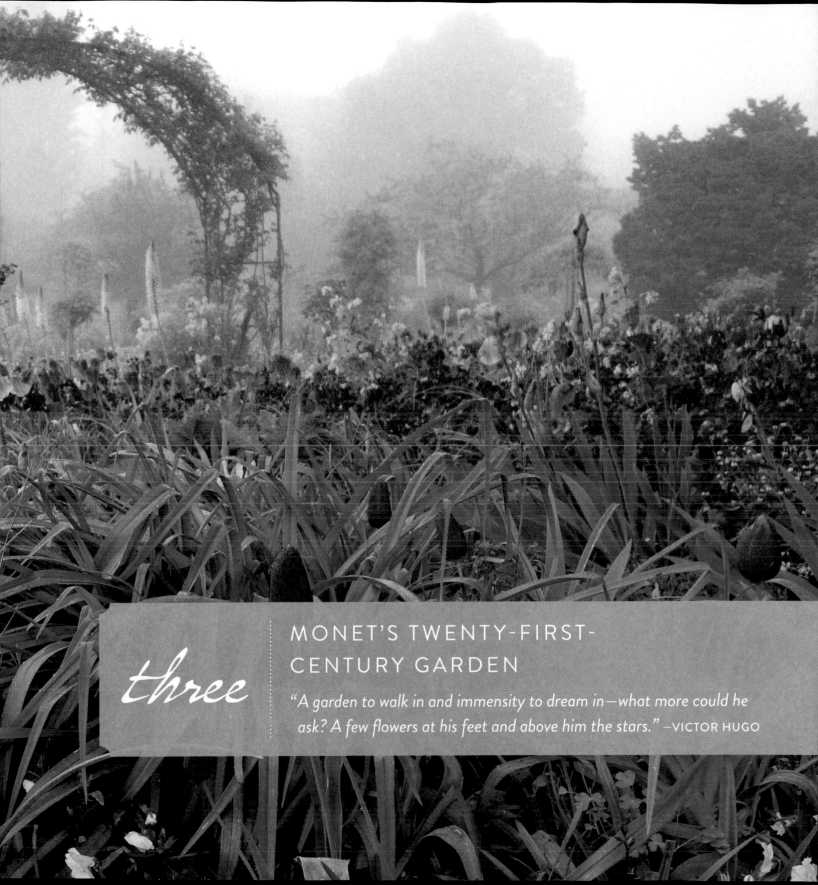

MONET'S TWENTY-FIRST-CENTURY GARDEN

three

"A garden to walk in and immensity to dream in—what more could he ask? A few flowers at his feet and above him the stars." –VICTOR HUGO

HEAVEN ON EARTH

It's true! A picture does say a thousand words, and Giverny has always reminded me of a moment in heaven. I took the photograph that opens this chapter during a crisp, rainy morning in May, at Monet's garden. My fingers were ice cold as I stood among the tulips and purple irises that stretched all the way to the sky. The lavender, poppies, and irises were so tall and danced in the garden, guided by the soft breeze. They shimmered.

The colors of the garden intertwined with the mist in the air, reminding me of the northern lights, the aurora borealis. I felt as if it was a slice of heaven and that Claude Monet had somehow magically painted all the beauty that was surrounding me. I had stepped into the living world of impressionism, a world I knew from paintings, that had now come to life.

Whenever I arrive at Monet's Giverny, no matter the time of year, I ache to get into the garden. Looking around the garden at all the different flowers, colors, shadows, and light, I have no doubt that when Monet chose the placement of each flower, it was done with the same intention that he applied to his art. The color, textures, size, light, and lines are simply all part of a different type of paint box.

A GARDEN FOR ETERNITY

"My garden is my most beautiful masterpiece." —CLAUDE MONET

Leave it to the father of impressionism to transform an apple orchard and small kitchen garden into nearly three acres of the most cherished flower garden in the world. Monet—with advice from some friends who were also gardeners, like the artist Gustave Caillebotte—treated his garden as another work of art.

In line with the original garden, today's garden (pictured opposite) is truly inspired by the original one you would have seen so many years ago, and which Monet walked through, grew, and cherished. Jean-Marie Toulgouat, the great-grandson of Alice

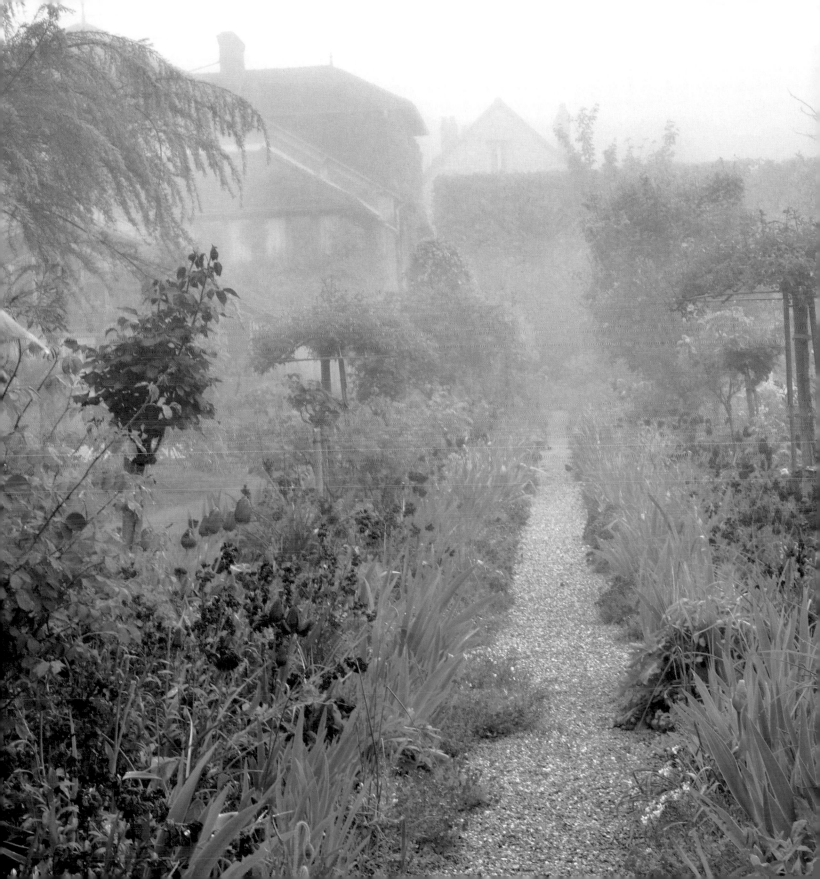

Monsieur Gilbert Vahé—head gardener since 1980.

Hoschedé, Monet's second wife, is the reason today's garden looks so close to what it looked like initially. He had many photos and archives that helped guide Gérald Van der Kemp, the curator, and Gilbert Vahé, the head gardener, with the restoration of Giverny, completed in May 1980.

It is very special to know that you are seeing Monet's garden just as Monet intended it, whether in person or through the gorgeous photos that exist to mark the garden in time and space. When you bring the key garden plants into your own living space, you, too, are part of the stewardship of Monet's garden.

Over the decades since 1980 when the garden was first restored, Monsieur Gilbert Vahé was given the enormous task of bringing Monet's living world back to life. Beyond his gift of horticulture, I have come to know Monsieur Vahé as a man of sincere dedication and kindness. Watching him tend so carefully to the garden is an education. I am so honored to have gotten to know him and to have witnessed his love of the garden and of Monet. I am so grateful that through the pages of *Everyday Monet*, and specifically in this chapter focused on the garden, I will be able to share what I have learned through my almost four decades' association with Monet's garden, as well as the tips I have learned from Monsieur Vahé, true to Monet's original vision.

Giverny was planted with the same impressionist spirit Monet applied to his art and was part of a very glorious vision realized today by Monsieur Vahé in the garden's current form. When you bring the key garden plants into your own living space, your friends and family will enjoy and appreciate the subtle references to Monet's style and to his impressionist sensibilities that you choose to include.

A JOURNEY THROUGH THE GARDEN

Allow me to take you on a tour of Monet's living floral masterpiece. As we journey through the garden, which is divided into a formal garden and a water garden, through the rows of flowers and natural plant life, I will share some simple ways you can bring the beauty of Monet's garden into your home.

Close your eyes and imagine every color and scent, every feeling of joy brought about by the gorgeous images of Monet's garden. Entering Monet's garden is like stepping from Kansas into Oz. It's as if the rest of the world is in sepia, and the garden, the world around you now, is in Technicolor.

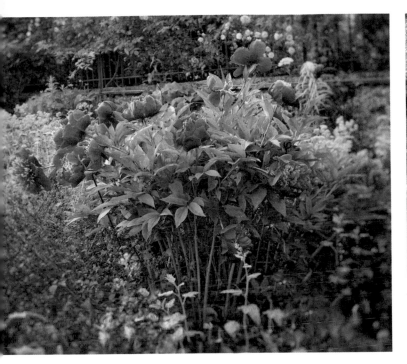

Just look at this breathtaking tulip, at the end of its days, but still open to the world, to the air, to the mist of Monet's garden, which leaves droplets on its sweet petals.

Now imagine the calming effect of the sweet fragrant lilacs as we pass through the main path of the garden toward the house.

Time in the garden is very hard to gauge—it's as if time stands still. As we make our way past Easter egg–colored tulips, we continue our journey alongside the pebble paths, heading toward the heart of the garden, the Grand Allée.

Can you see the sole magenta poppy, peeking out among the magnificent sterling tulips in the top right photo? It is exactly these moments of surprise and natural wonder that appear in the magical garden. There isn't an inch, patch, or stretch of this natural carpet that doesn't draw you in. I have seen visitors linger in front of just one flower, marveling at its beauty.

As we follow this path, it will lead us to Monet's home, which leads us to the formal garden and then the water garden.

As we make our way from the entrance to the garden, the sand-colored path twists past pink and apricot roses and Jordan almond purple lilacs and weaves across the yard where the chickens and roosters reside.

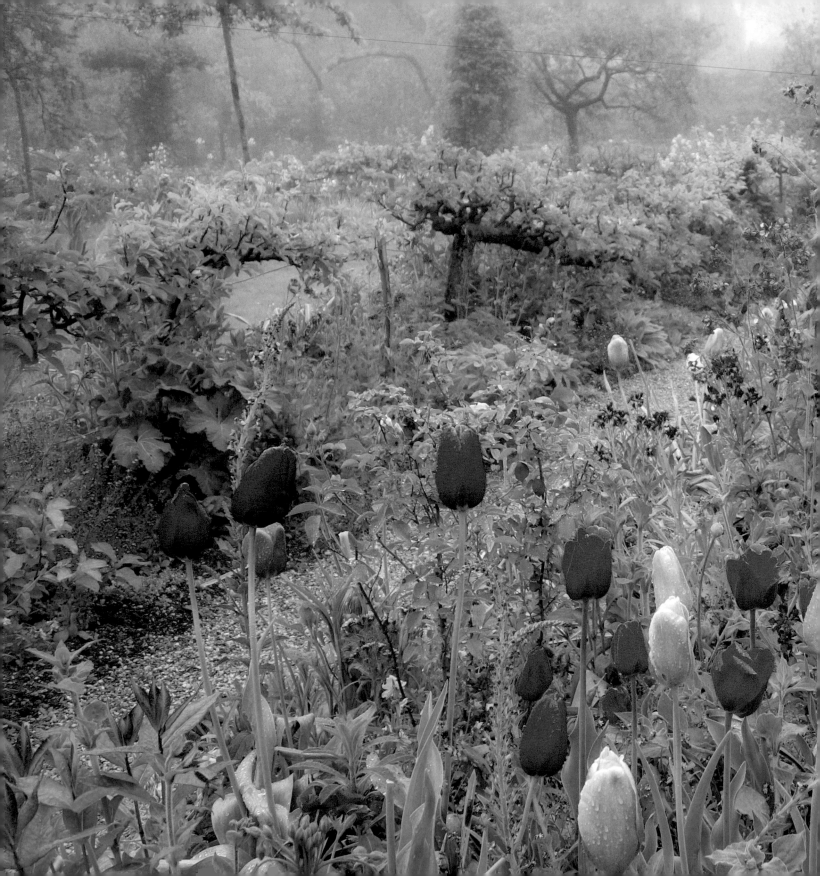

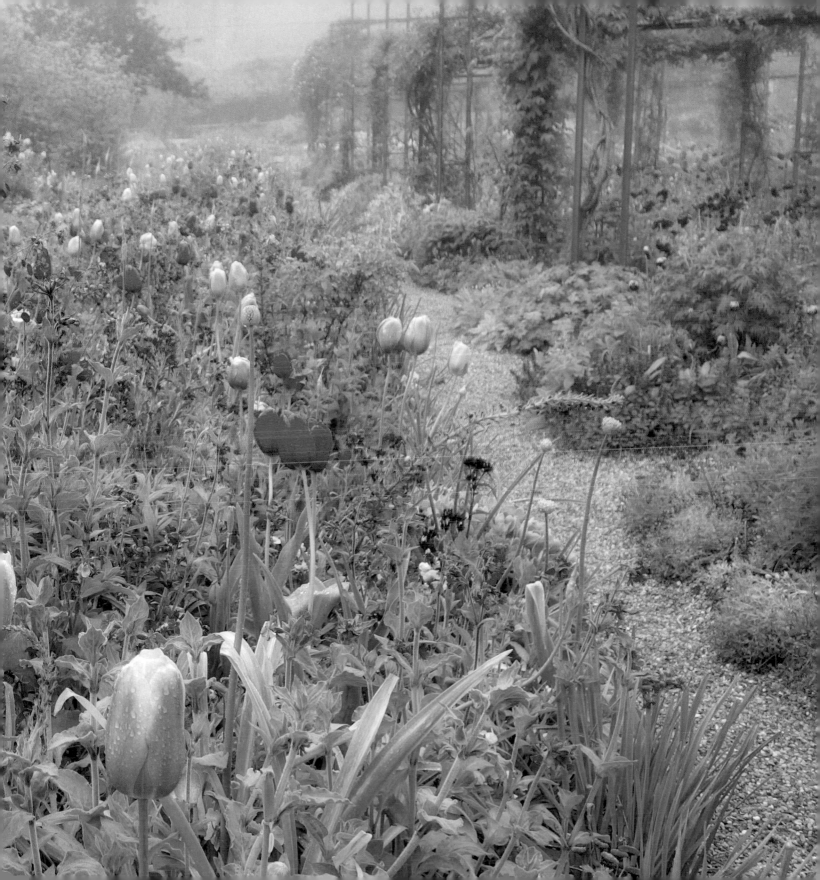

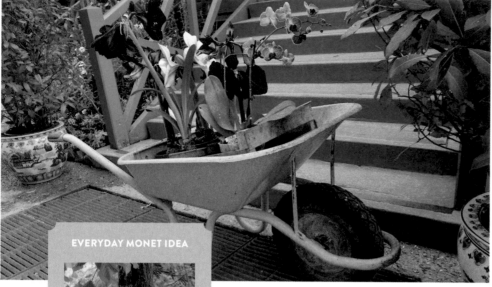
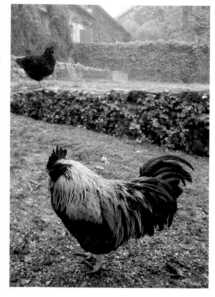

EVERYDAY MONET IDEA

Be inspired by the aesthetic of Monet's wheelbarrow; it can be a novel spring vessel for potted flowers. Fill it with soil to use as a bed for tulips and forget-me-nots. If you don't have a wheelbarrow already, think outside the box. Consider using any nontraditional vessel that invokes the same ambiance, color, and feeling. A wooden chest you find at a flea market or a bird house that can second as a way to hold up some hanging vines are just two ideas.

The roosters and chickens in Monet's yard are competing for our auditory attention. They win, and we visit with them, albeit for a few moments. By the way, they lay the best eggs I have ever eaten, with deep, deep orange yolks.

As we meander and search the garden as if on a treasure hunt, our attention is drawn in so many directions. So many things catch our eyes, as if we have never seen them before. As we round the front steps of Monet's home, we notice a charming mustard wheelbarrow. It is stocked with the everyday orchids that are nurtured at the greenhouse and then displayed throughout Monet's home.

As we weave our way through more of the garden, we come across Monet's greenhouse, where a lot of the magic starts. The greenhouse is where all the bulbs, seeds, and specimens of water lilies and orchids are nurtured. The climate is rough in Normandy, and cold weather can set in as late as May. Trust me, I have been bundled up, raincoat and umbrella in hand, in Normandy while, only some miles away, it's sunny and warm in Paris.

Now that we have passed the greenhouse, we have circled back to the main entrance at Monet's home, where we are greeted with a flourish of tulips and forget-me-nots, and truly all will never be forgotten. Tall rose topiaries reach up as stewards protecting the garden, and stunning vessels, the cherished Chinese planters that Monet owned and brought with him to Giverny, sit beside his front door to greet us.

Reaching the entrance to Monet's home, we will take a step back in time and discover how the garden came to be and visit with some of the floral stars in Monet's garden, which you, in turn, can take into your own home.

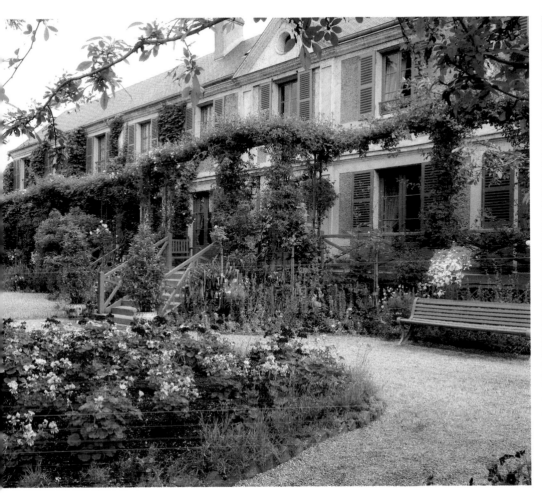

THE FORMAL GARDEN—*LE CLOS NORMAND*

"The richness I achieve comes from nature, the source of my inspiration." —**CLAUDE MONET**

Claude Monet's formal garden is called *le clos normand*, which in French means a vineyard with a closed wall. In the case of Monet's garden, there was an apple orchard enclosed by a wall. This type of design is much different from the water garden, but it is equally indicative of Monet's era and there are many ways you can bring aspects of his formal garden into your own.

　　Before and during Monet's time, classic French garden design was in vogue. This type of garden always included a water element, a topiary, and an allée. All these

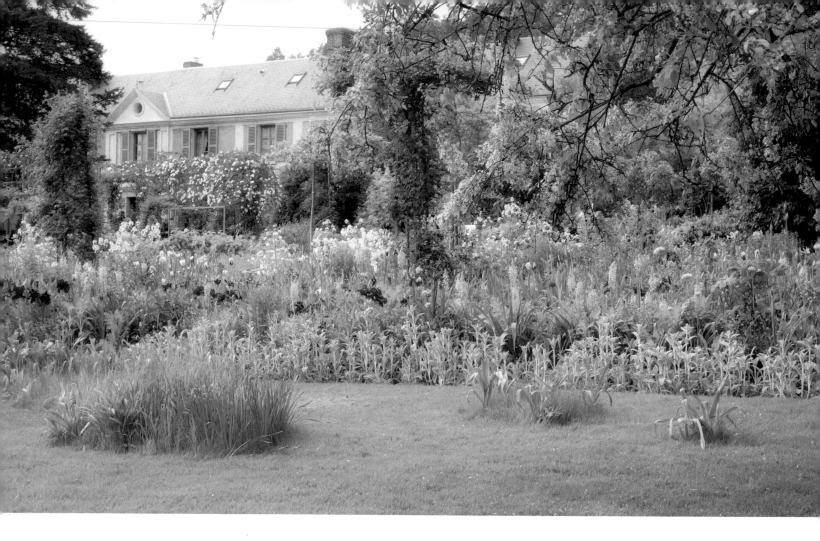

elements flourished at the Palace of Versailles, under King Louis XIV, which is located just a half-hour drive from Giverny.

Elements of beauty abound in every inch of Giverny. The colors, shapes, arrangement, and juxtaposition of light and dark convey emotion. Monet always made measured decisions when it came to the garden, and he did not enlarge the garden without thoughtful planning. He would pore over books and magazines like *Country Life*, a British publication founded in 1897 that focused on gardening, architecture, and lifestyle. A notable English gardener, Gertrude Jekyll, famed for her roses, was a contributor to this magazine and was influenced by the impressionists—and in turn, Monet was influenced by English garden design.

Monet's research and creativity produced the garden we cherish today. The garden is tied to his art, and his art is forever tied to his garden. He used basic concepts

like garden scale and incorporating blocks of a single color floral arrangement. He sprinkled these blocks of single-hue flowers with a rotating succession of annual bulbs and different perennials. He favored particular color combinations, like blue and pink, red and green and silver, gold and blue, and pink and white—which I like to think of as "matches made at Giverny." Using these color combinations in your own garden and home is a simple way to bring just a bit of Monet and his style into your life.

Nothing in Monet's garden is random—he used flowers like oil paint, dabbing color in a very focused way. One of the central design elements in Monet's formal garden was the border made up of irises, peonies, and poppies. The flowers are lush and spill over one another. In addition to their placement, height was important to Monet, and he included flowers and plants of varying sizes, like pansies and peonies. Another design element is what is called "Monet shimmer," which was created by placing light flowers like dame's rocket in the mix with other, darker flowers to catch the light and create the shimmering, reflective effect—an effect that was also represented in impressionist paintings.

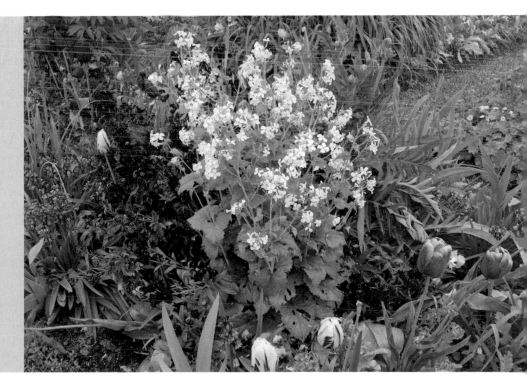

EVERYDAY MONET IDEA

Unlike most gardeners who seek traditional color harmony, Monet, with an impressionist's eye, used dramatic color combinations like orange, yellow, and blue. The photo here contains all the elements I mentioned: the dame's rocket, shimmering and towering above the dramatic color palette of the red and yellow tulips, orange erysimum, and Spanish bluebells. There is even a touch of purple creeping thyme, which Monet used profusely in the garden. To replicate Monet's formal garden, combine these colors and varying flower heights, and you will experience the same shimmer that exists in both Monet's garden and in the most gorgeous floral impressionist paintings.

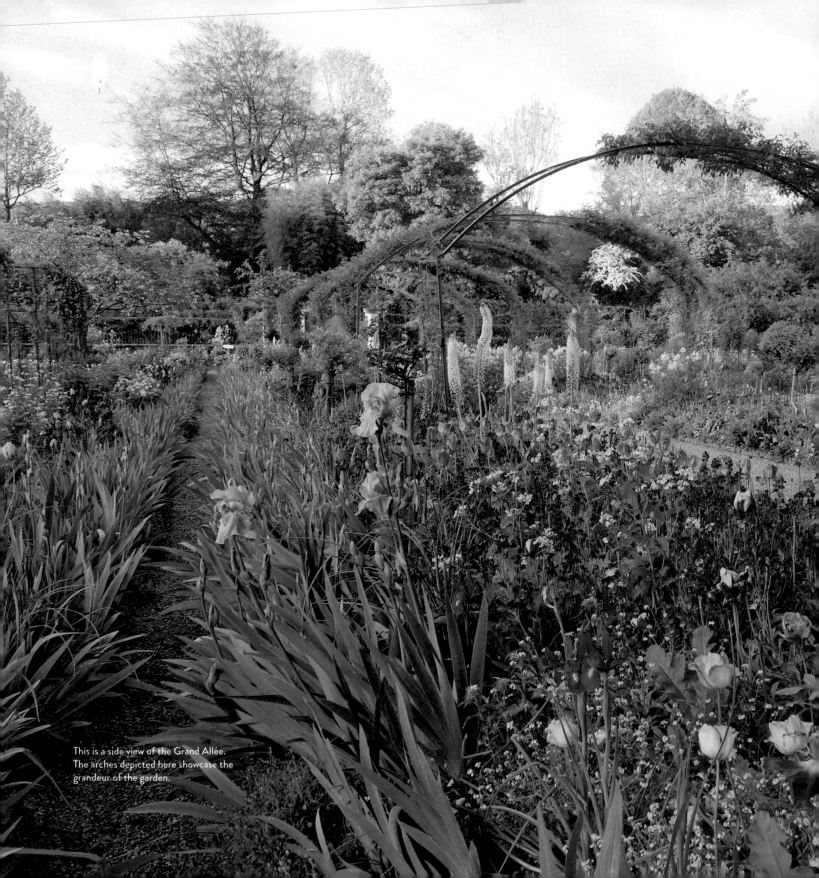

This is a side view of the Grand Allée.
The arches depicted here showcase the
grandeur of the garden.

THE GRAND ALLÉE

"With time, my eyes began to open and I really started to understand nature. I also learned to love it. I would analyze its forms with my pencil. I would study its colorations." —**CLAUDE MONET**

Claude Monet's garden, tucked away in the tiny hamlet of Giverny, has a Grand Allée—an *allée* is a French term for a long path or promenade. As illustrated in the painting above, the allée is lined with trees or tall shrubs, creating a feeling of vastness.

The rose arches over the allée in the garden create an impression of enclosure. The blue of the sky and the warmth of the sun on your cheek makes it like no other place in the world. Beds of purple Negrita tulips join with peach tulips among a bed of white violas, which catch and reflect the light beautifully.

During the warm months, nasturtiums are in their prime and spread out across the garden floor, but they do well in cooler weather too. Both the flower and stem are edible and have a sweet, slightly spicy flavor. Nasturtiums have become very popular in the twenty-first century as edible garnishes to varying dishes, the most common of which is a salad. One such dish is a wonderful microgreen salad. Combine arugula, microgreens, tarragon, and chives and dress the salad, sprinkling the fragrant and beautiful edible nasturtiums. If you don't want to plant nasturtiums yourself, simply purchase them from a grocery or garden store; they are fairly simple to find— you can even find them at your local Whole Foods or a similar market.

THE WONDROUS WATER GARDEN

"These landscapes of water and reflections have become an obsession." —**CLAUDE MONET**

Claude Monet's obsession with water lilies is perhaps his most defining work, both on canvas and in the creation of his water garden. Because of the importance of water lilies to Claude Monet's life work and aesthetic, I've devoted an entire chapter later in this book to sourcing and growing your own water lilies. However, I mention them here first because they are central to his water garden, which was of course a central feature of his home garden.

HE LEFT HIS HEART IN GIVERNY

The water garden includes more than just the water lilies, it is a world unto its own. The central image we know of the water garden at Giverny is the bridge, draped in royal purple and lavender wisteria. The lace effect of the cascading flowers, gently floating above the water and reflecting down, is just so beautiful.

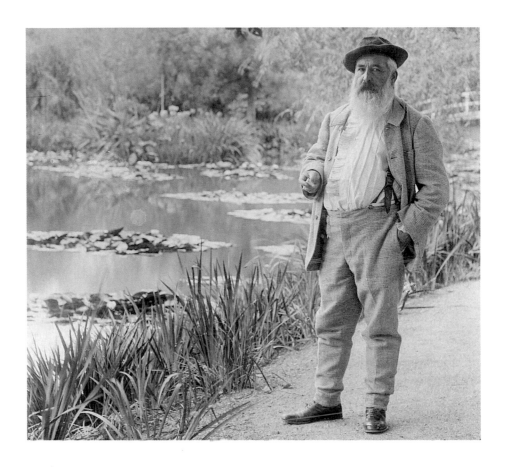

Photograph of Claude Monet (1905). This image truly speaks of Claude Monet's passion and pride in his water garden, as he surveys the lilies, agapanthus, wisteria, and water paradise he created. He went to great lengths to create this light-reflecting basin of water, fed by a tributary of the Seine River.

EVERYDAY MONET IDEA

I can think of no better way to bring Monet's water garden home than to own a water lily. Chapter 4, "A Water Lily Grows in Brooklyn Too," will provide you with a step-by-step guide on sourcing, growing, and showcasing a gorgeous water lily of your own. If you do not have the space, time, or inclination to own a water lily, then there are of course other ways to showcase the beauty of the water lily in your home. Purchase a print of one of Monet's famed water lily paintings, available online at various websites or, perhaps, at your local art museum. Then simply pick a colored wooden frame to display your print. Now, even without a living and breathing water lily, you have brought Monet's magical water garden into your world.

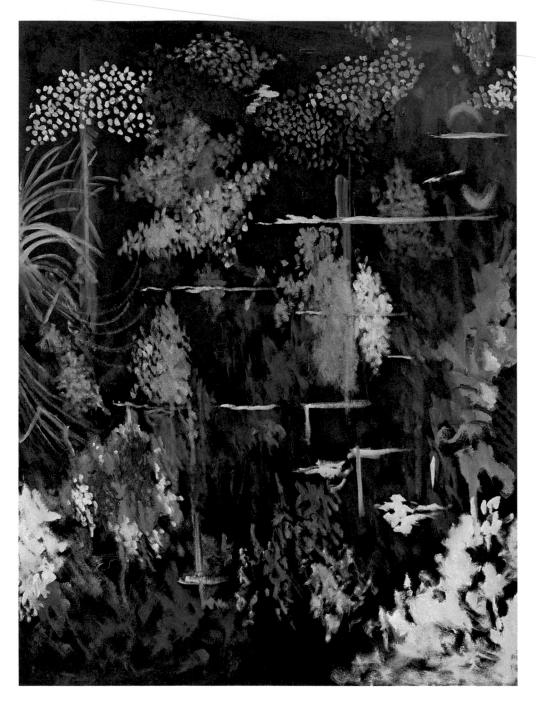

This painting is by Tony Bennett. Clearly, his ability to sing is matched by the magic he created in this painting while visiting Giverny. My mother enjoyed his company very much, and he, too, was delighted by her and exceptionally interested in her contribution to Giverny.

© Tony Bennett/Anthony Benedetto. Courtesy of Benedetto Arts, LLC.

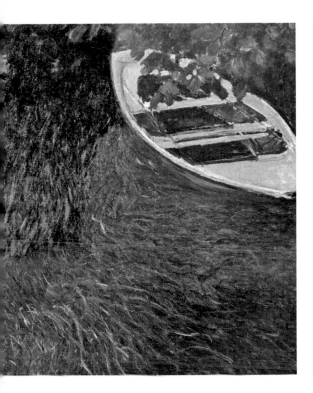
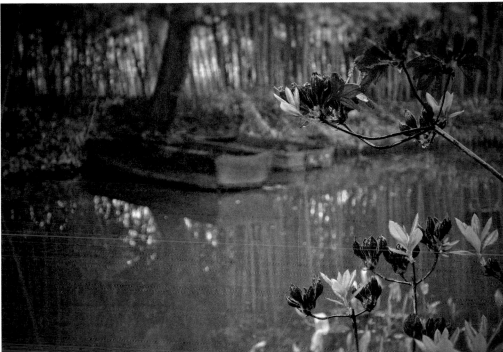

Rowboats were used in the water garden to tend to the water lilies. Imagine Claude Monet, in the early morning mist, dressed with a warm overcoat and his straw brimmed hat. A chorus of frogs welcome their guardian artist, as tiny drops of rain create swirls upon the water. This is the world Monet created and that he left for us in his paintings and garden.

BRINGING MONET'S GARDEN HOME

"To plant a garden is to believe in tomorrow." **—AUDREY HEPBURN**

Now that you have walked through each part of Monet's garden—from the pathways, through the formal garden, up the allée, and over the bridge along the water garden, you have experienced the feeling of the garden and seen the gorgeous elements that you, too, can bring into your own space. Pick and choose from the ideas that follow based on your own space, time, preferences, and environment.

Roses, tulips, peonies, and chrysanthemums will transport Giverny to your home. Choosing just one of Monet's favorite plants from this assortment will still allow you to add a dash of Monet to your space.

MONET'S FLOWERING CALENDAR: A SELECTION OF MONET'S FLOWERS BY MONTH

"I am following nature without being able to grasp her, I perhaps owe having become a painter to flowers." —**CLAUDE MONET**

There are thousands of annuals and perennials planted at Giverny. The following is a list of those that have been planted the most over the years. Monet tried his very best to create a comfortable home for his natural guests. The soil at the garden tended to be very alkaline. Monet made adjustments to the alkalinity by adding peat and other natural additives to improve the environment and create the lush garden we know and love. Water was never an issue at Giverny, since rain was abundant, no matter the season. The very sunlight that gave birth to impressionism—that "Monet shimmer" I mentioned previously—was showering down on Monet's impressionist garden.

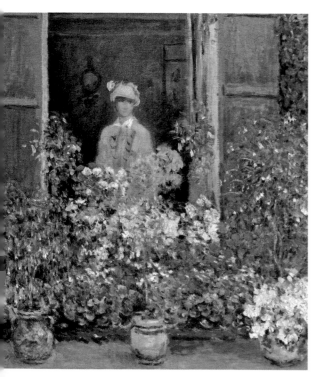

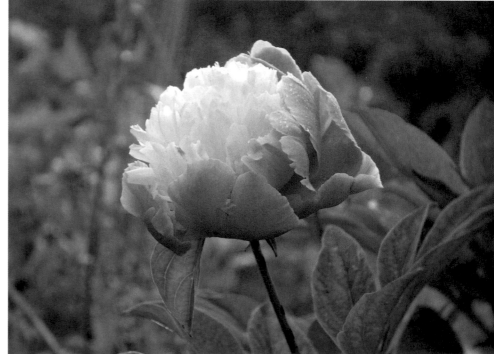

MONET'S FLOWERING CALENDAR

APRIL

Annual Honesty, Apple Blossom Trees, Aubrietia, Azaleas, Campions, Cherry Trees, Clematis, Forget-Me-Nots, Fritillaries, Hyacinths, Laburnum, Narcissi, Ornamental Garlic Daisies, Pansies, Primroses, Tamarisks, Tulips, Wallflowers

MAY

Alchemilla, Azaleas, Columbine, Clematis, Campions, Dame's Rocket, Dutch Tulips, Forget-Me-Nots, Foxgloves, Geranium, Irises, Japanese Poppies, Ornamental Garlic Daisies, Pansies, Peonies, Rhododendrons, Sweet William, Tamarisk, Viola, Wallflowers, Wisteria

JUNE

Agapanthus, Alchemilla, Amaranths, Anthemis, Blue Hydrangeas, Bugloss, Clematis, Cleomes, Columbines, Daylilies, Foxgloves (Digitalis), Fuchsias, Geraniums, Japanese Poppies, Lavender, Lilies, Meadow Rue, Nasturtiums, Ornamental Garlic Daises, Ox-Eye Daisies, Pansies, Phlox, Roses, Sweet William Tobacco Flowers, Violas, Water Lilies

JULY

Agapanthus, Ageratum, Alchemilla, Amaranths, Anthemis, Carnations, Chrysanthemums, Clematis, Cleomes, Coreopsis, Cosmos, Crocus, Daffodils, Dahlias, Daylilies, Dutch Tulips, Fuchsias, Geraniums, Gladioli, Heliotropes, Hollyhocks, Impatiens, Meadow Rue, Japanese Poppies, Larkspurs, Lavender, Nasturtiums, Phlox, Primrose, Roses, Rudbeckias, Snapdragons, Snowdrop, Sunflowers, Tobacco Flowers, Water Lilies

AUGUST

Agapanthus, Ageratum, Amaranths, Anthemis, Blue Thistle, Carnations, Christmas Roses, Chrysanthemums, Clematis, Cleomes, Coreopsis, Cosmos, Dahlias, Delphiniums, Fuchsias, Geraniums, Gladioli, Heliotropes, Hollyhocks, Impatiens, Japanese Poppy, Larkspurs, Lavender, Meadow Rue, Nasturtiums, Phlox, Primrose, Roses, Rudbeckias, Snapdragons, Sweet Pea, Tobacco Flowers, Verbenas, Water Lilies, Zinnias

SEPTEMBER

Ageratum, Amaranths, Anthemis, Asters, Autumn Crocus, Blue Hydrangeas, Carnations, Chrysanthemums, Clematis, Cleomes, Cosmos, Dahlias, Fuchsias, Geraniums, Gladioli, Heliotropes, Hibiscus, Hollyhocks, Impatiens, Lavender, Meadow Saffron, Nasturtiums, Phlox, Roses, Rudbeckias, Sage, Snapdragons, Sunflowers, Tobacco Flowers, Verbenas, Zinnias

OCTOBER

Amaranths, Anthemis, Asters, Carnations, Chrysanthemums, Clematis, Colchicum, Cosmos, Dahlias, Geraniums, Heliotropes, Hollyhocks, Impatiens, Lavender, Nasturtiums, Phlox, Roses, Rudbeckias, Sage, Snapdragons, Sunflowers, Verbenas

POTTING YOUR MONET FLOWER

There are many easy ways to incorporate Monet's cherished flowers into your own space. You can purchase a simple bouquet and display it in a vase or you can pot the flower or arrangement. Choosing just one specimen from the botanicals grown at Giverny will help you to achieve Monet's special aesthetic. Buying plants locally, just like buying fruits and vegetables locally, will ensure the best quality and success for your region's climate.

Regardless of the space you have, a singular Giverny floral star or your favorite flower will connect you each and every day to the beauty, joy, and spirit of gardening that Monet embraced. If you live in an urban area, it is rare to have an enclosed outdoor space to grow your own plants. However, a great way to accommodate a more limited space is to integrate "a touch of Monet" by arranging a number of potted plants or a few small containers and pots together.

If you don't have a green thumb, you can of course buy an existing arrangement and/or a potted plant, rather than planting and potting your own. Although they can be expensive, there are very high-quality silk flowers and plants that needn't be replaced as often and might work better depending upon your lifestyle and locale. You can showcase these in the vestibule of your home, upon your bedroom dresser, along a windowsill in your kitchen, or in any number of sunlit spaces.

MATERIALS

A flowerpot, or terra-cotta planter, with a draining hole; if for outside, the container should be at least twelve inches wide and ten inches deep

Coffee filters

Potting soil

Scissors

Room-temperature water, preferably in a watering can

Already potted plant—please consider the season and your own geography and climate when choosing the plant or plants

POTTING THE PLANT

The first step to potting a plant is of course the flower itself! You do not need to start from seeds; instead, you can look to your local garden nursery and purchase an already potted plant. The nursery owner will want to see your plant flourish and can help you choose a flower that will grow beautifully in your space—whether your potted plant is going to live outside, exposed to sunlight, or live indoors in limited light.

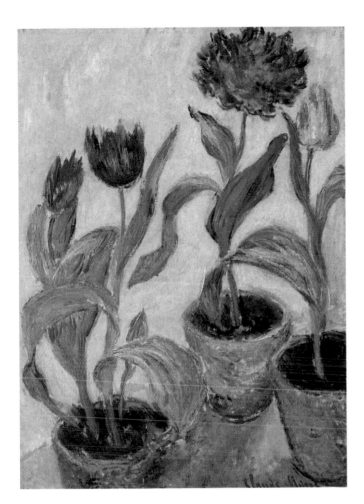

I suggest purchasing an already potted plant, which you can decide to keep in the original container. However, the steps that follow are for a potted plant that you are removing from the original container. Keep in mind that you may need to repot your plant if it outgrows the original pot.

Make sure the new pot you have chosen is larger than the original one, as the roots will need space to spread and acclimate to their new home.

Cover the drainage hole at the bottom of the new pot with a coffee filter; this will allow water to drain slowly. If you chose a terra-cotta pot, soak it first in water for about thirty minutes.

Put about an inch of base potting soil into your new planter.

Turn your plant upside down and tease it gently from the original pot; if it's stuck, you can use the tip of the scissors to separate the roots from the pot.

Remove any dead roots and untangle the healthy roots.

Ease the plant into the new pot, adding sufficient soil to fill in any gaps and making sure the plant is centered.

Water the plant, but don't overwater it. Depending on the type of plant you have, this will differ. Take guidance on frequency and amount of water from the nursery where you purchased your plant.

Don't keep it in direct sunlight until it gets used to its new home; this typically takes a couple of days.

Always make sure your plant is pruned and watered and is getting sufficient sunlight for its particular needs. This is another time when your local nursery can give you specific guidance with respect to the type of plant, the season, whether it is best kept indoors or out, and your general geographic location.

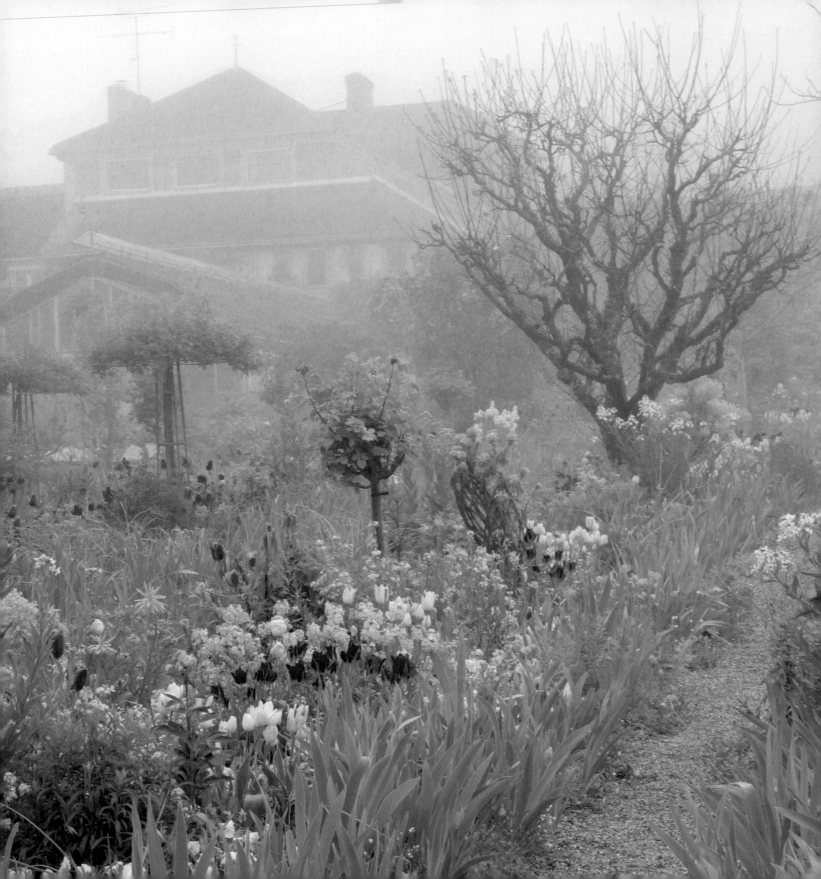

THE FLORAL STARS OF MONET'S GARDEN—ROSES, TULIPS, POPPIES, IRISES, AND PEONIES

"They make the beds too soft—so that the flowers are always asleep."

—LEWIS CARROLL, *THROUGH THE LOOKING-GLASS*

The garden at Giverny was planted with the same impressionist spirit Monet applied to his art. The effects of light on wheat fields or the English Channel were now being applied to every nook and cranny of the property he finally called home. Monet's exuberance for color, especially the blue, orange, purple, pink, and red of his canvases, now could exist in living color among the flowers.

A visit to Monet's garden would not be complete without admiring his special blooms. These stars include the water lilies, irises, tulips, poppies, roses, and peonies. Each flower possesses a sense of shape, color, texture, and light that Monet used with great intention. Of course, they all live among a profusion of forget-me-nots, daisies, pansies, marigolds, dahlias, sweet rocket, and hollyhock. The rotation of flowers is like the rotation of art on display at the Louvre. However, in this section we focus on the floral masterpieces: his roses, tulips, poppies, irises, and peonies.

THE ROSES

"I take this opportunity to give you the address of the rose grower, and also the name of the rose bushes that you admired, the one climbing in front of the house; Crimson Rambler, and the one on stem, the Virago." —**CLAUDE MONET**

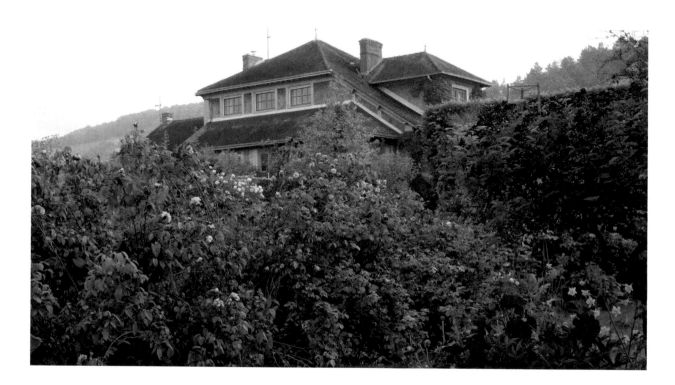

Roses were particularly popular in Monet's time—and clearly the same is true in the twenty-first century. As we learned earlier, Monet was inspired by English gardeners, including Gertrude Jekyll, who was known for her roses and her admiration for the impressionists.

Many of the roses in Giverny climb upon the numerous topiaries and arches in the garden. Through the years at Giverny, I have been treated to a living bouquet of Creamsicle, yellow, sterling lavender, crimson, pink, and white roses. However, the primary roses used were pink and red, and in particular Paul's Scarlet Climber is found throughout the garden. All the roses in the garden are perennials and are extremely hardy—each season their intoxicating fragrance delights the visitors and honeybees alike.

EVERYDAY MONET IDEA

The easiest way to bring roses into your home, terrace, garden—any space—would be to pot a selection. Here I have used the same delicate and sweet-scented pink roses in a trio of plain pots, which can then be repotted into larger permanent vessels as they grow. Or you can always cut the flowers back, if you prefer to keep them small. See Chapter 2, "Monet's Style," to choose a vessel for your plants that is delightfully Monet.

If you're not a gardener, you can treat yourself to a bouquet of red roses instead of potting your own. They do not have to be for special occasions, and you do not have to wait for someone else to gift a bouquet of roses to you. You deserve a bouquet of these treasures anytime your heart desires, and when you showcase them in a vase in any area of your home, you will instantly be reminded of Giverny.

THE TULIPS

"There are the most amusing things everywhere. Houses of every color, hundreds of windmills and enchanting boats, extremely friendly Dutchmen who almost all speak French. . . . I have not had time to visit the museums, I wish to work first of all and I'll treat myself to that later." —**CLAUDE MONET**

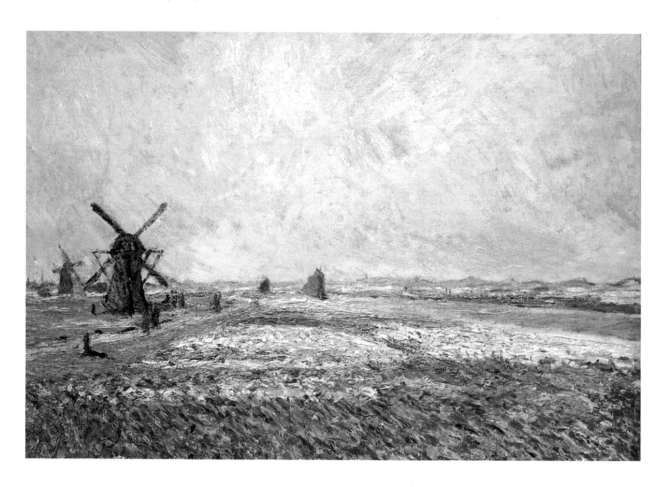

Next to the water lilies and roses, tulips significantly influenced Monet's art and the design of his garden. His trip to Holland in 1886—just three years after buying the home at Giverny—was an immense inspiration. He clumped certain flowers together as splashes of color and texture but expanded the color palette of the garden by using various tulips. He planted rows of flowers, but not in the same rigid fashion as the tulips

in the painting opposite. Near the house, there are beds of marigolds, irises, tulips, and Japanese anemones that became known as his "paint box beds."

Tulips are perennial, blossoming in the early spring before going quickly dormant. They require plenty of sunlight and do well in temperate climates. However, Giverny can get quite cold, and some seasons, the tulips have suffered. Nevertheless, they are the most popular flower at Monet's garden, having the most varieties of any flower in the garden.

 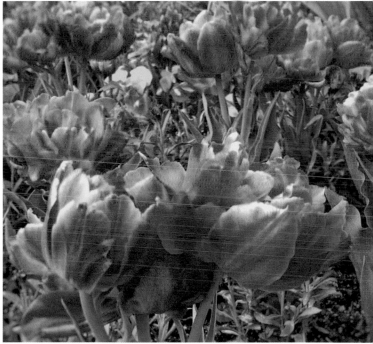

The lace effect and tulips.

"To me the motif itself is an insignificant factor; what I want to reproduce is what lies between the motif and me. . . . Other painters paint a bridge, a house, a boat. . . . I want to paint the air in which the bridge, the house and the boat are to be found—the beauty of the air around them, and that is nothing less than the impossible." —**CLAUDE MONET**

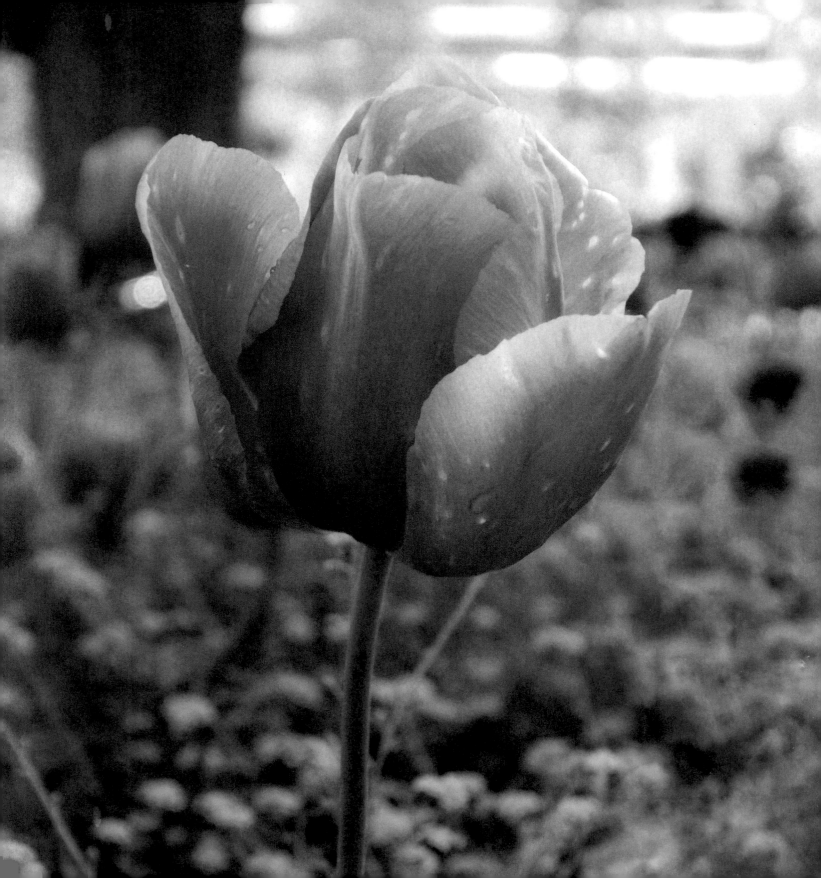

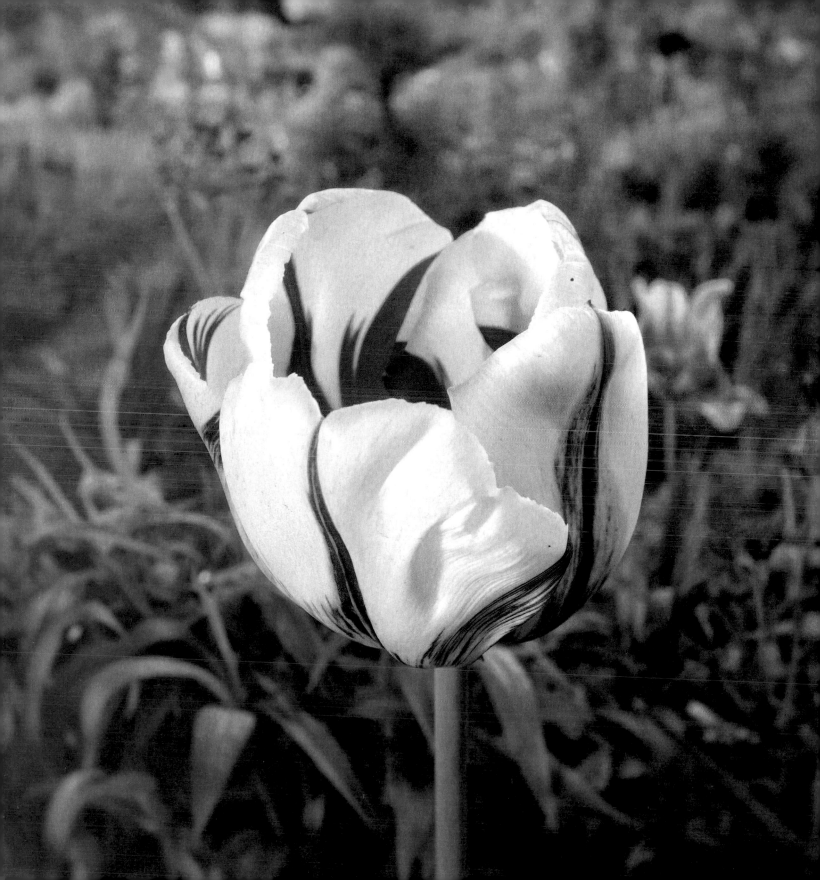

This is a rare parrot tulip—its frayed edges remind me of a rustic tablecloth, not just feathers. Spectacular!

Monet would scatter tiny white flowers around favored flowers, like tulips. He would also use plants like hollyhocks and multicolored flowers liberally through the landscape. The small white forget-me-nots and other white flowers throughout the garden create that "Monet shimmer."

Beyond their shimmer, the white flowers have also always made me think of Monet's love of light and lace. Not only does the lace effect come across in the formal garden in the white flowers nestled between the tulips and other flowers, but it is also brought about by the draping of wisteria from the bridge in the water garden. The shimmer and the lace effect combine to make Monet's garden a living and breathing work of art.

To this day, an early spring rotation at the garden in front of the house at Giverny always includes tulips and forget-me-nots. Pictured below is the signature and iconic pairing at Monet's garden. It is a match made at Giverny, and the garden and home are known for this very special look.

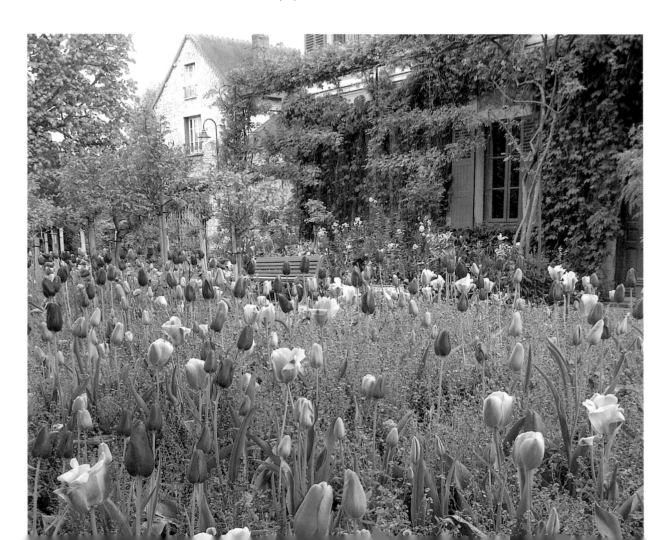

Because Monet had a deep fondness for tulips, it's no surprise he created the beautiful canvas featured on page 79 in "Potting Your Monet Flower." Although this painting depicts potted tulips, as opposed to cut tulips, you can still create a similar feeling by arranging two or three small pots of a variety of tulips side by side. They can be placed at your front door or in tiny pots on your windowsill. In addition, you could showcase a living arrangement of tulips in a more ornate flowerpot as a centerpiece for a spring brunch or luncheon. Here is a simple arrangement of tulips that mimics the iconic lace-like flower and tulip pairing planted every spring at Monet's home. It sits so perfectly, showcased in a guest bathroom.

THE POPPIES

"Monet is nothing but an eye . . . but good God, what an eye." —**PAUL CÉZANNE**

Monet adored poppies, so with his easel and paint box in hand, he traveled throughout the French countryside to paint the fields where they flourished. The dabs of red for the poppies on so many of his canvases are intense. By looking at his paintings it is clear Monet loved poppies, and it helps shed light on why he would have brought those seeds back to Giverny—to make it all so special.

The poppy's stalk is extremely strong, and the flower, which grows profusely in the wild, is predominantly colored red, white, and yellow. Poppies grow with fervor and must

be pruned, otherwise they will take over any garden. At Giverny, the splashes of red sitting among the daisies, irises, tulips, gladioli, clematis, and foxgloves make an exuberant statement.

In addition, in keeping with Monet's love of Japanese style, he obtained the very rare seeds of purple poppies. To this day, they adorn *le clos normand*, the part of the garden closest to Monet's home.

Each and every time I see the poppy fields in France, and take in their singular and simple beauty, I think of *The Wizard of Oz*. When I was creating my film, *Monet's Palate*, I intentionally started the sequences of scenes in black and white, then transitioned the film to color—imagery that invoked the idea that Monet's Giverny is just like the magic of Oz.

EVERYDAY MONET IDEA

If you live near or are able to travel to a field filled with poppies, where they grow tall, beautiful, and free, gather as many as you can. If you do not live near a poppy field and cannot grab the stalks yourself, then buy a poppy plant and place it in a Monet-yellow planter, as pictured (far right). Any shape planter will do. You could also consider a toast, inspired by the poppies—this delicious Monet's Palate Rosé is set atop a beautiful set of linen napkins I found in Normandy (right). The wine is served with some very French ladyfingers. A toast to Monet and poppies!

THE IRISES

"How right it is to love flowers and the greenery of pines and ivy and hawthorn hedges; they have been with us from the very beginning." —**VINCENT VAN GOGH**

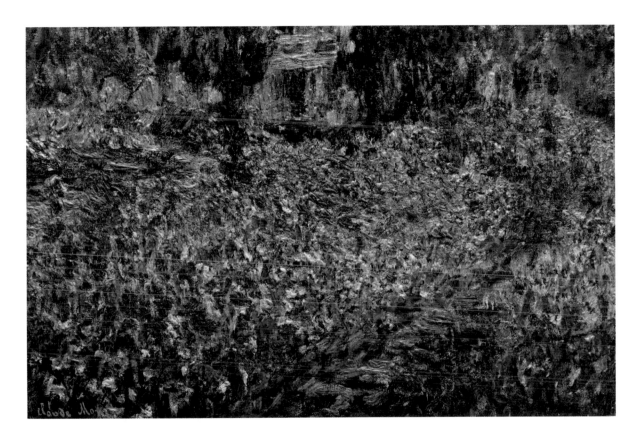

Monet cherished his irises as well, witnessed by the fact that there are significant paintings of the iris section of the garden—which was a place to relax and entertain. Irises were the early spring bloom at the garden, and they displayed some of his favorite shades of blue and purple.

Monet planted sweet rocket around certain areas of irises, and they gave life to the already statuelike flowers. Irises are perennials and require plenty of sunlight. The way the irises sway in the breeze, and the way the light bounces off their flowing petals, showcases the translucent look that irises possess. It is a sight I always look forward to seeing at Monet's garden. It just so happens that the name Iris is derived from the Greek word for *rainbow*. A match indeed for Monet!

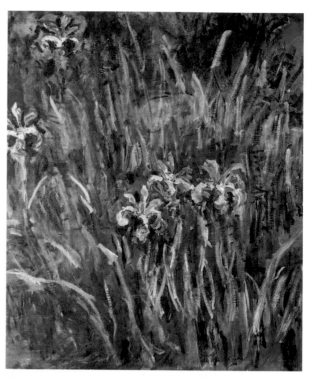

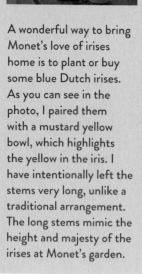

A wonderful way to bring Monet's love of irises home is to plant or buy some blue Dutch irises. As you can see in the photo, I paired them with a mustard yellow bowl, which highlights the yellow in the iris. I have intentionally left the stems very long, unlike a traditional arrangement. The long stems mimic the height and majesty of the irises at Monet's garden.

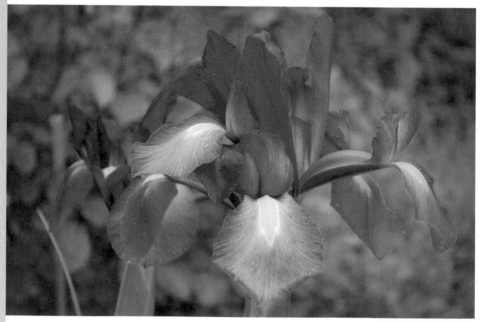

THE PEONIES

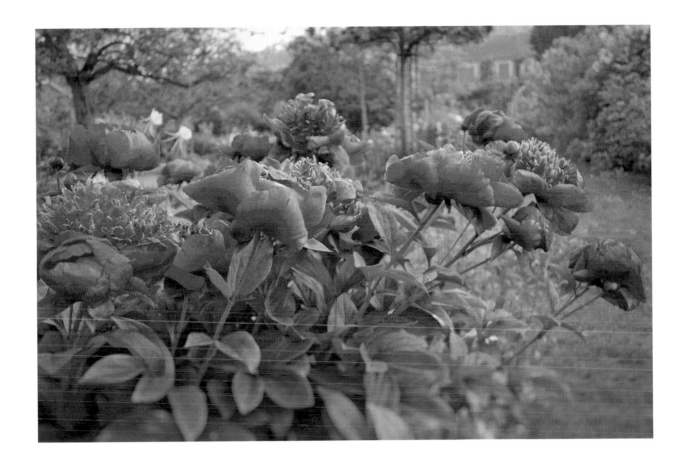

Each and every time I encounter Monet's peonies, I smile. The lush, vibrant, and pink profusion in the garden is magnetic. Monet loved peonies and surrounded his kitchen garden with these beauties. It's as if they were standing guard, protecting the vegetables and herbs for his table.

The peonies flourish in the spring and summer at Giverny, and they are perennials that require much sunlight and water. Their color, situated beside the home, connects with the blush stucco of the house. The peonies sit in the formal garden, where they are a splash of vibrancy and energy that cannot be missed. They raise their colossal layered blooms toward the sun and nestle upon their shiny deep green leaves.

Since I have already shown you how to bring Monet's floral stars home individually in an Everyday Monet manner, now consider grouping the stars together for a hit display. Taking two or more of these beauties and arranging them together mimics a garden, even if you do not have the time, skill, or space to plant one on a large scale.

Julia Kirkham, noted English garden designer and plantswoman, recently visited Giverny with the Royal Horticultural Society (RHS) Fellows. Inspired by the gardens, she created this delicate arrangement of spring flowers in an antique crackled green vase to reflect the green of the railings seen through the blue-and-white gingham curtains in Monet's kitchen.

THYME AT HOME

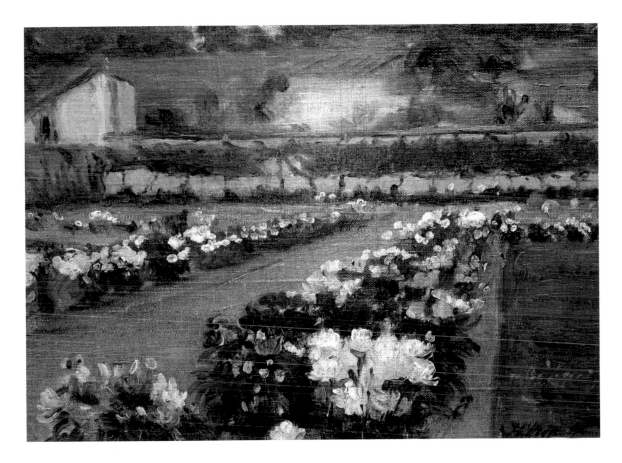

The painting above, by the American impressionist Willard Metcalf, is one of only two paintings of Monet's kitchen potager. As you can see, the beautiful pink peonies that surround the herbs and vegetables really created another living masterpiece.

Monet's favorite herbs, and those that were always grown in his kitchen garden, included thyme, basil, oregano, chives, tarragon, rosemary, sage, and parsley. To bring Monet's culinary expertise into your home, consider the ways to incorporate these herbs into every dish and even by planting or sourcing your own. Each individual herb has its own requirements for light and germination periods. For example, basil, oregano, and sage require full sunlight, while parsley and chives require sun and shade, as they do not thrive in full sunlight. Each of the herbs needs water, but be careful not to saturate them. In addition, the basil, chives, and oregano take about one week to germinate, while the thyme takes about two weeks, and the parsley as long as three weeks.

Even if you don't have a terrace, a deck, or a backyard, just one potted herb from Monet's kitchen garden placed on a kitchen windowsill can connect you with Monet's life at Giverny. Monet adored thyme, basil, oregano, chives, tarragon, rosemary, sage, and parsley. There wasn't a day that went by that Monet did not help to plan the menu for the day and include these herbs in his favorite dishes. Farm to table was the rule of thumb, and it certainly is a good way for us to enhance our everyday lives. Pot any of the herbs, and when they've grown cut from the bottom of the plant whenever you need to add a dash of herbs to a meal.

Monet's favorite composers were Claude Debussy or Erik Satie. If you want to bring the atmosphere of *Everyday Monet* home or to your car, or to the beach . . . play any of their music.

MUSIC OF THE GARDEN

"The landscapes of Claude Monet are in fact symphonies of luminous waves, and Debussy's music based . . . on the relative values of sounds in themselves, bears a striking resemblance to these pictures." —**CAMILLE MAUCLAIR, ART CRITIC**

Claude Monet adored music and was known to break into song while entertaining guests in the garden. Music has the ability to transport us to another place and time. It triggers memories, emotions, and pleasure. Many composers have been inspired by the majesty of Monet's Grand Allée, and if you bring some of that music into your world, you will bring the overall aesthetic of Giverny into your life.

In addition to Debussy and Satie, other contemporary composers of the period were Maurice Ravel and Gabriel Fauré. Buy or download selections of their music and bring the romance of Monet's garden into your home.

THE SMALL-SCALE GARDEN DESIGN

It is so very simple to bring small ideas from Monet's many garden areas into your own space, no matter where you live. You can bring the same joy and beauty into an indoor or outdoor space using Monet's floral stars, whether in a garden, in potted plants, or in vases.

EVERYDAY MONET IDEA

Simple spring combinations that shout Giverny include red tulips surrounded by blue forget-me-nots or violet pansies paired with yellow tulips. You can create this combination by planting in containers, window boxes, or any small planter or space you choose. I've created my own small-scale design for a deck, but you can adapt it to the space you have. On my deck, I've included all of the floral stars, some beautiful sunflowers, a small herb garden with oregano, parsley, and rosemary, surrounded by pink peonies. In addition, the red tulips are surrounded by blue forget-me-nots, and there is a container of lavender irises as well. There are red poppies with dame's rockets and a pot of multicolored pansies. There is one container just for red roses. They can be paired with any small green plant you enjoy. The center design is a container with one magnificent water lily. Everyday Monet!

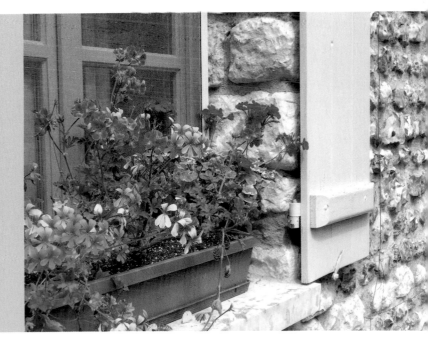

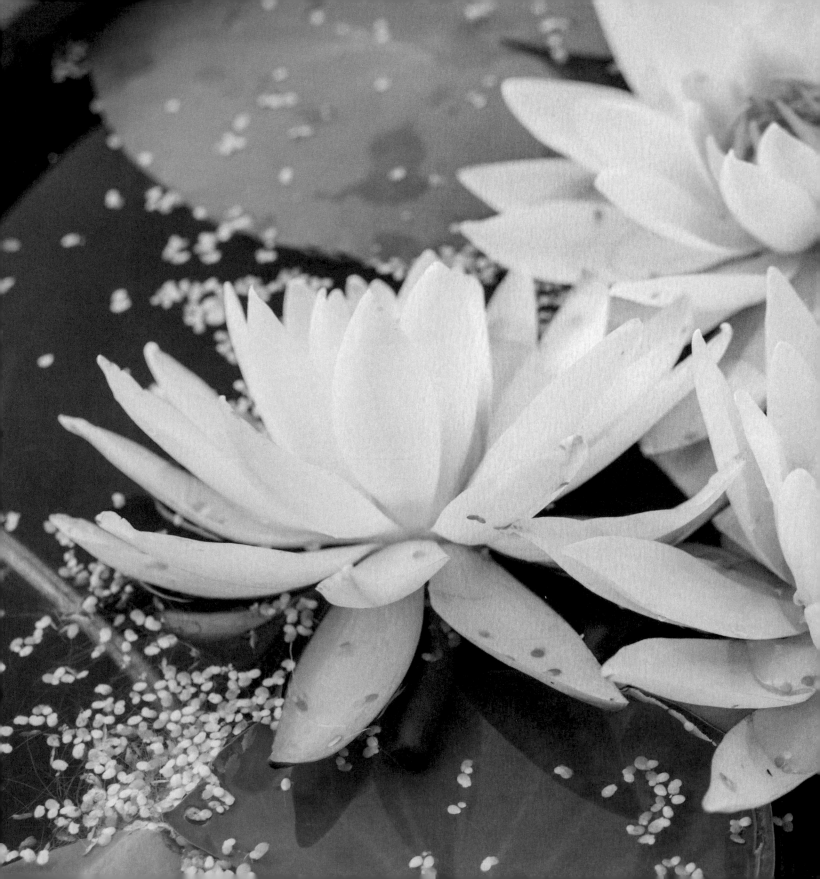

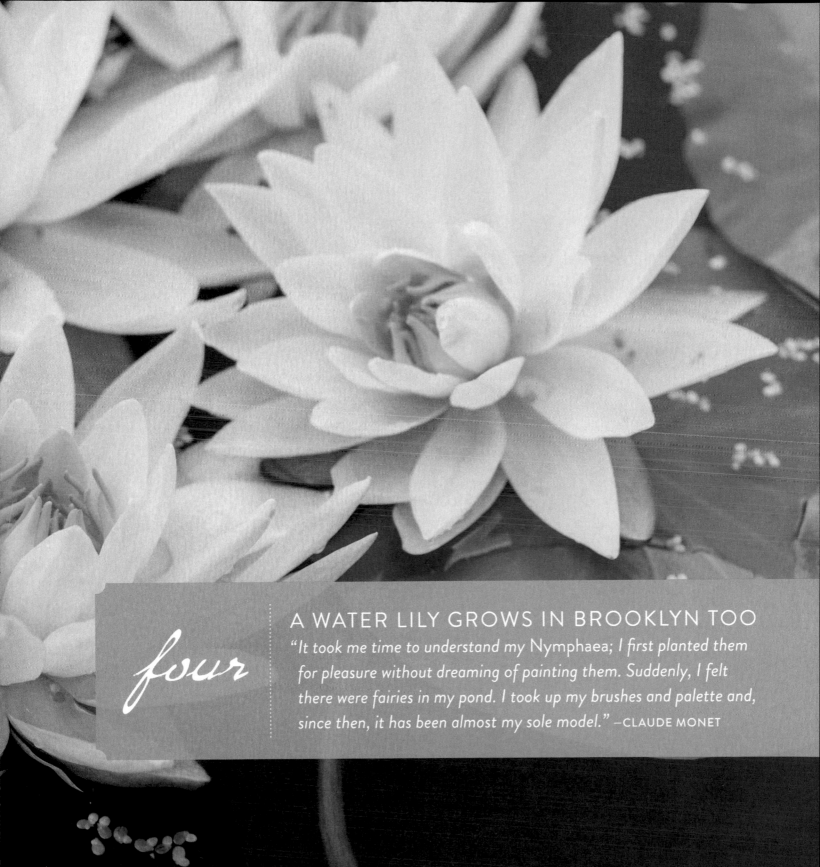

four

A WATER LILY GROWS IN BROOKLYN TOO

"It took me time to understand my Nymphaea; I first planted them for pleasure without dreaming of painting them. Suddenly, I felt there were fairies in my pond. I took up my brushes and palette and, since then, it has been almost my sole model." —CLAUDE MONET

PASSION

"Do you not like the bulb fields? I find them splendid and when the flowers in blossom are picked and thrown into the canals one suddenly sees yellow patches floating like colored rafts in the blue sky." —CLAUDE MONET

It was decades ago, after the restoration was already completed, that I experienced the wonder of Monet's enchanted water garden for the very first time. The garden had already closed to the general public for the day, but because of my unique access, my mother unlocked the heavy door and allowed me to enter. Immediately, all the intoxicating visuals and scents revealed themselves to me, and as the warm moist breeze touched my cheek, I had found heaven.

The breezes drifted toward me, carrying a fragrance of vanilla, strawberry, cut grass, and cracked black pepper—the scent of the water lilies. I could see the reflection of every cloud, every tree in the luminous pond. The water lilies looked like floating angels. Surrounding their core were wings of violet, soft pink, poppy red, and custard yellow. The mature green and younger violet leaves that surround lilies all seemed woven together, like a natural carpet upon the water. In the distance, a small wooden rowboat, the wood and paint worn from age, was nested against the bank. Overhead, a pair of hummingbirds danced among the blooms. Their silken wings guided them as they sought out the sweet nectar of Monet's floral masterpiece. Truly enchanting.

Visually, the amount of color and textures on the bank of the water garden was as serious as the pond. Varying shapes and shades of green fern, shrubs, and trees—including Japanese tree peonies—followed the path, creating contrasting shadows. At the same time, dramatic pinks, royal violets, and red peonies peeked through from the water's edge. This magical scene was also replete with vibrant magenta rhododendron, purple lily of the Nile, raspberry bushes, glossy holly with brownish-red berries, and lanky butterscotch irises—all their reflections echoed in the calm water.

At one point I turned, and a dragonfly, with iridescent wings, reflected every color of the garden that had caught my eye. The gold and crimson reflection of autumn leaves and the scent of fall made me feel so calm. I closed my eyes for a moment and could have sworn there was a whiff of the scent of roasted chestnuts.

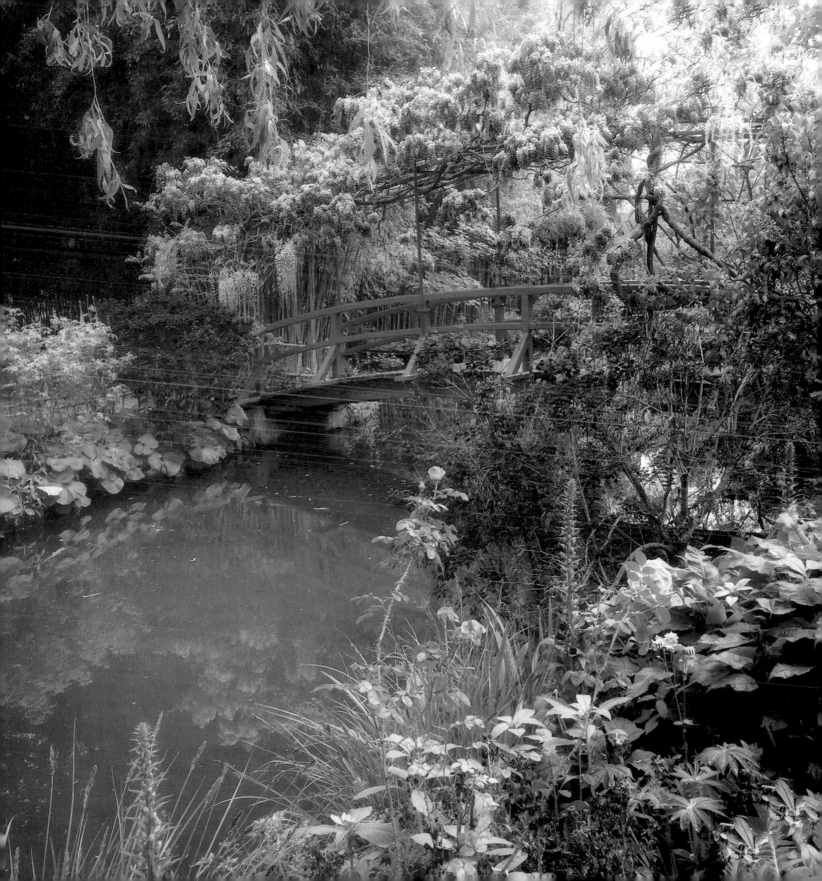

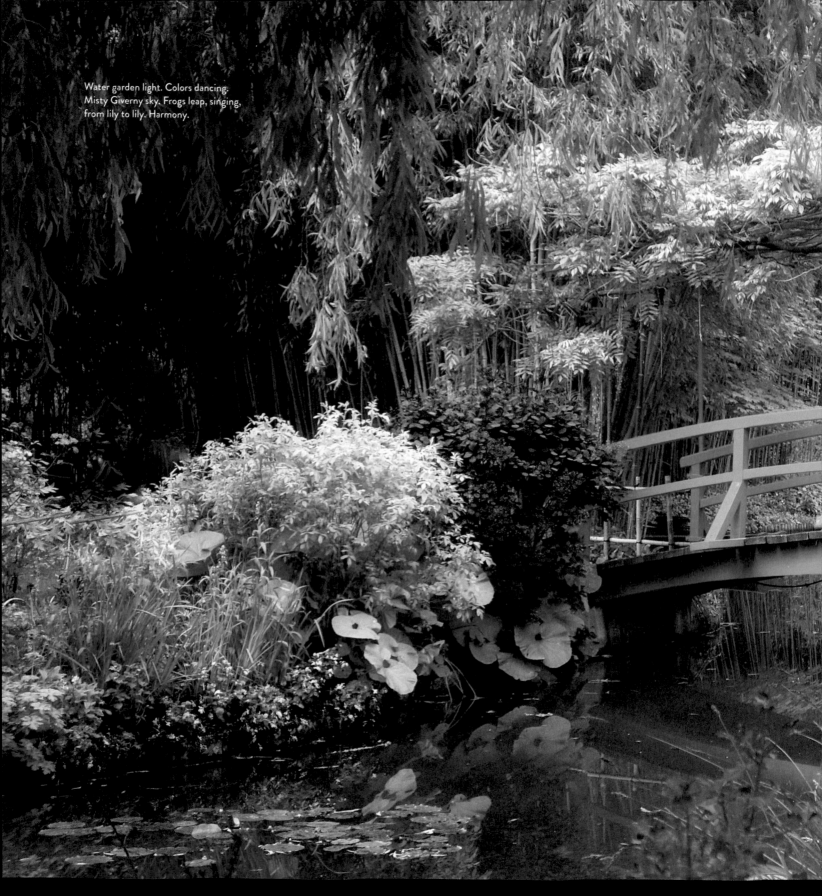

Water garden light. Colors dancing.
Misty Giverny sky. Frogs leap, singing,
from lily to lily. Harmony.

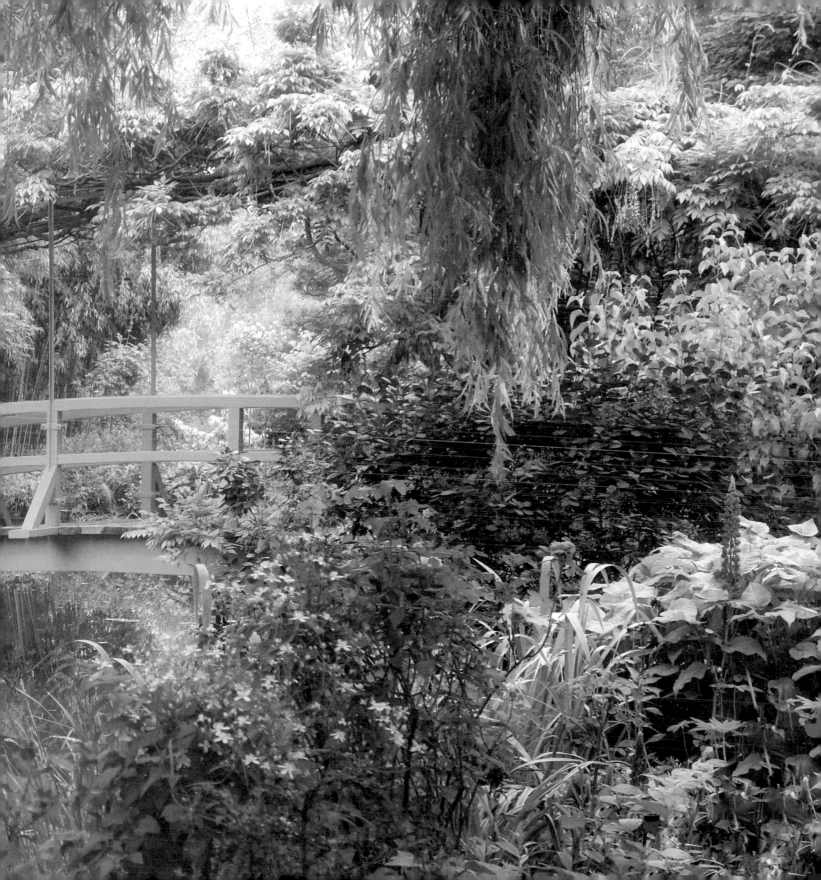

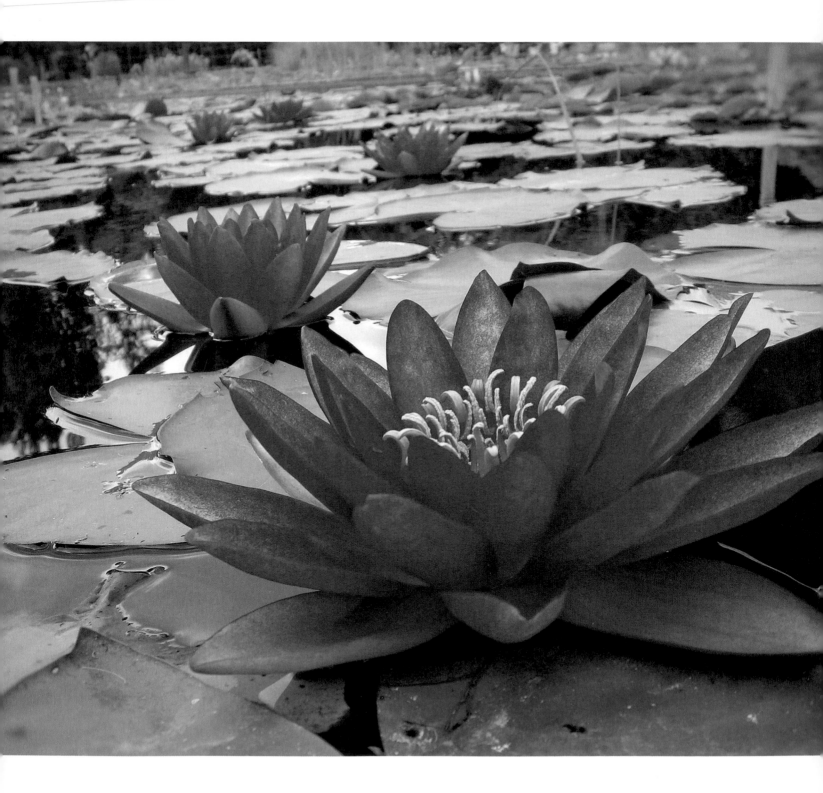

The very first time I stood on the iconic green bridge, I was overwhelmed. It was so surreal, as purple cotton wisteria floated above my head. It was as if I had stepped into one of those famed Monet paintings of the bridge and pond. I could almost hear one of Monet's favorite melodies, "Prelude to the Afternoon of a Faun" by Debussy.

The garden was speckled with light—almost like looking through trees with bright sunlight peeking through—and when you closed your eyes, you could still see the colors of Monet's palette. During this whole experience, there was an intense sense of intimacy and serenity at the water's edge. I have had many visitors to Giverny share that their first moment entering the garden felt like entering a place of worship. I wholeheartedly agree.

Even during this early visit, I knew that Claude Monet had strolled through his water garden often. In that same spirit, as I followed the lines and curves of the pinkish gravel path, I made frequent stops to take a photo. As a subject caught my eye, I took multiple photographs from the same vantage point but at different angles and levels. I imagined Monet doing the same with just his eyes, and how he must have felt as he walked this same stage, choosing the living subject for his art.

The early fall was a special time at the garden. Seeing the changing colors of the vines as they were clinging to the exterior of Monet's home was simply breathtaking. The green, gold, and ruby leaves set against the pink stucco exterior were dramatic. The garden was ever-changing with new blooms, rotating flowers in accordance with the seasons. There was also a sort of dance of light in the garden, guided by soft breezes, as it shimmered off the lilies, bamboo, Japanese maple, and peach-colored azaleas. The light that Monet achieved with his very intentional placement of the plants was all very real to me, very palpable. You could count the seconds as the mist began to rise slowly off the pond. This mist enhanced the impressionist effect Monet craved. As I stood there, in my very first moments in the garden, I imagined Monet, through the seasons, as he would walk the paths, seeking the light and searching for the right view, just the right place to start a new canvas.

Just imagine being connected to Monet's spectacular legacy. His water lilies and his art. His love for beauty and nature. In spite of the vast number of aquatic plants that grow in Monet's garden, the beautiful and fragrant water lily is the garden's signature bloom. Who else but Claude Monet could imagine placing a water garden filled with water lilies amid apple orchards, grazing sheep, and fields of ruby red poppies? Such an unexpected sight.

Monet so passionately created his water garden, and at its center is the water lily. Let me explain how you can bring the garden's star, the water lily, home. Perhaps you don't have the space for a full water garden at your own home. Fear not, because a

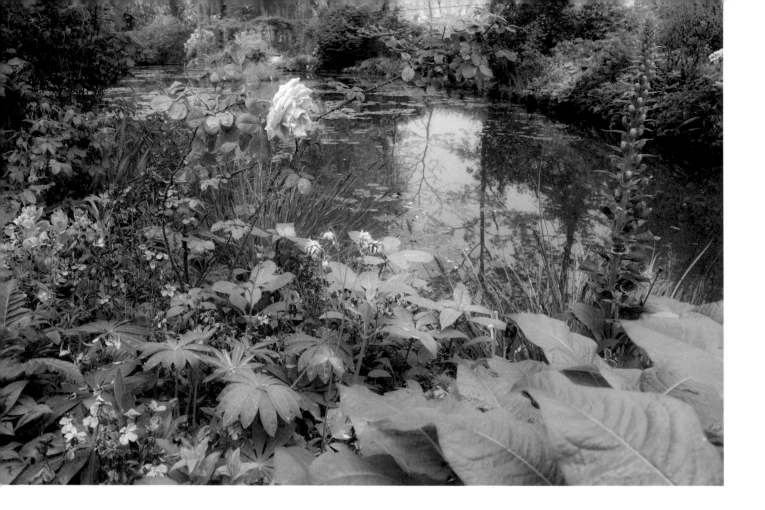

water lily will thrive beautifully in a small space such as a terrace, deck, rooftop, balcony, or patio.

I am far from alone with respect to this passion for Monet's water garden. I get messages on a daily basis from all over the world, from guests who have made the pilgrimage to Giverny.

The visitors who come to Monet's home often yearn to simply stand on the bridge and look out at Monet's wonderland. At the property, many couples make donations to the foundation, just so they can stand on the bridge and be wed in the presence of the floating jewels.

I wish I could have the whole world step into my shoes and see that wonderland for themselves. To enter Monet's inner sanctum during the still of morning, or at midnight under the moon, and stand on the bridge is such a privilege. It is because of this that I feel a responsibility to share with you my most treasured memories.

MONET'S FLOATING GARDEN

"I planted my water lilies for pleasure; I cultivated them without thinking of painting them. A landscape does not get through to you all at once. And then suddenly, I had the revelation of the magic of my pond." —**CLAUDE MONET**

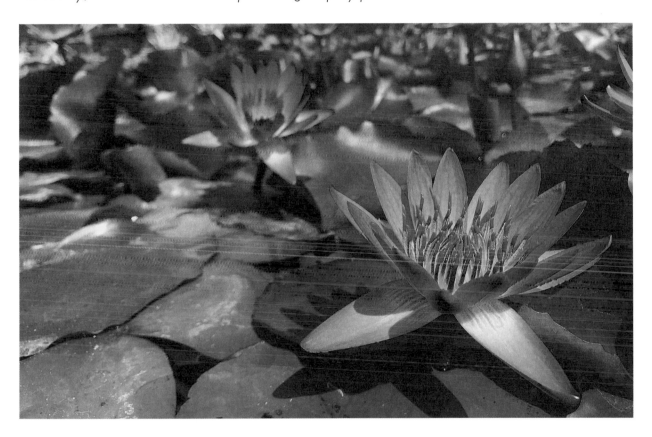

It was simply a matter of time before prosperity and desire converged, and Monet could create his own floating rafts as subjects to paint.

So many of Monet's interests, passions, and skills merged, resulting in what we have come to know as Giverny. Who but Claude Monet would have placed a Japanese footbridge, adorned it with wisteria, and hovered it over water lilies? Oh, and in Normandy, France.

As discussed in Chapter 2, "Monet's Style," Japonism/Japonaiserie was in vogue at the same time Monet was designing his home and garden. It seems only natural that

Japonism/Japonaiserie at the water garden.

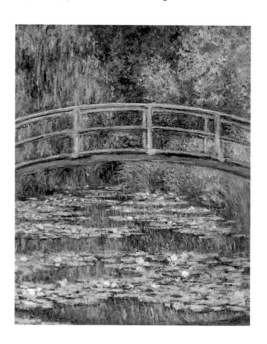

Monet would carry his Japonism into his own home. Ponds are the central element of a Japanese garden, and Monet added other important elements, including the bridges, exotic aquatic plants, and paths. It is no wonder that Monet chose to include the Japanese motif found in his dining room at the pond as well. A perfect example of flow from interior to exterior, the garden and home were mirrors in design. Simply standing in his dining room adorned with Japanese woodcut prints and then walking across the Japanese bridge showcases the connection.

The original garden was much smaller to start and extended just beyond the iconic Japanese footbridge as shown in the painting to the left. The arching of the Japanese bridge allowed sunlight to pass beneath and above, creating the shadow and light effects Monet's art required.

CLAUDE MONET AND BORY LATOUR-MARLIAC

"As far as aquatic plants and especially Nymphaea, I am convinced I will operate a revolution by obtaining a very hardy hybrid that will possess all the rich colors of the most remarkable subtropical Nymphaea." —**BORY LATOUR-MARLIAC**

Had Claude Monet and Bory Latour-Marliac never crossed paths at the 1889 World's Fair in Paris, there would be no water lily paintings, nor the water garden as we know it today. It was at that World's Fair that Latour-Marliac entered Monet's life. The brilliant horticulturist introduced the first colored water lilies at the fair. Before Latour-Marliac, white water lilies grew in the Seine, but colored water lilies did not exist.

Prior to the 1889 World's Fair, Monet had bought additional land near his home to create a pond. He had to divert a brook and then dig the pond, the size of which kept expanding to accommodate his growing vision for the canvases and aquatic plants.

When Latour-Marliac presented the first hybrid of a hardy, colored water lily at the fair, Monet immediately wanted to include it in his water garden. Of course, the rest is history and Latour-Marliac's nonwhite lilies would become the subject of Monet's water lily series of paintings.

I was so excited to connect with Robert Sheldon, the present owner of the water lily nursery Latour-Marliac in Provence, and an American who is making sure that Latour-Marliac water lilies remain in existence. Robert shares my mission of stewardship. The very notion that in the twenty-first century it is possible to visit the same nursery where Monet purchased his cherished water lilies is extraordinary.

Robert was also so generous of heart. When I queried him about sourcing water lilies, he unselfishly told me there were many great places worldwide to source water lilies, including the United States. I suggested that for some, owning a water lily directly from Latour-Marliac would be special, and he assured me this is possible. Robert honored me with an invitation to visit Latour-Marliac to pore over their archives, and he promised special photography of the lilies. He also showed me the original receipts for Monet's purchases with Latour-Marliac. Wow!

We can only imagine how it must have felt for Monet to envision the water garden, discover and transport the Latour-Marliac lilies, and then see the living masterpiece he created. It is truly fate that Latour-Marliac and Monet, both visionaries, were interested in experimentation and that they were obsessed with the beauty and colors of nature. The lilies became exquisite subjects that during some of Monet's darkest days brightened his world. Thankfully the paintings and the water garden continue to brighten ours.

MONET'S WATER GARDEN ORDERS

"I've grown used to the flowers in my garden in the spring and to the water lilies in my pond on the Epte in the summertime. They give flavor to my life every day." –CLAUDE MONET

The photographs here show the three water lily specimens favored by Monet and still available at Latour-Marliac and aquatic gardens shops worldwide.

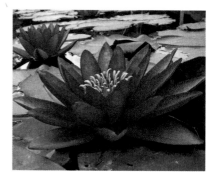

NYMPHAEA 'ATROPURPUREA' (HARDY LILY)

The 'Atropurpurea' petals are reminiscent of a deep red and pink starburst. This lily also has the sunny/golden center and leaves that change from purple to green as they mature.

NYMPHAEA 'SULFUREA' (HARDY LILY)

'Sulfurea' petals have gentle yellow leaves and are star shaped. The center stamens are also golden and new green leaves are flecked with a royal purple.

NYMPHAEA 'ARETHUSA' (HARDY LILY)

'Arethusa' have gentle powder puff pink petals that darken to chartreuse near the golden center called stamens.

MONET PLACED HIS FIRST ORDER WITH LATOUR-MARLIAC IN 1894 AND IT INCLUDED:

3 *Polygonum amphibium* (Water Smartweed)

3 *Trapa natans* (Water Chestnut)

3 *Trapa verbenensis* or *narbonensis* (Horn Nut)

3 *Arundinacea picta* (Syn. *Phalaris A. picta*, Ribbon Grass)

3 *Caltha polypetala* (Syn. *C. palustris*, Marsh Marigold)

3 *Carex folliculata* (Northern Long Sedge)

3 *Eriophorum latifolium* (Broad-leaved Bog Cotton)

3 *Eriophorum scheuchzeri* (White Cottongrass)

3 *Hydrocotyle bonariensis* (Largeleaf Pennywort)

3 *Hydrocotyle vulgaris* (Marsh Pennywort)

3 *Hydropyrum latifolium* (Syn. *Zizania latifolia*, Manchurian Wild Rice)

3 *Lysimachia vulgaris* (Yellow Loosestrife)

3 *Myriophyllum proserpinacoides* (Syn. *M. aquaticum*, Parrot Feather)

3 *Orontium aquaticum* (Goldenclub)

3 *Pontederia montevidensis* (Pickerel Rush)

3 *Sagittaria gracilis* (Syn. *S. sagittifolia*, Arrowhead)

3 *Saururus cernuus* (Lizard's Tail)

3 *Saururus loureiroi* (Syn. *S. chinensis*, Chinese Lizard's Tail)

3 *Scirpus maritimus* (Syn. *Schoenoplectus maritimus*, Saltmarsh)

3 *Scirpus radicans* (Syn. *Schoenoplectus radicans*)

3 *Sisyrinchium sulfureum*

3 *Typha stenophylla* (Syn. *T. laxmannii*, Laxman's Bulrush)

2 *Nymphaea flava* (Syn. *N. mexicana*, species from Florida)

2 *Nymphaea* 'Laydekeri Rosea' (Latour-Marliac, 1892) Pink

2 *Nymphaea* 'Sulfurea Grandiflora' (Latour-Marliac, 1888) Yellow

1 *Nelumbium album* (Lotus, species)

1 *Nelumbium japonicum roseum* (Lotus, species)

1 *Nelumbium luteum* (Lotus, species)

1 *Nelumbium* 'Osiris' (Lotus, Latour-Marliac, c. 1890)

1 *Nelumbium speciosum roseum* (Lotus, species)

MONET'S SECOND ORDER, PLACED IN 1904, SHOWED HIS INCREASED PASSION FOR WATER LILIES AND INCLUDED:

1 *Nymphaea* 'Atropurpurea' (Latour-Marliac, 1901) Deep Red

1 *Nymphaea* 'Arethusa' (Dreer, 1902) Pink-Red

1 *Nymphaea* 'William Falconer' (Dreer, 1899) Deep Red

1 *Nymphaea* 'James Brydon' (Dreer, 1889) Deep Pink

MONET'S THIRD ORDER, PLACED IN 1908, INCLUDED:

6 *Nephrodium thelypteris* (Syn. *Thelypteris palustris*, Marsh Fern)

GRANDES DÉCORATIONS DES NYMPHÉAS

"I have set up my easel in front of this body of water that adds a pleasant freshness to my garden." —CLAUDE MONET

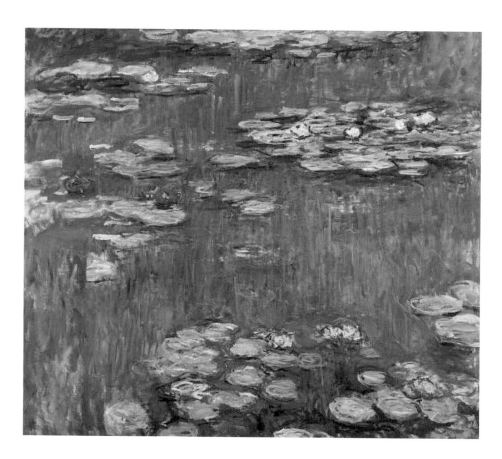

Monet's water lily paintings are grand indeed—most of the canvases measure six feet high and twenty feet wide. With intense passion, Claude Monet created approximately 250 paintings of his water lily garden. Each canvas was started *en plein air*—outside—and then completed in the studio he dedicated just to this series. The lilies would take center stage late in his artistic life. Monet could not help but be inspired by the calm energy of the water garden. The paintings capture the essence of impressionism, as expressed by the master's brush and palette. The changing light, which was the key to his art, was magnified by the water.

Claude Monet's famed water garden and the series of paintings we know as *Les Nymphéas* might never have been created had it not been for two conflating factors. Initially, the farmers in the surrounding hamlet of Giverny thought that aquatic plants would somehow contaminate their water and ecosystem and, therefore, their crops and livestock. Monet needed to divert the water from the Epte River, a tributary of the Seine River, to have fresh water for the planned garden—and to live peacefully alongside his neighbors. In 1893, just one year before Monet would place his first aquatic plant order with Latour-Marliac, the local residents and town officials tried to block the water garden. Ultimately, Monet prevailed with help from some influential friends like Georges Clémenceau, the prime minister of France.

Monet's artistic style in his later years used more vibrant colors and broader brushstrokes. Monet's fascination with how light reflected upon water became more intense. This is so well expressed in this *Nymphéas* shown here.

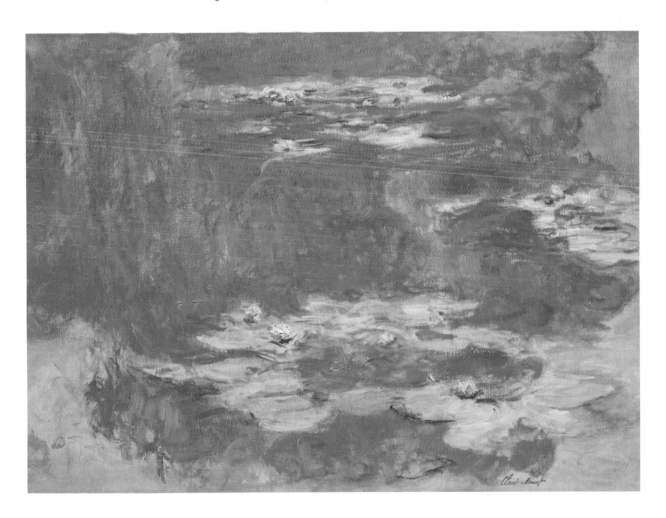

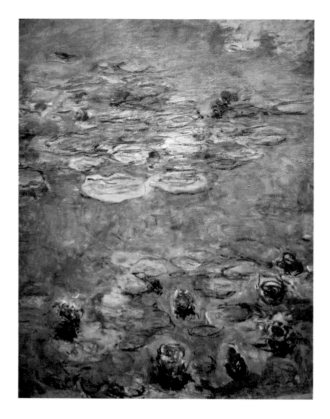

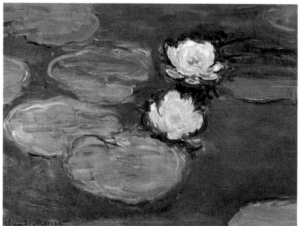

The second factor: When Monet placed his order for aquatic plants, he ordered an equal number of lotuses and water lilies. However, the lotus did not thrive as well as the lilies. The current management of the Latour-Marliac nursery that provided the aquatics often jokes that had Monet been more successful with the lotus, we would have famed lotus paintings. *Les Nelumbium* not *Les Nymphéas*! It is extraordinary to imagine that there could have been no water garden or water lily paintings had these two factors never been resolved.

Few people know that when Monet started to paint the water lilies, it was a very difficult time in his life and the world. By 1911, his second wife, Alice, had passed away; by 1914, France was at war and his eldest son, Jean, had died. And, at the same time, the father of impressionism was losing his sight due to cataracts. Painting the water garden became Claude Monet's true salvation throughout so much difficulty and hardship.

The series, *Les Nymphéas*, for the most part is held in a permanent collection at Musée de l'Orangerie in Paris. In 1922, Claude Monet donated *Les Nymphéas* to the French government. The paintings hang in two immense elliptically shaped rooms at the L'Orangerie. In the exhibit hall, Monet's *Grandes Décorations* are lit from above with diffused light, held like jewels as they adorn the concave walls. The lighting captures the true impressionist effect Monet had intended.

It is so exciting to see the lilies and then recognize them in his paintings. Seeing them in all their glory at Giverny is a dream come true for so many. There is a joke my mother has shared with me time and time again, through her decades at Giverny. Madame Monet, while visiting Claude in the water garden one day, states, in reference to his paintings, "Oh, Claude, not another water lily." No matter how many times Mom shares this with me, the joy she gets from relaying the story makes me smile.

BRINGING THE LILY HOME

Now that I have shared the joy and passion of Monet's water garden, let me help bring the beauty to any home. Many people do not have the space or inclination for a full water pond, but there is no need for a pond as long as you have a watertight container.

It is simple to maintain a water lily and you needn't be a master gardener. Lilies are so forgiving and are truly sustainable. They bloom and close depending on the time of day, season, and geography. When speaking about water lilies, the phrase "the gift that keeps on giving" holds true. As they bloom they drop seeds, which spawn new lilies. Seriously, just one lily placed in the middle of a swimming pool (clearly, without chlorine), will keep spawning new lilies. And, if not cut back, it would take over the entire pool.

The following is a step-by-step guide to bringing the star of Monet's enchanted water garden right to your terrace, deck, pool side, rooftop, or backyard. Even if you have never grown any plant, fear not, because what follows will show you how to plant a water lily. I promise, you will make a splash anywhere you choose to place your lily.

The beauty of one water lily will bring Giverny home.

LILY BY LILY

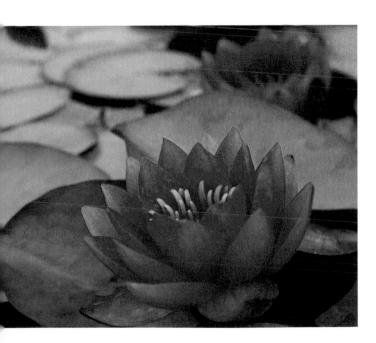

There are two distinct types of water lilies and choosing which type is best often depends on where you live and the climate.

HARDY

Hardy water lilies were the variety Monet used, including the vibrant hybrids he was able to source from Latour-Marliac. From spring to summer in the water garden there was a palette of burgundy reds, misty rose pink, eggshell white, peaceful lavender, sunflower yellow, and melon orange lilies. Hardy lilies are day or night bloomers and thrive very well. They generally bloom from June through early September depending on the weather. They have been bred to grow well in cooler climates. They can withstand the cold and live through the winter as far north as Alaska. It's no wonder the cool climate of Monet's Normandy in France was a good place for hardy lilies.

TROPICAL

Unlike the hardy lilies, tropical water lilies are well named because they need warmth. They require a temperature of at least 70°F/21°C. They can bloom day or night depending on the variety. The blooms and pads are larger and much more fragrant than those of hardy lilies. Monet tried his hand at growing tropical lilies, but the cool Normandy climate prevented his success. They are a good choice in the summer when using a small container garden. The water temperature can rise considerably and even a hardy lily cannot live up to its name under such conditions. It happened to be an extreme, record-setting heat the day we were photographing the water lily in Paris. The fragile stems did all they could to shine . . . the show had to go on. I think you will agree that a water lily regardless of its placement is a thing of beauty. An Everyday Monet connection.

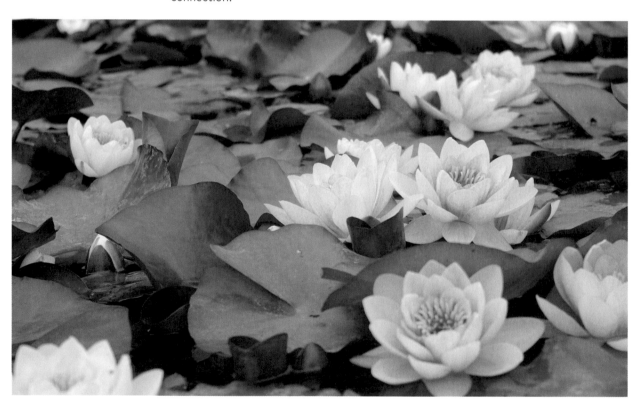

STEP-BY-STEP PLANTING GUIDE

One decorative container, at least twelve inches deep and sixteen inches in diameter

One four-gallon pot in which to plant the lily

Waterproofing material, preferably siliconized acrylic latex

One water lily specimen, hardy or tropical variety with a bloom

Aquatic cloth planter, ideal size eight inches by six inches

Aquatic planting soil, small bag or use clay-rich topsoil

A slow-release fertilizer tablet

Gravel, small bag

Aquatic plant fertilizer tablets, small package or a mix of bone and blood meal and dolomitic lime

Two bricks

Mosquito dunks, small package

Water

CHOOSING THE CONTAINER

Choosing a decorative container is an important step toward bringing water lilies into any type of space and any climate— truly bringing Giverny to any home. Some simple design ideas might include containers made of glazed ceramic, a wooden barrel, or an old deep marble farm sink. In Monet's garden there is a yellow-painted wheelbarrow, and you use can use something similar as a container for your water lily. Any metal container will work, except for copper, which reacts with the water and isn't good for the water lily.

This is a simple potting vessel. Please let your imagination run wild when you choose your pot.

TERRA-COTTA: Using a container made of terra-cotta is a very French style and is found throughout Monet's garden. However, keep in mind that this kind of container can become very heavy once filled with water.

WOOD BARREL: A wood barrel that has been cut in half horizontally can work very well. The beauty of an aged barrel combined with the water lily results in a very rustic French look. Make sure there is no residue of wine, cider, or spirits in the barrel. Water lilies are teetotalers. The container, if simple, can be painted with an outdoor flat paint (See Chapter 2, "Monet's Style," for key samples of Monet's color palette) or you can add a colored fleur-de-lis stencil.

Make sure to apply a multisurface sealer to wood or terra-cotta to ensure they are watertight. Siliconized acrylic latex is a very good product and can be used to seal surfaces even if the container has an irregular shape. Keep in mind that less is more in the case of this container and this project. The simpler the container, the more the water lily will shine.

I do not recommend growing water lilies from seed. Instead, you want to source a lily specimen that has already germinated and is displaying its center flower and surrounding leaves. Generally, just buying a bare-root specimen, which is cheaper, can be problematic. They are fragile and often do not bloom. I also recommend buying a hardy lily, since there are greater challenges associated with having a tropical lily thrive, even if you have the right climate. Of course, if you live in a particularly hot climate, you can certainly try a tropical lily. If you are using a container, I recommend using tropical varieties for the container. Although Monet is not known for tropical lilies, he bought them and grew them in decorative containers. In the last couple of years, Giverny has ordered the tropical plant as well. The advantage with tropicals is that they bloom all year long. They are also heat-tolerant, which is preferred because a container water garden can heat up excessively in the sun since it's so small.

That said, if you can't grow a tropical lily, there is so much beauty and variety in hardy blooms, and you will be planting the same variety as Claude Monet. At the end of the day, choose a hardy or tropical water lily you love. Ask lots of questions at the nursery even if you have gotten the lily online. Ask questions like: What is the ultimate size of the lily? What if the water lily doesn't thrive? How will I know when to separate water lilies that have grown together?

POTTING THE LILY

Early spring planting is ideal if you want the lilies to look good the same year. But one of the nice things about water lilies is that they can be planted throughout the season, since they grow in water and don't have a precise flowering period like most perennials.

It is important to have your container chosen and prepped to receive the water lily before it is planted. It is also important to make sure whatever container you choose is watertight. The dimensions of the container must allow for the needed depth and the minimum circumference of the lily. Plant the lily in a pot that is four gallons in volume. I use round, black four-gallon planters with no holes. If you choose to use a planter with holes, you will need to add a cloth or paper liner to keep the earth in. Additionally, these basket-type pots can break easily when you have to divide the plants after two or three years of growth.

Fill the planter with aquatic planting soil or clay-rich topsoil; avoid compost or potting soil. It is very important that you *do not use regular potting soil*. Water lilies favor claylike mediums. I have even heard of using basic kitty litter—but, let's not.

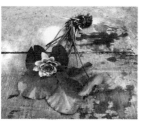

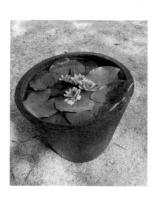

Next, place the rhizome, the main stem of the lily, which grows horizontally as opposed to vertically, at a forty-five-degree angle into the aquatic potting soil or clay. This position shows that the crown is at the surface of the soil and the rest of the stem is buried under one to two inches of soil.

Make sure the part of the stem that is already cut (opposite the crown) is touching the side of the planting container so that it can grow into the center of the pot.

Once planted, lightly water the soil to get most of the air out and make sure the soil is well packed. This will prevent the rhizome from floating up when you submerge the pot. Don't overwater. You can also place a small rock or other weight over the rhizome to keep it secure until it's rooted.

Cover the soil with about a half inch of gravel. Covering the soil in this manner will help prevent any of the soil from escaping into the water. Make sure not to cover the growing point or pads of the water lilies with any of the potting soil or gravel.

PLACEMENT

Water lilies require at least five hours of direct sunlight per day to thrive and bloom. Therefore, make sure that where you have decided to place the container gets enough sunlight before you place the water and planter inside.

PLACING THE PLANTER IN THE CONTAINER

After filling the container with water, very slowly and carefully lower the potted lily into the container. Be careful not to upset the pot and lose earth or gravel.

Submerge the pot in your decorative container, or if in a larger pond, in twenty to thirty inches of water, depending on the variety. In container gardens, small water lily varieties work best, but medium-sized ones also do well.

Generally, the plant is placed at the bottom of the container. If you feel the container is too deep, you can rest the plant on bricks to create the proper depth. You might even decide to remove the bricks as the water lily grows larger. It takes about five to six weeks before the lily becomes stable.

CARE

Most water lilies require at least five hours of direct sunlight per day for optimum growth. Water lilies also have quite an appetite, and as a result it is very important to fertilize your lily. With the growing popularity of water gardens, many aquatic fertilizers are available on the market today. I recommend aquatic tablets. Make sure to follow

the manufacturer's instructions. Generally, they should be fertilized every four to six weeks. Place the tablet in the aquatic soil, not in the water. In the US, it is best to use Pondtabbs, which you need to apply every four to six weeks.

In addition, every spring, insert three to four Osmocote tablets, a long-lasting fertilizer that will feed the lily for up to six months, into the soil around the rhizome.

As noted earlier, water lilies can take over an entire water space. It will be important for you to cut back any new growth when it becomes too much for your container to handle. Similarly, after two to three years you will need to divide and replant the water lily—just as you would do with irises or daylilies. Otherwise, they will become overcrowded and eventually stop blooming and diminish in their beauty and their life span. This is also true for lilies planted in larger ponds. That is, unless the lily has managed to grow out of the planting container and into the bottom of the pond, in which case it may become unruly or even invasive.

The water level in the container can drop over time due to evaporation, so add a little water as needed. If there is a buildup of algae, remove the lily, refill the container with clean water, and then replace the lily.

Hardy lilies can go through a dormant cycle from the end of July to October. They may stop flowering during this period, but normally they would keep their foliage. If this occurs, please do not assume your lily has died, and remove any yellowing leaves.

The steps to care for your water lily are as important as the ones used to plant it. We want to be sure that the water lily, as one of the floral stars of Giverny, brings the same joy and beauty into your home too.

VISITING A WATER GARDEN

A water lily can grow in Brooklyn too. It is more than just a wish.

In fact, the proof is in the blooms at the Brooklyn Botanic Garden in New York City. This garden is one of the most exquisite water gardens in the United States. The curator, Wayken Shaw, has showcased more than a hundred varieties of hardy and tropical water lilies. A short list of other water gardens that feature water lilies includes the Atlanta Botanical Gardens, Atlanta, Georgia; the Missouri Botanical Garden in St. Louis, Missouri; Longwood Gardens in Kennett Square, Pennsylvania; the Longstock Water Park Garden, Hampshire, England; the International Waterlily Collection in San Angelo, Texas; the Queen Sirikit Botanic Garden, Chiang Mai, Thailand; and the New York Botanical Garden in New York.

Even if you cannot visit Monet's home and garden, I encourage you to visit and experience the beauty and serenity of a water garden near your home. Please make sure to visit your local museum, too, if they have water lily paintings on display.

SPREADING YOUR LOVE OF THE LILY

You can also help to share the beauty of Monet's aesthetic and the water garden. Even if your friends or family do not have room for a water pond, consider gifting them one of the blooms from your lily as it divides. Wouldn't it be so special, if there were water lilies growing even at the smallest dwelling, from San Francisco to St. Louis, Atlanta to Paris and, of course, Brooklyn too?

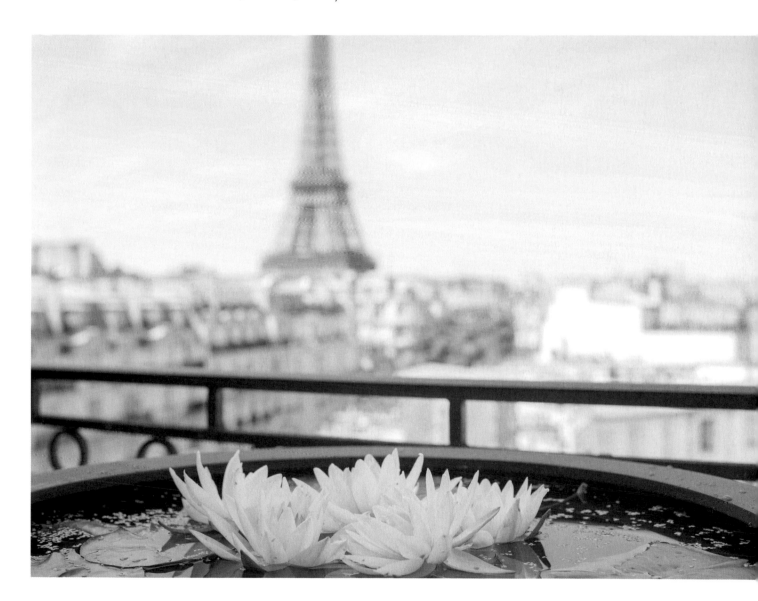

five | IMPRESSIONIST FLORAL
BOUQUETS INSPIRED BY MONET

"*I must have flowers, always and always.*" –CLAUDE MONET

My first time in Giverny, I was so excited the moment I walked into Monet's dining room and saw a glorious floral arrangement that included lily of the valley stems. It was May Day, officially known in France as La Fête du Muguet, and marked by lily of the valley flowers, the traditional flower for the holiday. The May Day flower displayed in the dining room reminded me of the lace effect of forget-me-nots that intermingle with Monet's spring tulips in the garden.

The fresh arrangement in the dining room, which includes different flowers each day, rests atop an oh-so-French yellow, sapphire, and white porcelain dish (pictured left). This is part of the original Limoges plates designed by Claude Monet. Limoges is a coveted porcelain, dating back to the eighteenth century. It is manufactured near the city of Limoges, France, which is located about four hours southwest of Giverny. Leave it to Monet to commission the porcelain maker to the kings. The original service still exists and is brought out for special occasions at Monet's home.

During that first magical experience in Monet's home, natural light was streaming in through the open French door, leading to the main hallway. As I walked through the dining room and into the kitchen, I experienced a dual sense: I saw spotlights cast on the wood floor and I smelled the sweet fragrance of lilies floating through the air. Throughout his home, I walked past vases and other floral containers Monet had chosen himself, primarily displaying orchids.

Monet grew, nurtured, displayed, and painted his floral world—what he experienced for himself both inside and outside his very own home. It is so special to have Monet's still life paintings of his flower arrangements preserved for all time on

canvas. The beautiful heirlooms of the flowers he chose, arranged, and then painted is both overwhelming and inspiring.

I think about Monet *en plein air*, paintbrush in hand among the poppy fields. Who could be better than Monet, the piper of beauty, to wander the fields of poppies and sunflowers? Then planting the seeds, gathering blooms, arranging the flowers, and painting the gorgeous arrangements. When I think of Monet and his love of flowers and fields, it reminds me of a moment in Emily Brontë's novel *Wuthering Heights*. As Heathcliff and his love, Cathy, frolic upon the grassy English moor, Cathy, with great passion, begs of Heathcliff, "Please fill my arms with heather," and as he does, she gathers them into this living symbol of their love—a bouquet. If Monet had visited the Yorkshire Moors, the place where this lovely scene in *Wuthering Heights* takes place, I am certain we would have paintings of long-stemmed heather, with its lavender and soft pink buds, near misty cliffs. I am also certain heather would have made a wonderful floral arrangement in the blue salon of Monet's home—the same place he arranged his floral masterpieces, which you can still see replicated in his home today, and which you, too, can replicate in your home.

These are stunning Vallauris pots from Provence.

A FASHION FOR FLORALS

Floral bouquets and arrangements have been central to French decor and aesthetic for centuries. Whether it's a single bloom sold by a flower girl on a Paris street, or the more elaborate bouquets created as works of art in flower shops, flowers have decorated French dining rooms and kitchens for years, elevating those homes to beauty beyond words. And even so, there is a universal love of flower bouquets that extends beyond the French—but having said that, I know of no other culture than the French who have perfected the arranging and giving of flower bouquets to as high an art!

BOUQUETS AT THE TIME OF MONET

Recently, I was taking a stroll through my favorite neighborhood of Paris, Saint Germaine, located on the left bank of the Seine River. It is beautiful, ancient, and quaint, with wonderful places to eat, go antiquing, and shop. It is a neighborhood frequented by artists, which included Claude Monet in his time. In fact, the Musée d'Orsay is located here, a museum that houses one of the greatest collections of impressionist art, including Monet's. (And I must say, if you haven't already been, the Musee d'Orsay is a must visit if you are ever able to travel to Paris.)

During one of my early visits to Saint Germaine, I stumbled upon a singular exquisite carnation arrangement. It was breathtaking. It reminded me of how flowers, once they are cut, can continue to bring beauty and joy into our world and into our lives. A flower, especially in a bouquet, is a great voice for feeling and expression; flowers can communicate romance, sympathy, gratitude, and celebration as they travel from their bed to their eventual home.

Throughout time, bouquets have often marked special occasions, especially romantic ones. Did you know that in Victorian times flowers were always sent with the intention of expressing an underlying message? Even to this day, flowers communicate similar messages—giving an arrangement can express so many different feelings, from love to sympathy; that is, the intention behind the gift can be conveyed simply by the colors of the flowers. Take yellow roses—if you were to send yellow roses instead of red roses, the message would be quite different. Yellow roses mean friendship and warmth; red roses mean true love and romance.

Saint Germaine has some of the most exquisite flower shops I have ever seen. The arrangement included here caught my eye because of the many colors, but also because it had such a sense of elegance. It reminded me of greetings cards made during the Victorian era, which I'd seen in museums showcased beautifully in glass. During the Victorian period, the bouquets were elaborate with strong colors of various hues, and they tended to be bound in an oval shape. They also tended to have one single type of flower, as opposed to many different varieties.

MONET'S FLORAL ART

Monet's floral paintings feature the single variety of stems fashionable during the Victorian era, and they are reminiscent of the bouquets I'd seen for myself in Saint Germaine. Monet took a minimalist approach in his floral paintings, creating the lushness of the blooms by showcasing a specific flower.

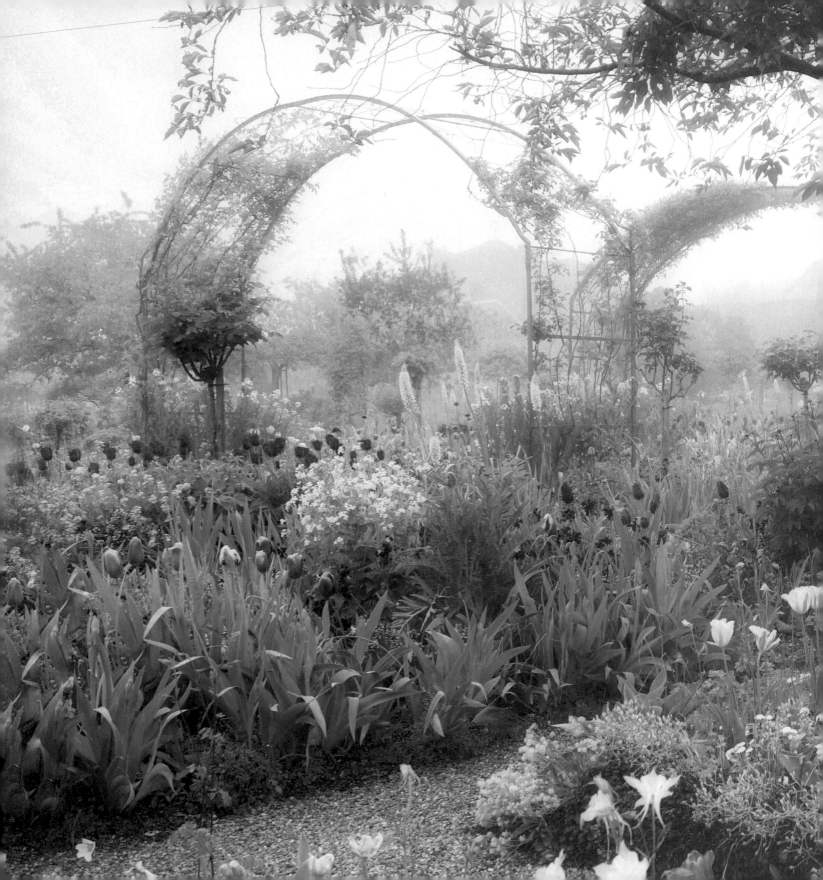

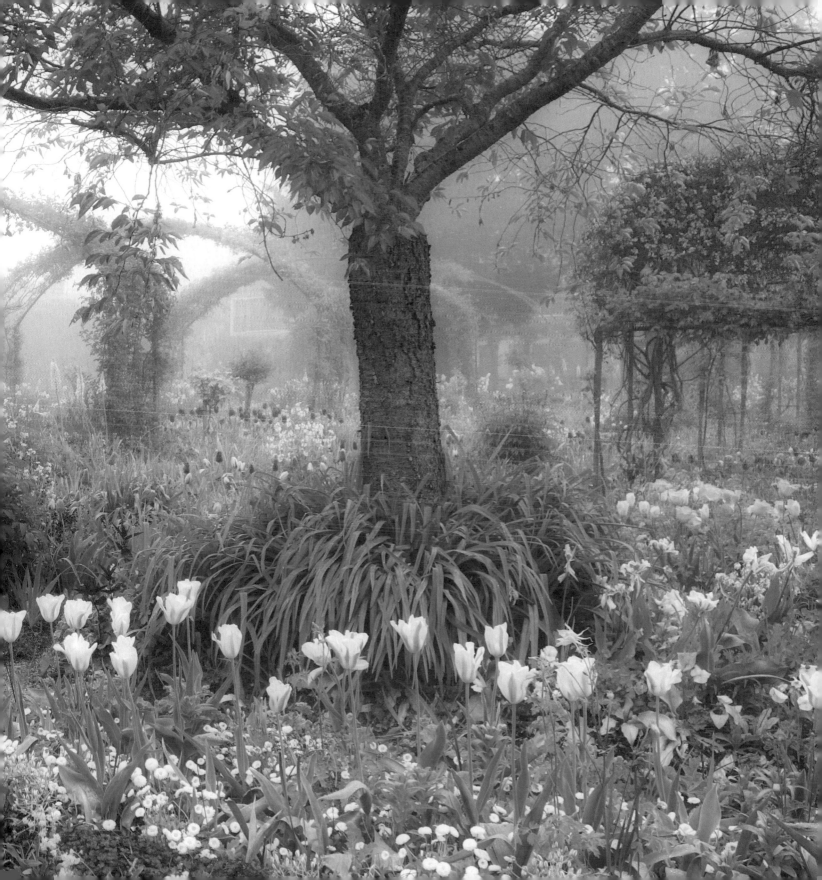

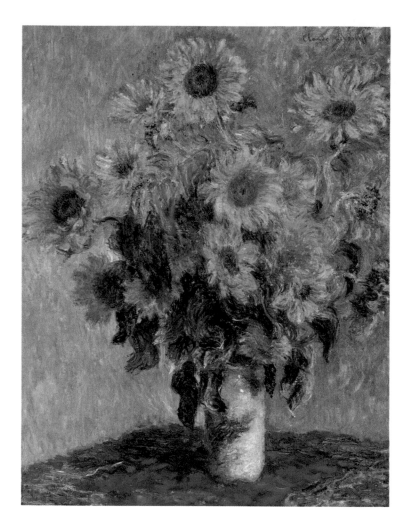

One of the first books ever written about flower arranging is a Japanese text dating back to 1445—and it was wonderful to discover that it brought Monet's aesthetic to mind. The simplicity of the arrangements in the book mimics the simple lines that Monet adored, used in his home and garden, and then painted. The flowers he chose and arranged were uncomplicated, based on what was the freshest cut, and what appealed to him at that moment.

Monet created series of flower and bouquet paintings that you can see in any number of museums across the world. In a particular series, he focused on a gorgeous bouquet of sunflowers.

Monet also grew many varieties of mums in his own garden, and after seeing so many Japanese woodcuts that showcase mums, I have to imagine that together they may have influenced his arrangements and the series of flower paintings featured on the opposite page.

AN IMPRESSIONIST SUNFLOWER

"Gauguin was telling me the other day—that he'd seen a painting by Claude Monet of sunflowers in a large Japanese vase, very fine." **–VINCENT VAN GOGH**

Collectively, I can think of no other singular bloom that has made such a powerful statement in art and floral design than the sunflower. Whether painted by Monet, Van Gogh, or any other number of impressionist artists, this flower always appears magical: seeing, holding, or receiving a sunflower instantly brings a smile. Monet used oil, pigment, and canvas to preserve the stunning sunflower arrangement. His method gives the impression of the same happiness that the flowers themselves evoke in real life.

Monet, as you discovered in the garden chapter, loved to place delicate white flowers among the bed of a specific bloom (bottom left). The introduction of white, paired with the color, helped create the lace and shimmer effect in the garden. Introducing a white flower into your arrangement can bring that same light effect into your home.

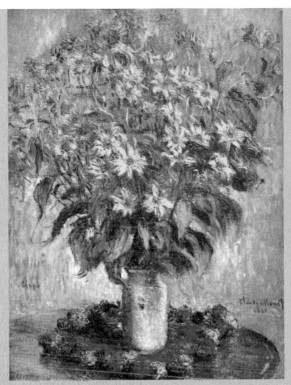

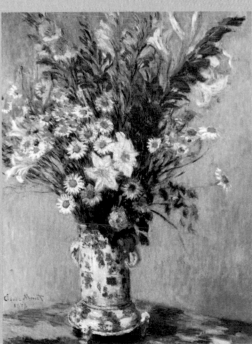

Although we may be used to seeing Monet's paintings that showcase landscapes and nature exclusively, Monet created a number of works that include people—a fact I always like to share. In the top left painting, *Portrait of Suzanne Hoschedé with Sunflowers*, Monet included his stepdaughter Suzanne. She spent many days at Giverny with Monet, enjoying the array of flowers and beauty that surrounded her in that gorgeous natural space. Suzanne was one of the eldest of Monet's six stepchildren, who went on to marry the famed American impressionist Theodore Butler. She also posed for the famed *Woman with a Parasol*. Of all the possible flowers to choose to include from his garden, once again the sunflower shines in this painting with Suzanne. I can imagine Monet, trying his best to cut just the right flower, at just the right time of its life cycle to grace his home, his table.

ARRANGEMENTS Á LA MONET

"Monet channeled to me the essence of his soul and expression of beauty. His art is a gift that magically delivered the beauty of Giverny, but most of all his love, the Nymphaea. It is alive always and delivered to us again and again with flowers." —**PAIGE DIXON**

I am always so grateful to those who share my passion for Monet and help me bring Monet's world to you. Without missing a beat, the noted floral designer Paige Dixon offered to help design glorious arrangements specifically for *Everyday Monet*, with the support of decor designer Jeff Leatham. Paige approached each arrangement guided by the sensibilities of Monet's aesthetic. It was pure delight to be a part of the process of helping her create these homages to Monet's garden and paintings.

The arrangements you will see in the pages of this chapter can be easily replicated depending on the time of year and the flowers you have access to locally. I promise, you will leave this section knowing how to bring these to your own home. While creating the arrangements, Paige visualized our common celebration of seasonal change, delighting in the mystique and everyday seasonal flowers that she was able to source, just as Monet did. We looked together at Monet's floral bouquet paintings, noting that he gravitated to one flower arrangement in his home. The following are some of Paige's everyday arrangements, true toasts to Monet that can and will inspire your own creations and arrangements. Although Monet might have included more than one variety of flowers in an arrangement, there was, as we saw at Monet's garden, a floral star of the arrangement.

SIMPLE IS SPECIAL

In the twentieth century we became accustomed to floral bouquets that, for lack of a better way of describing them, were busy. But busier isn't necessarily better—as the saying goes, less is more. Simple floral designs, as we've already discussed, evoke Monet's everyday style. It is going to be so easy for you to bring Giverny-inspired flower arrangements, using the knowledge you've gained already, either from your own experience planting some beautiful flowers, or what you've learned about sourcing flowers at your local florist. Just think of all the possibilities to include flowers that bring a sense of impressionism into your life, including your home entrance, hallways, dining table, living room, terrace, and even your bathroom.

I am so happy that in the twenty-first century, we are returning to floral simplicity, and that mass-produced flowers are being swapped for what is seasonal, local,

and affordable. Even if your budget does not allow for something elaborate, a bouquet of roses placed on a sideboard or entry table in a vase will connect you to Monet's rose garden and topiaries. As noted in Chapter 2, "Monet's Style," vases made of mediums including copper, glass, ceramic, terra-cotta, stoneware, and traditional pottery all bring about Monet's aesthetic.

CUTTING GARDEN

It is wonderful that we are all able to bring the beauty of Monet's garden into our homes—either as a basket on your terrace, as a single stem at your desk, or as a full arrangement gracing your dining room table.

Perhaps you do have a garden, or you at least have a space for a container inside your home. Plant some flowers with the sole purpose of cutting them for an arrangement. Or, instead, plant flowers to give as gifts. Just as I gave you some ideas regarding growing your own herb garden, you can also fashion your own cutting garden—a small garden where the main purpose is to provide you with fresh cut flowers.

The best flowers in arrangements have long stems, such as tulips, sunflowers, roses, dahlias, and daffodils—all these flowers were favored, planted, and painted by Monet. Make sure to use fresh water and change the water as often as you can remember. Also, there are additives that you can buy at your local garden shop that help preserve flowers once they are cut. Of course, your local florist will always provide the packet of flower food if you purchase their flowers to make your own arrangements—just don't use the packet in your coffee!

CREATING AND PRESERVING A MONET ARRANGEMENT

Just because you may not have space for a garden at home does not mean you can't bring the garden into your world. I hope some of the paintings of Monet's floral arrangements, and the designs and floral arrangements inspired by Monet have given you a starting point to make your own creations that bring Monet and his love of flowers into your own home, in your own special way.

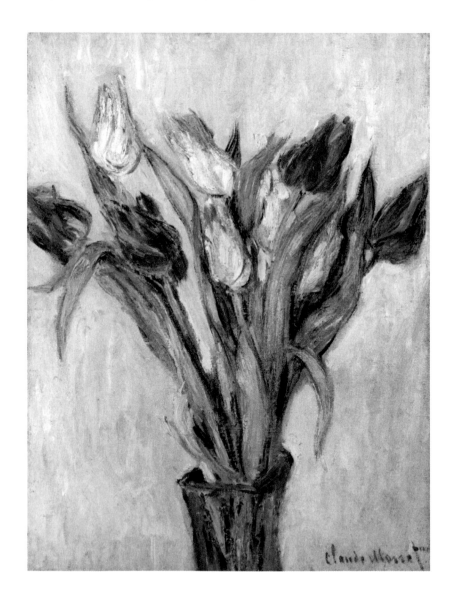

FLOWER-ARRANGING FORMULA

The following is a formula for creating a Monet-inspired floral arrangement, from the expert floral stylist Paige Dixon:

I believe all flowers have a face they shine to the sky when they are "awake." Look at the curvature of the flower's stem—where does the flower shine best?

Twist and feel the flower, and look at its best position.

Arranging flowers becomes like a puzzle of beautiful components that piece together. It is like painting; follow your intuition. The beauty of the elements—just like the brush-strokes, the color—become the masterpiece.

Look at what you have put together. I admire Monet for his very modern approach to color, be it in his garden or painting. The impact is in the strong images or color, and the subtle whispers that peek through. They speak to our soul.

Conditioning of flowers is the most important step—cut the flowers on an angle with a sharp knife if you do not have secateurs (or pruning shears).

Let the flowers drink the water, and do not crowd the flowers together, as the heads will pick up as they get hydrated.

Remove any cellophane or plastic to stop the flowers from sweating and to prevent mold.

To arrange, it is difficult to just "place flowers"—they need a format to build on. Think of laying a formation that is strong. I place the flowers initially in three different quadrants and build mounds of flowers; they eventually will all meet together.

Water should be changed often in arrangements. And I always add a touch of bleach, which helps to remove bacteria. I personally do not use Chrysal, the powdered plant food in a packet that one gets from a florist, as it tends to block the floral arteries.

Do not put flowers and fruit together in an arrangement, as the fruit omits methane and can cut the longevity of the flowers.

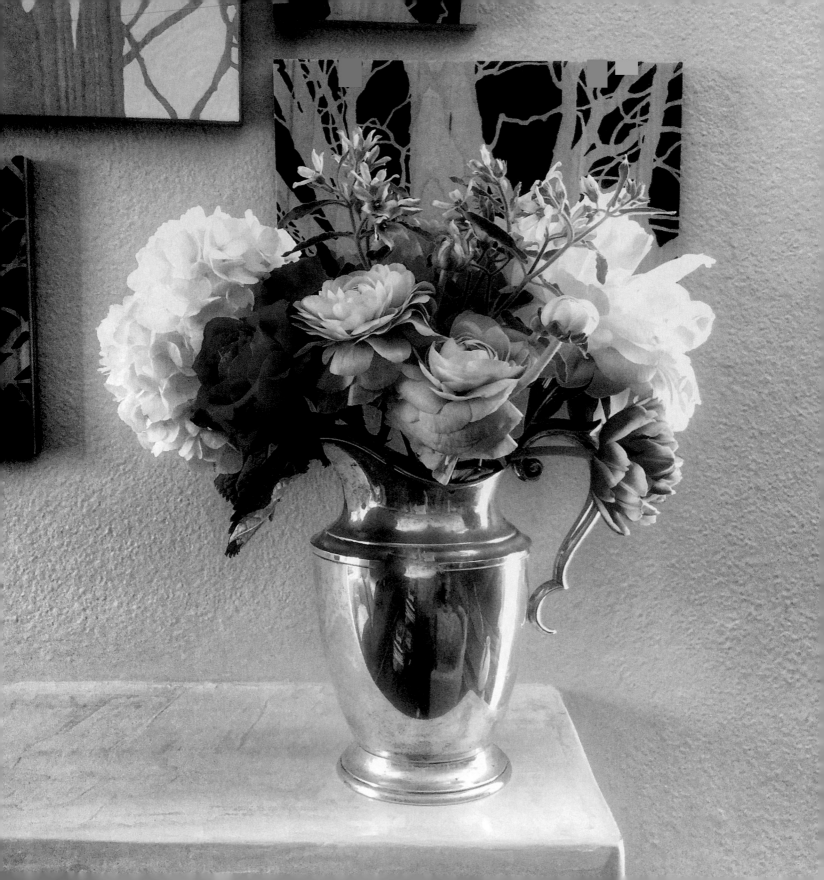

MAKING YOUR OWN FLORAL ART

An arrangement may only remain lush for a week or two, but there are many ways to extend the life of a favored bouquet, creating a permanent fixture of floral art in your home. Drying and pressing flowers are two ways to bring the most beautiful flowers into any room.

DRIED FLOWERS

We have all received a cherished bouquet of flowers that we wish we could hold on to forever. Even the simple sprig of dried lavender I mentioned at the beginning of the book, gifted to me by my mother almost forty years ago, becomes an heirloom.

When dried, aromatic flowers like lavender can maintain their sweet scent. Don't believe me? Even the opening of a three-thousand-year-old Egyptian tomb revealed the dull scent of dried flowers.

Drying flowers is a great way to preserve a full bouquet or a single stem from an arrangement. The best time to dry a flower would be just before it has fully matured. There are various ways of drying flowers, from hanging to applying a substance/chemical that removes the moisture to microwaving. My favorite is the time-honored hanging method.

Strip off the leaves of the stems and tie them into small bunches, depending on the size of the bouquet.

Turn the bunch, or even a single stem, upside down in a darkened area with warm, dry air.

It takes about one to three weeks for bunches to dry. Note that the colors tend to darken once dried.

PRESSED FLOWERS

Whether a fresh stem cut from your container garden, a bouquet from your local florist, or flowers you kept for sentimental reasons, pressing flowers can be just as simple a preservation method. Using the petals of various pressed flowers is also a wonderful way to create art that is very special. It is not easy, and like any form of art, it requires talent, time, and dedication.

On page 142, you can see one-of-a-kind designs created by my mother's dear friend Bernice Peitzer. The pressed petals were arranged as an homage to Monet. Take note that the frame colors are reminiscent of Monet's yellow dining room and the pink stucco of the house.

OPPOSITE: In Chapter 3, "Monet's Twenty-First-Century Garden," you were introduced to some of the floral stars that grace Monet's iconic garden. This is a floral arrangement that includes some of those stars—tulips, roses, peonies, with white chrysanthemums as a shimmering contrast. Create your own masterpiece!

My time-honored method of pressing flowers will hopefully help get your creative juices flowing as you think about ways to create gorgeous pieces of art with your flowers—pieces that Monet would have envied.

Take a treasured stem, a heavy, closed hardcover book on which you can put more weight, wax paper, and two paper towels.

Place the stem and petals between two pieces of wax paper, followed by a paper towel on either side. Make sure the flower is centered on the page before closing. This will allow for equal weight upon the stem.

Open up your hardcover book and place the stem, wax paper, and paper towel combination between one of the bottom pages of your book, close the book, and wait until your pressed flowers are ready to use—absolutely stunning!

It usually takes about two to three weeks for pressed flowers to be finished. You don't want to keep them in the pages of the book too long or they might fall apart.

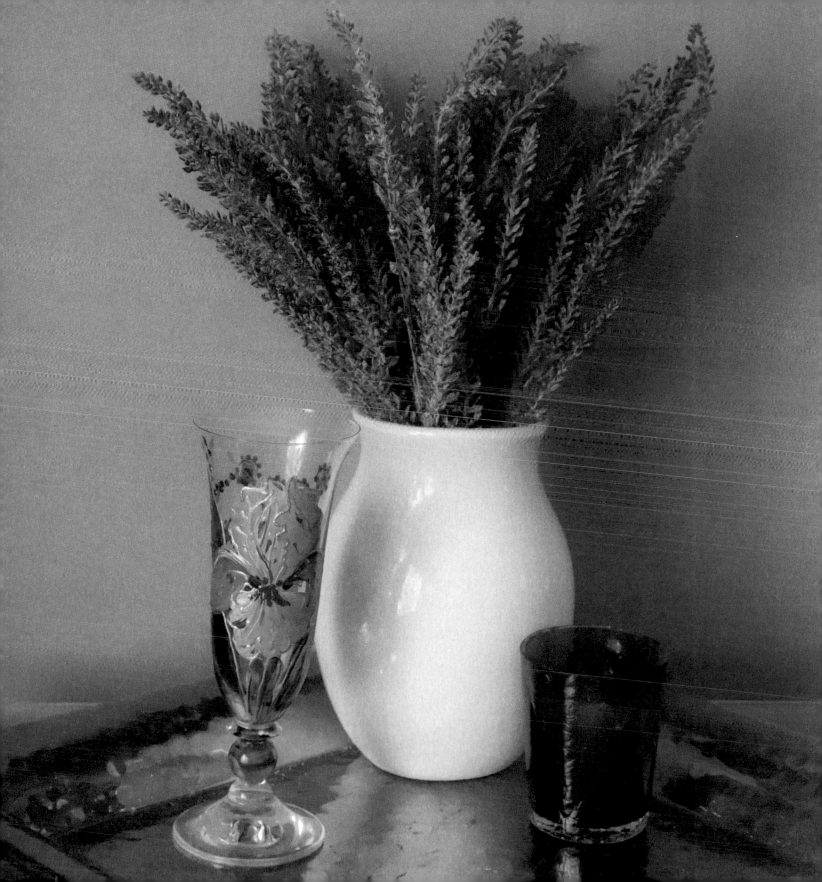

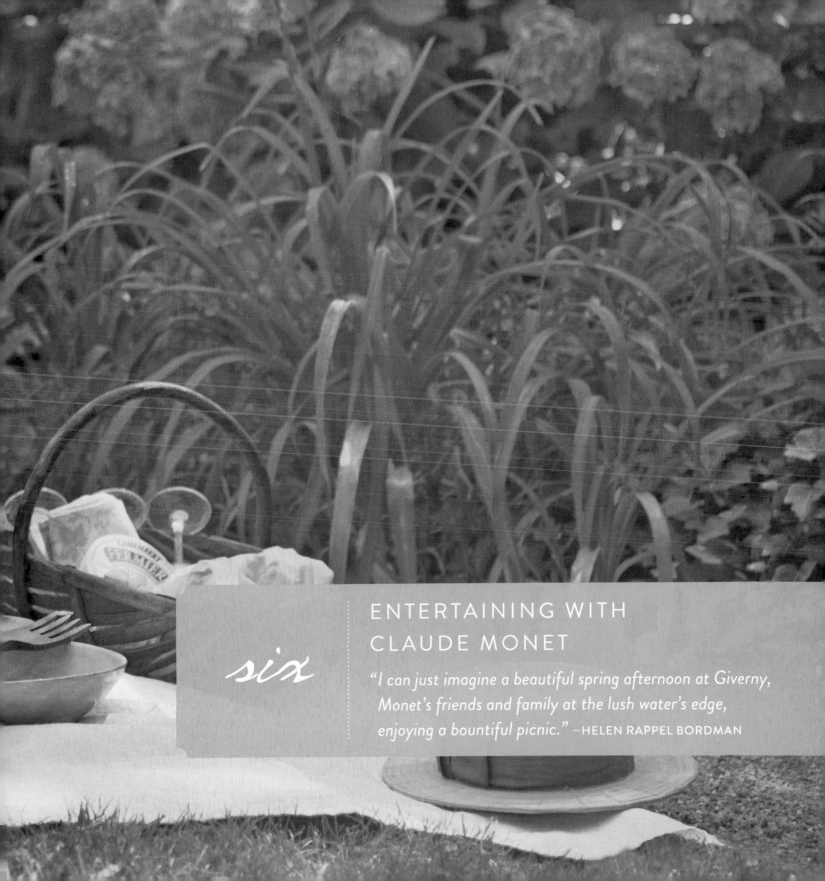

ENTERTAINING WITH CLAUDE MONET

"I can just imagine a beautiful spring afternoon at Giverny, Monet's friends and family at the lush water's edge, enjoying a bountiful picnic." —HELEN RAPPEL BORDMAN

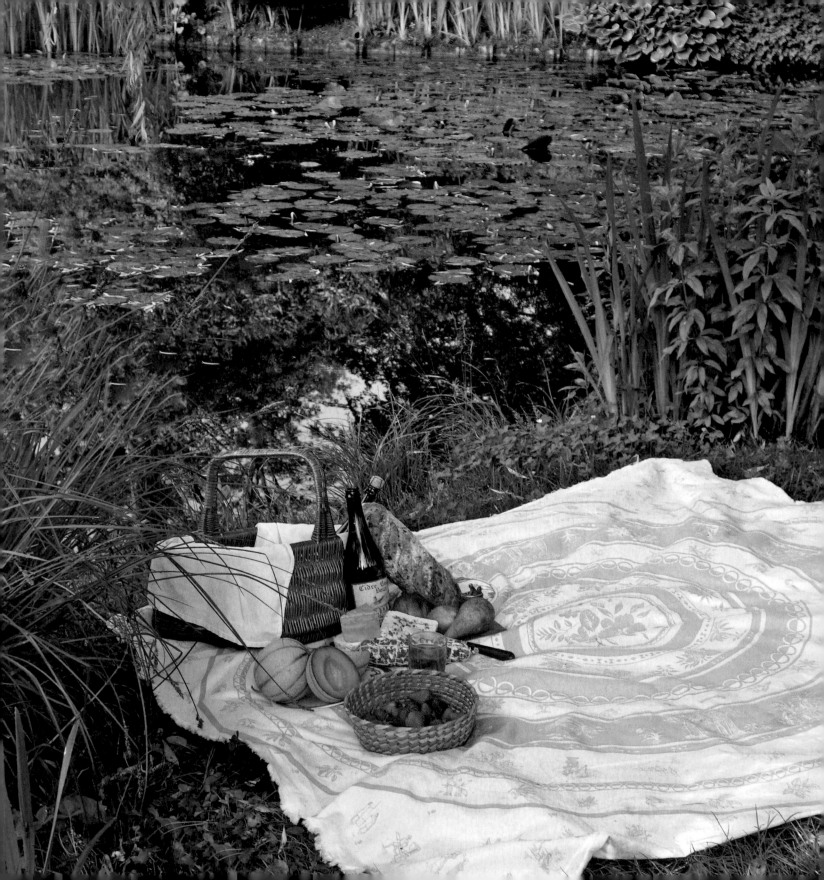

THE ENTERTAINER

Now that you've witnessed the home and garden, experienced the floral stars of Giverny, and learned how to grow your own water lily and make your own Monet-inspired floral arrangement, it's time to entertain like Monet too.

Claude Monet loved to entertain. He wasn't one of those artists who would lock himself in a studio, barricading himself from enjoying the gifts of life. He designed his home and garden not only as a place to dwell but also as a place to experience all the rich dimensions of everyday life— with family, friends, and fellow artists.

Entertaining at the Monet home was taken as seriously as his art. The home and garden at Giverny was *the* place to be invited –both for the company and for the spaces he created. Just imagine lounging in the gardens or having tea with scones in the two-toned blue-colored drawing room. The entire Monet family was involved in the preparation of the festivities, in addition to Marguerite, Monet's cook, and Florimond, the head kitchen gardener.

At the time, the day's menu would be created using seasonal vegetables and herbs picked that same morning. Entertaining in the garden meant an outdoor meal, rattan chairs and tables, and large umbrellas overhead to provide shade.

Invitations to the Monet home were highly sought after. Celebrities, diplomats, and artists all vied for a coveted invitation for lunch, dinner, or a picnic. Many of Monet's guests, like Mirbeau and Caillebotte, were expert botanists and could not get enough of Monet's Shangri-la. Others, like Paul Cézanne, could impress Monet by bringing a beloved recipe for Monet's chef to prepare. Evidently, Cézanne wowed Monet with a salt cod recipe and became a frequent guest to the home.

Many of Monet's friends owned cars, and the flurry of guests at Giverny increased over the years, and thus entertaining at Giverny became an important part of *le vie quotidienne* (everyday life). As much as his friends traveled near and far to Giverny, Monet in fact never learned how to drive—although he held a passion for automobiles. Today, I always inform people that Monet's home is close to Paris. I suppose the fact that Giverny is located in Normandy gives travelers the sense that it is a very long trip to the garden. In fact, Monet's home and garden is a mere forty-five-minute voyage by train from Paris—a trip that in fact was made by many artists and esteemed individuals of the period.

LA BELLE ÉPOQUE

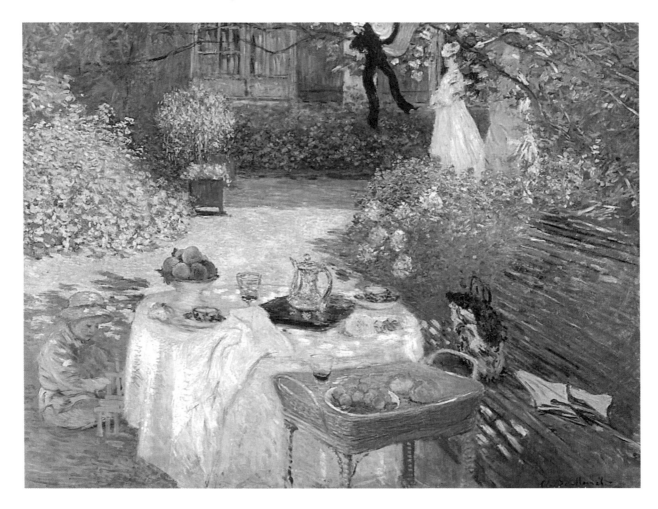

La Belle Époque is a French term for "Beautiful Era" and is characterized as a time of true elegance, culture, and intellect. La Belle Époque began mostly in England and France around 1871, which is about the same time Monet moved to Giverny. Monet's art was pre-Époque and set the foundation for the art nouveau artists, also known as postimpressionists—like Paul Gauguin, Henri Matisse, and Henri de Toulouse-Lautrec. Just imagine these illustrious guests at the home or on a picnic with Monet: the energy, the excitement of life, was at an all-time high.

This was also the time for the international fair of 1889, when Gustave Eiffel unveiled his monumental tower. It was the same fair where Monet began his romance

with the water lilies. The mood created by outdoor entertaining and the *pique-nique* at the time of La Belle Époque was, in one word, fashionable. This was a new time in history where finally an individual did not have to be part of the traditional aristocracy but could dine, play, and socialize in the same manner. There was a theatrical quality, as men and women dressed with great style, even for their outdoor play and dining.

Monet and his family and friends embraced this era with gusto. He made sure that his home and garden at Giverny would be the destination for this newfound freedom and zest for traveling. Life at Giverny was a party, and to be entertained by Monet was an experience, the home and garden a kaleidoscope for his guests' senses!

Just imagine Madame Monet and the other women at the home taking a stroll through the garden, resting casually upon the green rails of the Japanese bridge (pictured below). Visualize butterflies dancing upon their hats, while their stylish

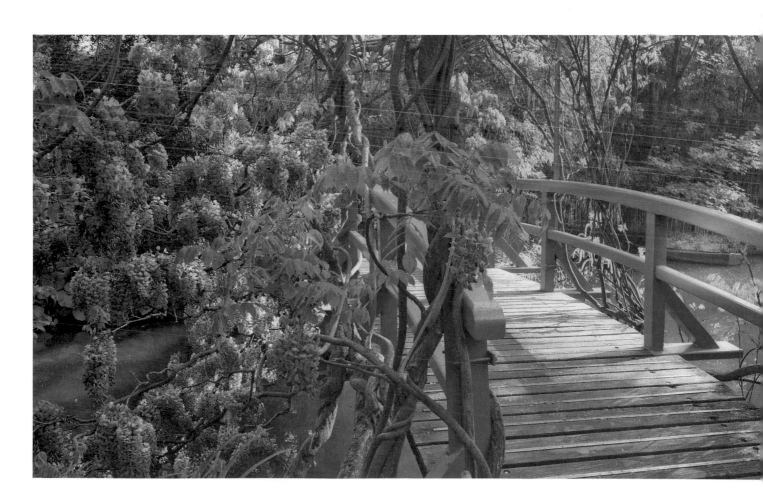

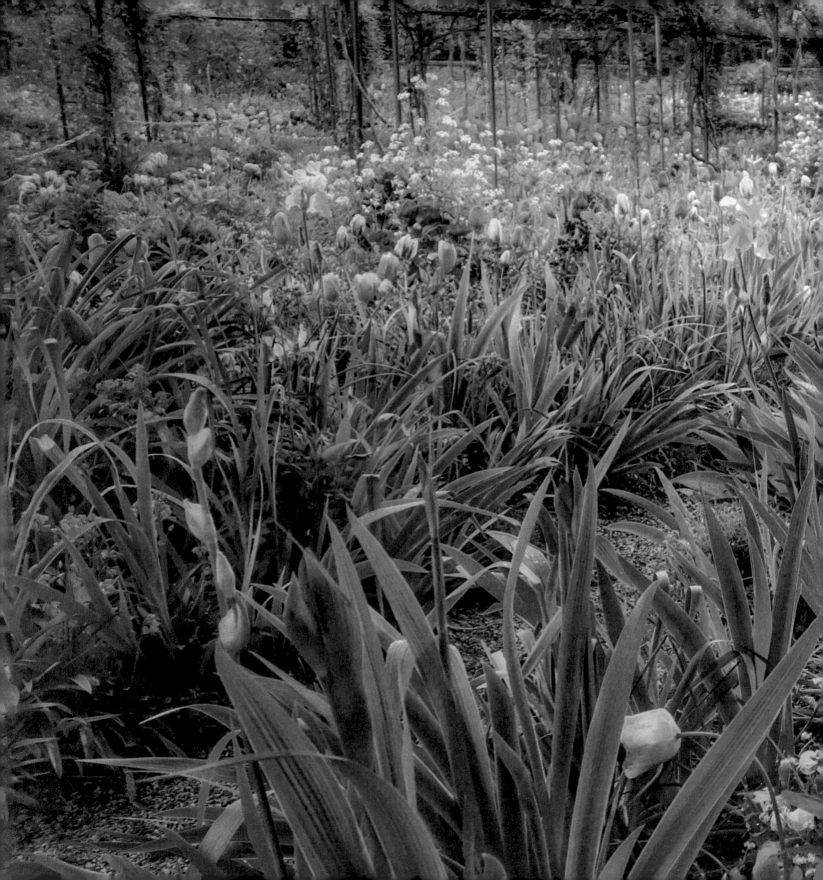

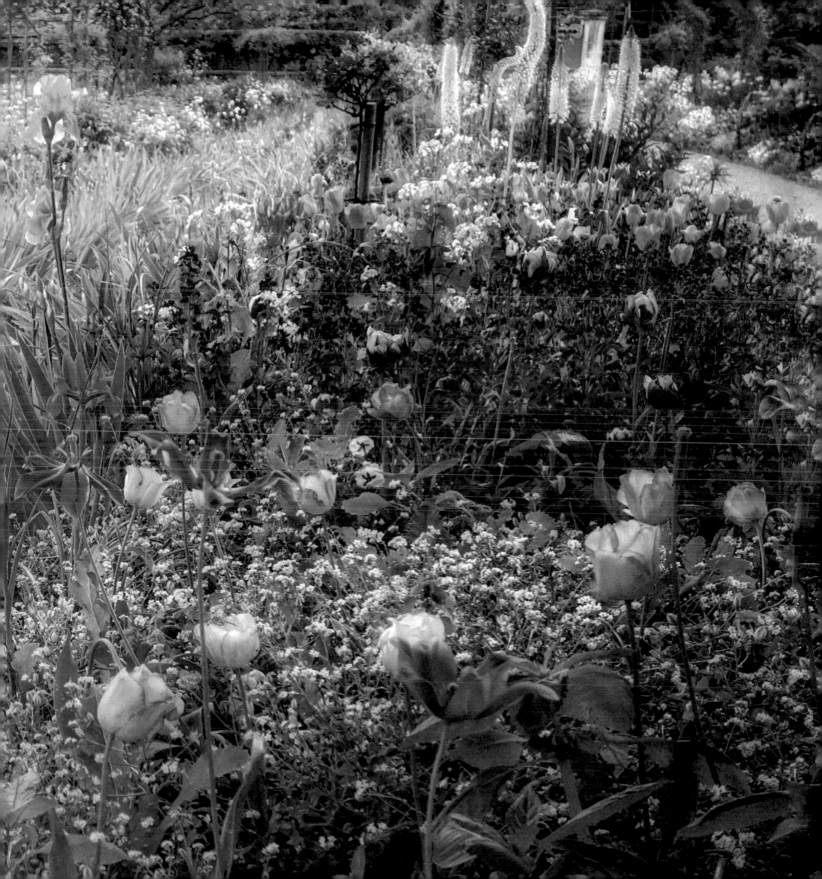

The influence of Monet's world has made an appearance throughout history. A grand example of entertaining á la Monet occurred in Washington, DC, on February 11, 2014. With true pomp and circumstance, the president of France and guests were welcomed to a spectacular state dinner at the White House. The planners summoned the magic of Monet at the gala, captivating and transporting the guests to Giverny. It was held *en plein air* in large tents, and Monet's water lily paintings were showcased. The tables and ceilings were arranged with quince branches, white and purple irises, blue agapanthus, and water lilies all in radiant bloom. Transport your own guests by arranging your tables and ceilings with branches of flowers, such as the wisteria shown here.

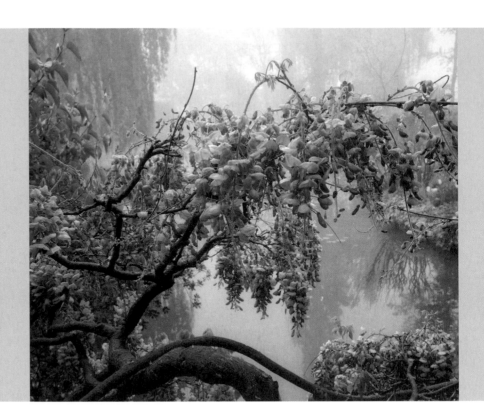

dresses melded into the many garden colors. Some of the fashion statements at this time were ornate umbrellas and hats with bows. Both were intended to guard women's complexions from the sun. It's an incredible image: standing upon a flying carpet, woven of flowers and vines, overlooking Monet's garden.

MONET'S PASSION FOR PICNICS

Just imagine a picnic at Monet's garden and how beautiful the surroundings would be. There are simple ways you can entertain with the taste of Giverny. This is your guide to a little culinary celebration, one Monet would have enjoyed in his radiant dining room or at a picnic *en plein air*.

La Belle Époque was a time during which men wore mustaches and women began to smoke, while picnicking outdoors or while entertaining indoors—it was such a departure from the staid tea and cakes of the Victorian era. Guests were giddy at

Monet's home and garden. The superb champagne would flow, and the festivities continued well into the evening. Monet actually decanted his champagne as he did not care for the bubbles.

Once upon a time I took a road trip with my cousin Marcel from Paris to our family's home in the town of Juan-les-Pins on the Côte d'Azur in southeastern France. I could imagine Monet making his way to the French and Italian Riviera to paint, eat, and find inspiration. The colors of the Riviera were lush . . . the sea blue, beach pink, orange, and lavender. These colors became a part of his home and garden; the flowers became living decorations for his guests.

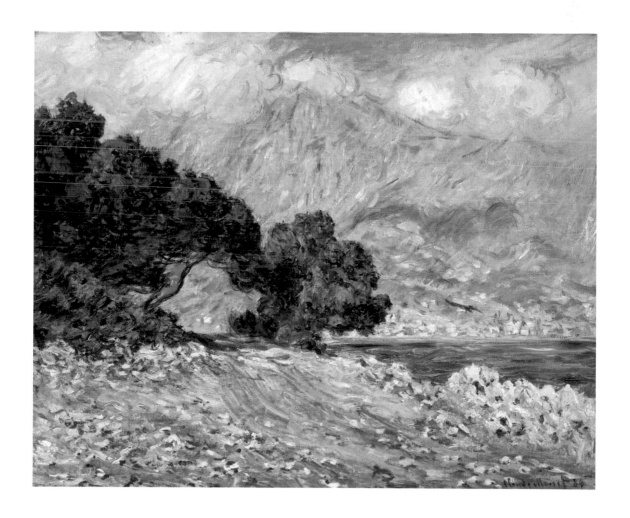

I still remember my trip as if it were yesterday. Marcel handed me what I thought was an ordinary sandwich, albeit one nestled and cleverly folded in waxed paper. As I opened the paper, I immediately inhaled the sweet and briny aroma of smoked salmon. The bread on either side of the salmon was thin, yet crusty, and the fish lay upon a generous layer of sweet, creamy butter. This was more than just a sandwich. It was something Marcel had carefully planned and lovingly prepared at home. He knew that he wanted us to experience the pleasure of dining *en plein air*, even if that meant that we would have to sit on the trunk of the car to do so. And that is exactly what we did. It was a seemingly spontaneous picnic, and yet there was forethought in Marcel's preparation. I will mark that joyful moment in time forever.

Just as Marcel and I enjoyed the art of travel and picnic, Monet did too. I often think of Monet traveling. I imagine him visiting the seashore to paint, and then enjoying a hearty sandwich with some wine. Of course, if the light changed he would immediately have to put down the sandwich and run back to his easel, to set the colors and perspectives in paint. Imagine being among the irises Monet meticulously planted, nurtured, and painted—and eating a luxurious picnic all at the same time.

The French make picnicking easy and I appropriated the habit in a heartbeat. Marcel set an example that I followed with gusto. I would pick up or whip up *pissaladière* (Niçoise olive, sweet onion, and anchovy pizza); or a sandwich, whether as elemental

You needn't travel far to experience the passion Monet held for entertaining and picnicking. Even without a deck or backyard, one can enjoy a celebration on a plush urban terrace, rooftop, balcony, or blanket. Guests will feel transported. What better way to enjoy an outdoor dining experience than to follow the lead of the master of outdoor art. What better way to entertain like Monet than to dine with dear family and friends in your outside space.

Close your eyes for just a moment. Feel the breeze as it carries the aroma of good food and the perfume of flowers. Feel the sun on your face. Taste with all your senses. You are bringing the joy and beauty of Monet's Giverny home for your guests.

and elegant as *jambon-beurre* (a baguette sandwich of sweet butter and salty ham) or as deliciously messy as *pan bagnat* (a round roll sandwich filled with tuna, anchovies, vegetables, hard-boiled eggs, olives, and olive oil). There was always a park bench for me to sit on to enjoy my little handheld feast. Or if family and friends were involved, I would fill a basket with whatever delicacies I had prepared at home, or head to a variety of shops and gather pâtés, cheeses, olives, radishes, bread, strawberries, and macarons for the occasion. Champagne and wine were a given and we would spread out a blanket just about anywhere.

I fantasized about luxuriating on that blanket in Monet's picnic painting on page 158. The roast chicken, paté, salad, bread, Camembert cheese, and rosé were laid out before me. Joining my little fantasy were Paul Cézanne, Isadora Duncan, Victor Hugo, Octave Mirbeau, and the Monet family. Perhaps I could see the fuchsia peonies bouncing as their fragrance married with the scent of my wine.

AN ORCHARD PICNIC AT HOME

Happily, I have spent time at Monet's garden throughout the seasons, including fall. At that time, the fragrance of apples perfumes the air and leaves swirl among chrysanthemums as a tapestry of fall colors shifts from green, climbing against the pink stucco walls.

I have always had a special fondness for a crisp fall day, when a sweater is required and the varied hues of autumn leaves make me smile. The season brings with it a special harvest of fragrant crisp apples, juicy purple figs, tart red cranberries, big and small orange pumpkins, multicolored textured gourds, and nectarlike pears. For many, these incredible seasonal ingredients can be procured close to home. Monet's life was filled with apples . . . in the orchards, on his table, and of course in his paintings. He painted orchards throughout the seasons, from cotton candy blossoms to ripe harvest.

Recently, I was in Giverny visiting with my mother. I took a stroll around an apple orchard near Monet's home, and as I did so an apple fell upon my head. I was hungry. As I gazed at the edible gift now in my hands, I let out an audible sigh. Where was my ripe Camembert, crusty bread, and bubbly cider? Alas, there would be no impromptu

In addition to apples, my local country store also grows and sells every kind of pumpkin, gourd, and squash imaginable. They make for incredible decorations for an indoor or outdoor experience. One squash that I love is called the turban, which is shaped like a sultan's hat and boasts striking colors and is very French.

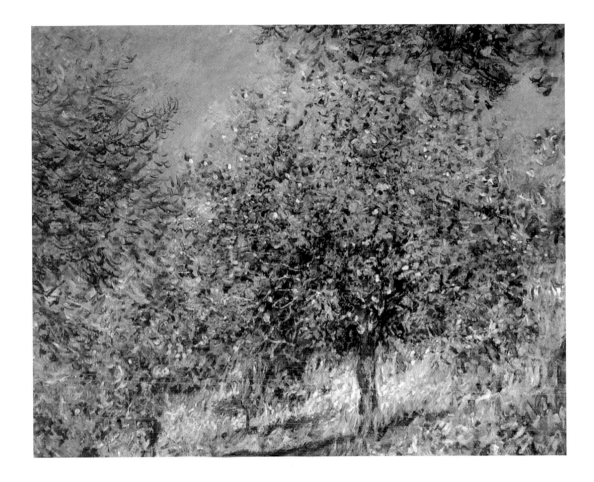

picnic for me, but that didn't stop me from thinking about the outdoor dining depicted in Monet's glorious paintings.

Apple orchards are commonplace in different areas and climates across the world, and Monet loved the fruit and space. He painted countless images of apple orchards, in some of his perhaps lesser-known paintings. Because there are orchards everywhere—from New Jersey to China—it is truly accessible to so many people to make a picnic instantly feel like a Monet picnic by moving the venue from your home to your local or nearby orchard.

I have chosen two apple recipes for the menu presented in the remainder of the chapter, because the tasty fruit is widely available regardless of season or geography, and of course, Monet loved apples too. Clearly, an orchard picnic can extend through the seasons and refers to other delicious fruits as well, such as ripe cherries, pears, and plums.

ENTERTAINING À LA MONET

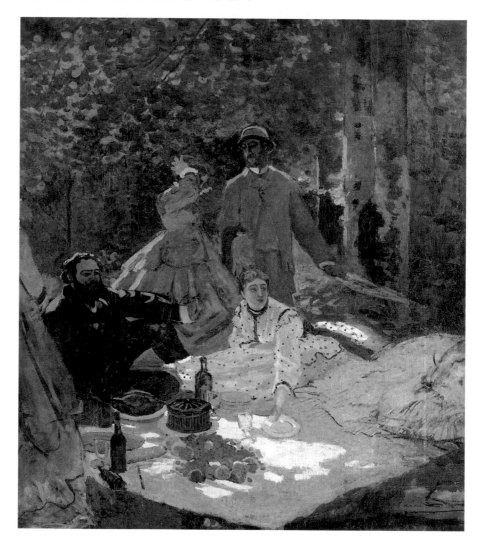

Now that you have transported a bit of Monet's garden and style home, it is time to entertain à la Monet. Treat your family and guests to a relaxed, creative, and delicious dining experience. Your guests will feel transported to Monet's garden and the era at Giverny.

The menus and the recipes I have created for you are in the very spirit of Monet. They are based on Monet's food preferences and will bring your celebration into the twenty-first century. The recipes are fresh, delicious, and easy to prepare. They are as accessible as Monet's art.

Monet's palate to palette is part of the experience. Don't forget to include some of the colors, plants, and flowers discussed in the preceding chapters to decorate the space. A wicker basket that pays homage to picnics and Monet's love of rattan is a wonderful way to transport items and give the look and feel of a picnic with Monet. A basket of Red Delicious and green Granny Smith apples and sunny oranges make a beautiful and colorful homage to Monet's palate on your blanket. The accoutrements to the experience should be kept as simple or extravagant as you prefer. Something as simple as a lace tablecloth, a French blue picnic blanket, and napkins or plates chosen from Monet's palette can evoke the beauty of his aesthetic. I love taking a simple white paper plate, a blue blanket or tablecloth, some yellow napkins, and flowers . . . et voilà!

The time of year for this Giverny celebration doesn't matter. It can be in the dead of winter, with mounds of white snow rolling outward from your front door. The fireplace is crackling and the warmth is broken by a slight cool draft. Set your favorite picnic blanket in front of the fire. The steak sandwiches are now room temperature, which is even better, as the beef juices meld with the honey mustard and soak into the bread.

You have opened a bottle of red wine and the scent as it is poured is deep, sweet, licorice, and robust. Happily, you remembered to buy fragrant honeysuckle from your local floral shop, which is available year round.

There . . . no matter the season, let's connect to Monet!

THE *EN PLEIN AIR* MENU

Imagine transporting the tastes and experience of a Giverny apple orchard home. Because a rotating orchard of fresh fruits is seasonal right through the fall, there is no excuse not to celebrate its bounty à la Monet. Start snipping your fresh herbs as you prepare these simple yet delicious dishes and bring a bit of Monet's joie de vivre for entertaining home today.

MONET'S PALATE CIDER OR MONET'S PALATE ROSÉ TO START!

Monet enjoyed his beverages . . . spirits! I like to imagine Claude Monet and his friends like Pissarro, Renoir, and Cézanne stumbling out of the Hôtel Baudy, located near Monet's home. Monet's regular was scotch whisky, which was first brought to France by the proprietor, Madame Baudy.

Come share a glass of my rosé wine or cider and be transported to Monet's world with every sip, morsel, and breeze.

BRUSSELS SPROUTS SLAW WITH POPPY SEED VINAIGRETTE

Oh my, just look at Monet's palette in this dish!

Monet enjoyed vegetables so very much. I have to imagine that Monet loved being able to design and then enjoy the bounty of his garden at his very own table. He insisted the long-stemmed sprouts be picked at their best, which was in the fall. More and more recipes now include raw brussels sprouts, and they are particularly delicious in this refreshing salad. This salad is very transportable and perfect for an outdoor meal on your terrace, deck, rooftop, or picnic site.

MAKES 6 SERVINGS

DRESSING

¼ cup extra-virgin olive oil

3 tablespoons fresh orange juice

½ tablespoon honey

1 teaspoon poppy seeds, lightly toasted

½ teaspoon sea salt

½ teaspoon freshly ground pepper

SLAW

1½ pounds brussels sprouts

1 medium carrot, peeled and grated

¼ cup diced red pepper

2 tablespoons minced flat leaf parsley

Additional salt and freshly ground pepper

FOR DRESSING: Place the olive oil, orange juice, honey, poppy seeds, sea salt, and pepper in a small bowl. Whisk well to blend.

FOR SLAW: Cut the brussels sprouts lengthwise in half. Slice each half horizontally into julienne slices, discarding the ends. Place sliced brussel sprouts, grated carrot, and diced pepper into a large portable bowl. Pour in the dressing and toss well. Season with additional salt and pepper. Sprinkle with the parsley. Cover and refrigerate until ready to pack for the picnic.

GREEN GARDEN POTATO SALAD

Monet enjoyed hearty meals, and potatoes were a staple at his home. Fresh herbs, including chive, dill, and parsley, were plentiful and used generously by Monet's chef, Marguerite. You don't need a lot of ingredients to make a potato salad delicious, and this one filled with fresh herbs proves the point. If you have your own small herb garden, consider planting fresh, aromatic chives—they make this dish even more special. The potatoes are dressed with olive oil and vinegar rather than mayonnaise for a fresher taste.

MAKES 6 SERVINGS

16 medium Yukon Gold potatoes

2 tablespoons salt

¾ cup extra-virgin olive oil, plus extra for dressing

6 tablespoons white wine vinegar

1 teaspoon freshly ground black pepper

½ cup snipped fresh chives

¼ cup minced fresh dill

¼ cup chopped fresh flat leaf parsley

Coarse sea salt, kosher salt, or *fleur de sel* (French sea salt)

Place the potatoes and salt into a large stockpot. Add just enough water to cover, and bring them to a boil over medium heat. Continue cooking until the potatoes are fork tender, about 15 minutes. Drain the potatoes and cool slightly. Skin the potatoes while they are still warm. Cut the potatoes into ¼-inch-thick slices. Place the potatoes, the olive oil, vinegar, and pepper into a large portable bowl and fold them gently together. Cool completely. Add the chives, dill, and parsley and toss well. Drizzle with the additional olive oil and sprinkle with salt to taste. Cover and refrigerate until the salad is ready to be packed.

STEAK SANDWICH WITH CARAMELIZED ONIONS, FRESH DANDELION GREENS, AND WASABI-HONEY SPREAD

Here is a steak sandwich with a decidedly modern twist. It includes a bit of wasabi mustard, bringing the Japanese influence—so loved by Monet—into the recipe. Monet's cellar at home was always stocked with root vegetables and onions during the cold months. For this recipe, look for smaller, younger dandelion greens as they are more tender and less bitter than older ones—though any delicious green will do. Monet was crazy for cracked black pepper, so much so that he always had his own dish of pepper separate from his family and guests. As a nod to Monet, pack or place nearby a wonderful pepper mill for your guests. As a vegetarian alternative, you can substitute sliced grilled portobello mushrooms.

MAKES 6 SERVINGS

CARAMELIZED ONIONS

½ tablespoon extra-virgin olive oil

1 large Vidalia or other sweet onion, very thinly sliced

¼ teaspoon sugar

⅛ teaspoon salt

1 tablespoon water

WASABI-HONEY SPREAD

3 tablespoons honey

2 tablespoons fresh lime juice

1 tablespoon wasabi powder

STEAK

2 pounds sirloin steak, room temperature

Extra-virgin olive oil, for brushing

Coarse sea salt, kosher salt, or *fleur de sel* (French sea salt)

Freshly ground black pepper

SANDWICH

1 large loaf batard bread or 6 ciabatta rolls

1 bunch dandelion greens, ends trimmed or any preferred greens

FOR ONIONS: Heat the olive oil in a twelve-inch cast-iron skillet over low heat. Add the onion, sugar, and salt and cook until the onion turns deep brown, stirring frequently, about 30 minutes; do not burn. Add the water and stir to bring up browned bits. Remove from the heat.

FOR SPREAD: Place the honey, lime juice, and wasabi powder in a small bowl. Whisk until smooth.

FOR STEAK: Heat the grill over medium-high heat. Brush the steaks on both sides with olive oil and season with salt and pepper. Grill the steaks for 2 to 3 minutes per side for medium rare. Allow the steaks to rest. Cut the steaks on the bias into thin slices.

FOR SANDWICH: Slice the batard horizontally. Spread the wasabi honey lightly and evenly on the bottom half of the sliced batard or each sliced roll. Top with the steak, then the onions. Garnish with the dandelion greens. Place the top half of the bread on the greens. If using a batard, cut into sandwich-size portions. Wrap each sandwich in waxed paper and then in aluminum foil. Transport the sandwiches to the picnic site.

SLICED ORCHARD APPLES WITH ORANGE-CARAMEL DIPPING SAUCE

Monet, Normandy, and apples! They shout Giverny. Just imagine a picnic in an apple orchard near Monet's home. If you love caramel apples, you will love this dessert. The caramel sauce is made with condensed milk and brown sugar, which means you do not actually have to worry about making caramel. Buy your apples at an orchard, and wash, core, and slice them at the last minute.

MAKES 8 SERVINGS

One 14-ounce can sweetened condensed milk

4 tablespoons (½ stick) unsalted butter, melted

1¾ cups firmly packed dark brown sugar

¾ cup light corn syrup

2 tablespoons water

1 teaspoon grated orange peel

¼ teaspoon salt

Julienned orange peel

8 apples, preferably fresh picked organic orchard apples, cut into wedges

Place the milk, butter, sugar, corn syrup, and water into a heavy medium saucepan over medium heat; cook until the sugar is dissolved, stirring constantly. Remove the pan from the heat and add the grated orange peel and salt. Transfer the caramel sauce to an airtight container. Let it stand at room temperature until it is ready to pack for the picnic. Garnish the sauce with the julienned orange peel. Serve the sauce with a variety of freshly cut apples.

APPLE CIDER DONUTS

This recipe is an homage to the apple fritters Monet enjoyed at Giverny. The little bits of fresh apple in the batter add a wonderful texture. There is nothing quite like apple cider donuts: the flavor is subtle yet distinct and just sings of the season. These are delicious as is or rolled in cinnamon sugar or powdered sugar. If you prefer a glaze, try reduced apple cider mixed with powdered sugar and vanilla.

MAKES 12 SERVINGS

½ cup apple cider

2¾ cups all-purpose flour

¾ teaspoon baking powder

½ teaspoon baking soda

⅛ teaspoon salt

½ teaspoon ground cinnamon

¼ teaspoon freshly grated nutmeg

2 tablespoons (¼ stick) butter, room temperature

½ cup sugar

2 tablespoons firmly packed light brown sugar

1 egg

¼ cup buttermilk

½ teaspoon vanilla

1 small tart apple, peeled and cut into ¼-inch dice

Additional all-purpose flour

Canola oil (for deep frying)

Cinnamon sugar (optional)

Powdered sugar (optional)

Place the apple cider into a small saucepan and boil until reduced to ¼ cup. Then set it aside.

Sift together the flour, baking powder, baking soda, salt, cinnamon, and nutmeg in a large bowl. Set aside. Place the butter and both sugars in the bowl of an electric stand mixer and beat until creamy. Beat in the egg. Then beat in the reduced cider, buttermilk, and vanilla. Scrape down the bowl. Add the dry ingredients and beat until just blended. Using a wooden spoon, stir in the apple. Form the dough into a ball, cover, and then refrigerate for 30 minutes.

Heat the oil in a deep fryer, large pot, or wok to 300°F. Meanwhile, roll out the dough on a lightly floured surface to rough discs about ½ to ¾ inch in thickness. Using a 2½-inch donut cutter, cut out the donuts, reserving the holes. Add the donuts three at a time to the hot oil and fry them until a deep golden brown

on both sides, about 5 minutes. Remove the donuts using a slotted spoon and drain them on paper towels. Fry the holes separately, if desired. Cool the donuts completely, then store them in an airtight container. Pack cinnamon sugar and powdered sugar separately in containers, if using. Just before serving the donuts, ask your guests if they would like powdered sugar or cinnamon sugar. Roll the donuts and enjoy!

conclusion

What can one say about Claude Monet? That he loved beauty and nature. That his creative side had no boundaries. And that he has left us a living legacy. Monet led a life filled with passion and had an open heart. He brought exotic seeds, recipes, new colors, and different cultural influences into his home.

As I embarked upon creating *Everyday Monet*, my own palette had to be refreshed. I knew that the visuals, and my feeling about the world Monet created, had to be shared. It's not often that the opportunity to share your life's passion presents itself. It's also not often that that passion has no boundaries, and was created by a Frenchman living in the nineteenth century.

As I walked the garden, before taking my first photograph of it, before writing my first word, I immersed myself in the beauty of Monet's Giverny. Through a different perspective, I concentrated on all the ideas I have presented, endowed by Monet.

I hope that you now have a sense of Monet's style and preferences, from the rich color palette to the living garden to the entertainer extraordinaire himself. As you have embraced each chapter, I hope that the information, visuals, and ideas have become inspired steps for bringing Monet's brilliant aesthetic home. It is important that you follow Monet's lead, and just as important that you go off and include your own sensibilities and preferences.

Claude Monet has endowed the world spectacular gifts. The ability to take in your natural environment and integrate its beauty into your own space is a model for living well. If you take away anything from reading this book, viewing the photos, or implementing any one of the Everyday Monet Ideas—it is by incorporating these pieces of style and design that you are walking in Monet's path. No matter your budget, space, or locale, there will be at least one step, if not many, you can take to connect you to a magnificent lifestyle.

I promised that I would show you ways to live your best impressionist life, and I hope that these steps bring you and your loved ones the passion and joy of Monet's Giverny every day.

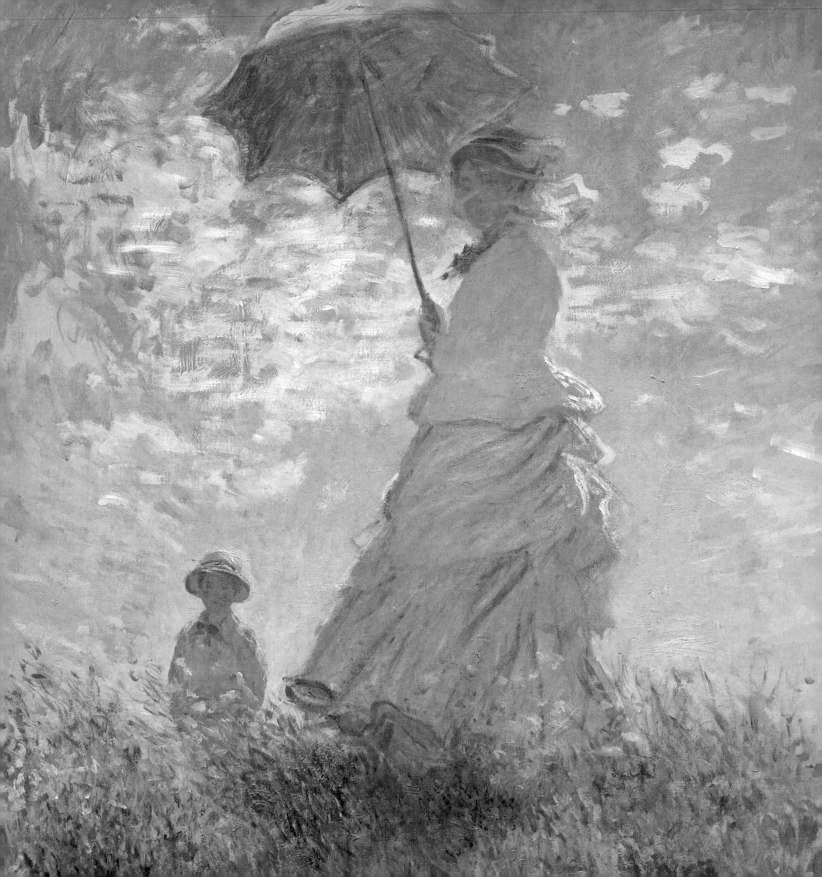

acknowledgments

I would like to thank Claude Monet for creating a world of beauty—a world that begs to be tended and protected in the same spirit as his garden. Thank you to the Fondation Claude Monet Giverny, including Monsieur Hughes Gall, Claudette Lindsey, Laurent Echubard, and Gilbert Vahé.

Special thanks to the brilliant Lisa Sharkey for believing in my mission, and for bringing *Everyday Monet* to her spectacular team at HarperCollins. To my editor, Alieza Schvimer, for her very special guidance and contribution. To my devoted literary agent and friend, Deborah Ritchken. Sincere appreciation to Meryl Streep, Tony Bennett, Nancy Klein, Rikki Rosen, Zeiss, Paige Dixon, Julia Kirkham, Clive Nichols, Matthew Taylor, Zoe Rowlinson, Jeremy Mogford, Diana Levinson, Robert Sheldon, Carolyn Louise Newhouse, Henri Bost, and my dear brother, Marc Bordman.

Last, but not least, forever gratitude and love to my mother, Helen Rappel Bordman. She inspires the world with her enthusiasm, humor, and warmth. Thank you for introducing me to the world of Claude Monet.

TIMELINE: *monet at giverny*

1883	Monet rents the home, which he will live in for forty-three years. It is a former cider press and is exactly what he has been looking for, as it includes a pond.
1886	Monet visits Holland to paint and is drawn to the tulip fields. He brings a number of different tulip bulbs back to Giverny.
1887	Monet's paintings are included in an impressionist exhibit held in New York City.
1888	Monet begins the series of haystack paintings at Giverny.
1890	Monet begins the poplar series on the banks of the Epte River, buys the pink stucco house and property at Giverny, and starts improvements on the water garden, which becomes his passion in the ensuing years.
1892	Monet is able to buy the property adjacent to Maison Bleue. It is two and a half acres and its sole use is as his kitchen garden/potager.
	He travels to Rouen and rents a room across from the main cathedral. He begins the series of cathedral paintings. At this time, he meets Monsieur Varenne in Rouen and begins his interest in orchids.
	Monet marries Alice Hoschedé. His stepdaughter Suzanne marries the American impressionist Theodore Butler.

1893	The Seine River freezes, and Monet tries to capture the extreme-weather event in his paintings. Monet purchases the land across from his home, just past the railroad tracks, to create the main water garden.
1894	Monet's friend Cézanne visits. While staying at Hôtel Baudy, he and Monet enjoy Scotch whisky, first introduced to France by Madame Baudy, the proprietor.
1895	Galerie Durand-Ruel mounts a very successful exhibit of the cathedral series in Paris.
1896	Durand-Ruel succeeds in exhibiting the cathedral series in New York.
1897	Monet builds an additional studio. It has a wonderful view of the main house and the Grand Allée.
	A huge and successful exhibition of Monet's paintings is held at the Galerie Georges Petit, Paris. George Petit was a prominent art dealer, who was a very early collector of impressionist paintings.
1899	Monet begins to paint views of the Thames from a room at the Savoy Hotel in London.
1900	Monet returns to London, staying once again at the Savoy Hotel, and paints the Houses of Parliament series. He falls in love with Yorkshire pudding and the hotel, and insists that his cook, Marguerite, perfect the recipe.
1902	Monet diverts the Epte, a small river, which is a tributary of the Seine River, to flow through his water garden so his rare plants will thrive. The landscape design includes the four now iconic bridges, as well as lush tropical plants, including bamboo.

1903–1905	Monet spends an enormous amout of time painting and working on the formal and water gardens.
1906	Monet, due to frustration, actually destroys a large number of paintings in his water lily series. He did not feel they were good enough.
1907	Monet's friend and frequent guest at Giverny Georges Clémenceau is elected as the prime minister of France.
1908	With Alice, Monet travels to Venice and paints, among other subjects, the Venice Canal. Once back at Giverny, he devotes his time to the water lilies series.
1909	A very large water lily exhibit is held at Galerie Durand-Ruel, Paris.
1910	Monet yet again enlarges the water garden.
1911	Alice Hoschedé Monet, his second wife, passes away. At the same time, the Museum of Fine Arts in Boston has an exhibit dedicated only to Monet's paintings. It is a huge financial success too.
1912	Monet has serious cataract surgery. His sight has become very compromised and he fears he might be going blind.
1914	Monet's eldest son, Jean, passes away. He starts the renovation of the barn near the main house to create a better studio in which to complete the water lily murals.

1916	The water lily studio is finished. It is large enough to accommodate the huge water lily canvases.
1917	Monet spends a good deal of time painting on the French coast of the English Channel.
1918	Monet, with great satisfaction, completes many of the water lily canvases. Having the third studio has made it possible for him to work regardless of the weather.
1920	Monet decides to donate a number of his water lily paintings to the government of France.
1921	The French government creates space at the Orangerie des Tuileries for the water lily paintings Monet has donated.
1922	Japanese businessman and friend Kojiro Matsukata visits with Monet at Giverny and purchases a number of paintings displayed in the studio salon.
1923	Monet has two major eye surgeries, which restores only fairly good sight in his right eye.
1924	Monet gets corrective glasses with the Zeiss lens. They help.
1925	With the benefit of the eye surgeries and glasses, Monet is able to complete to his satisfaction the water lily series, now and forever referred to as the Grandes Décorations.

1926	On December 5, Monet dies after battling a severe respiratory illness. He was a lifelong smoker. This same year, the water lily series finds a permanent home at the Musée de l'Orangerie, Paris.
1947	Blanche Hoschedé Monet, who has cared for the property since Monet's death, passes away, and the gardens fall into ruin.
1966	Monet's youngest son passes away, bequeathing the entire estate, including the home and garden, to the French government.
1977	M. Gérald Van der Kemp, credited with saving the *Mona Lisa* during World War II, and restoring the Hall of Mirrors at Versailles, becomes the curator at Giverny. Lila Acheson Wallace donates the first million dollars of seed money toward this effort.
1978	Charles Moffett becomes the curator of the landmark Monet exhibit in New York, *Monet's Years at Giverny*. He refers Helen Rappel Bordman to Lila Wallace and the Versailles Foundation to help with the restoration efforts at Giverny.
1980	The restoration of Claude Monet's home and garden are completed and in April are opened to the public. Helen Rappel Bordman officially starts her springs at Giverny, as the first American volunteer and founder of the volunteer program.
1992	The Terra Foundation, with huge contributions from Daniel Terra, opens the Musée d'Art Américain on rue Claude Monet in Giverny. The museum pays homage to the American impressionists, including Theodore Butler, John Singer Sargent, and Mary Cassatt.
1999	A plaque honoring Helen Rappel Bordman is installed by Fondation Claude Monet.

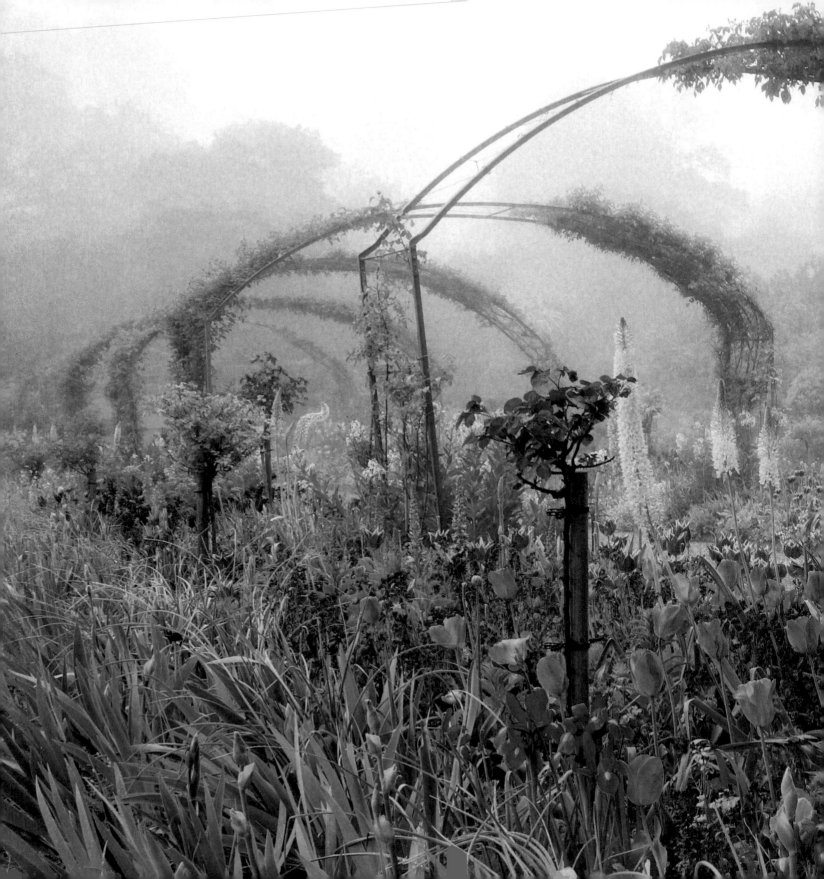

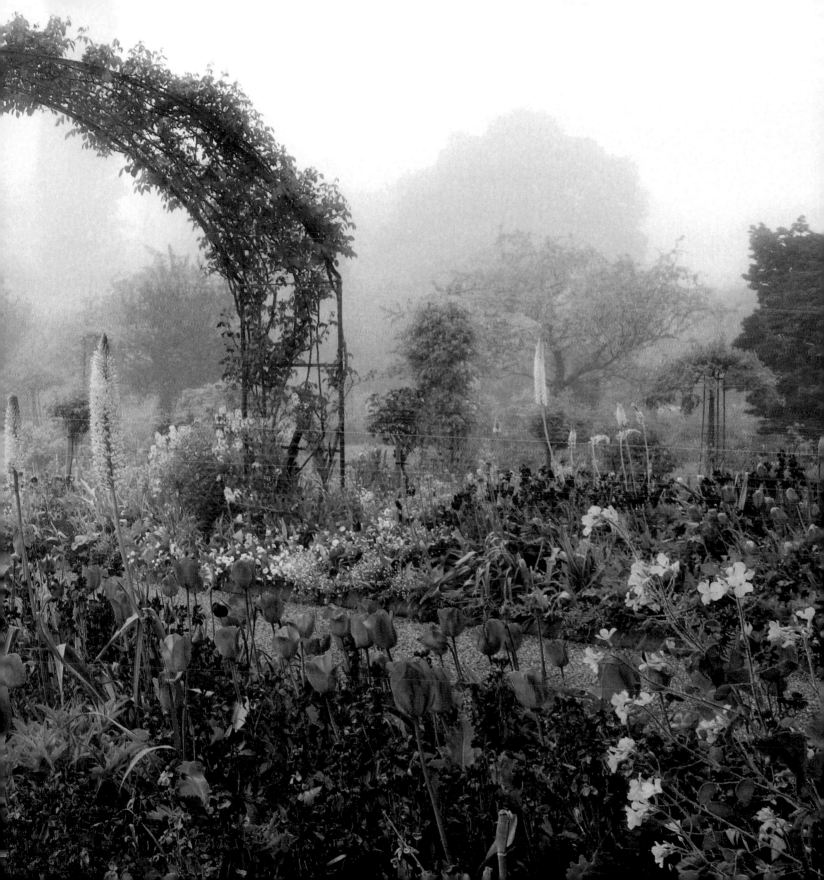

2002	Gérald Van der Kemp passes away and his wife, Florence Van der Kemp, takes his place at Monet's home and garden.
2008	Florence Van der Kemp passes away, and the Académie des Beaux-Arts becomes fully responsible for the stewardship and maintenance of Monet's home and garden.
2009	The Musée d'Art Américain becomes the Musée des Impressionismes, and its direction now falls under the Musée d'Orsay, Paris. The d'Orsay has the largest collection of paintings by Claude Monet.
2014	Blanche Hoschedé Monet's bedroom is renovated and, for the first time, opened for viewing by the public.
	The Normandy Office of Tourism opens a satellite office, right near Monet's home and garden. The mission is to promote the riches of the Normandy culture so loved by Monet.
2017	Helen Rappel Bordman receives the Chevalier Ordre des Arts et des Lettres, one of the highest cultural honors bestowed by the French government, for her contribution to Monet's legacy.
2020	The fortieth anniversary of the restoration of the home and garden at Giverny will be held at Monet's home.

resources

Guermont, Claude. *The Norman Table* (Charles Scribner, New York, 1985).

Holmes, Caroline. *Water Lilies and Bory Latour-Marliac* (Garden Art Press, Suffolk, 2015).

Joyes, Claire. *Claude Monet: Life at Giverny* (Vendome Press, New York, 1985).

Pissarro, Joachim. *Monet and the Mediterranean* (Rizzoli, New York, 1997).

Stuckey, Charles. *Monet: A Retrospective* (Hugh Lauter Levin Associates, New York, 1985).

Tucker, Paul Hayes. *Claude Monet: Life and Art* (Yale University Press, New Haven, 1995).

Wildenstein, Daniel. *Monet: Catalogue Raisonne*, Vols. I, II, III, and IV (Taschen, New York, 1997).

Wildenstein, Daniel. *Monet's Years at Giverny: Beyond Impressionism* (Abrams, New York, 1995).

credits

It takes a team to preserve the beauty in the world!

Additional Photographs

Jacket, 6, 144, 161, 162, 165, 167: Steven Rothfeld, stylist and photographer; jacket photo with Aileen Bordman.

x: Marc Bordman, photographer.

39 (left), 48 (right), 72, 89, 90 (bottom right), 96 (top), 97 (top), 140: Deborah Ritchken, stylist and photographer.

39 (right), 133, 134, 135, 136: Paige Dixon, stylist; John Downs, photographer; and Lisa Taylor King, studio owner and artist.

62: Richard Nuckolls, photographer.

81, 94: Julia Kirkham, stylist; Clive Nichols, photographer; Matthew Taylor and Zoe Rowlinson, flowers; and Jeremy Mogford, restaurateur.

98, 121: Lindsey Kent (www.pictoursparis.com), photographer.

107, 110, 115, 116, 119: Photographs courtesy of Robert Sheldon, Latour-Marliac.

Paintings

i: *Water Lilies* (1905), Museum of Fine Arts, Boston, Massachusetts, USA.

13: *Cliff Walk at Pourville* (1882), Art Institute of Chicago, Chicago, Illinois, USA.

23 (top): *Poppies at Argenteuil* (1973), Musée du Louvre, Paris, France.

25: *Water Lilies* (circa 1914–1917).

26, 91: *Monet's Garden at Giverny* (1900), Musée d'Orsay, Paris, France.

30: *The Japanese Woman* (1876), Museum of Fine Arts, Boston, Massachusetts, USA.

31 (left): *Three Women* (1790), Kitagawa Utamaro.

31 (right): *Asakusa Rice Fields Torinomachi Festival* (1857), Fondation Claude Monet, Giverny, France.

32: *Chrysanthemums and Bee* (circa 1831–1833), Katsushika Hokusai, Art Institute of Chicago, Chicago, Illinois, USA.

33 (left): *Rouen Cathedral: Harmony in Blue and Gold* (1894), Musée du Louvre, Paris, France.

34: *In the Meadow* (1876).

35: *Meditation: Madame Monet* (1871), Musée d'Orsay, Paris, France.

43 (top): *The Tea Set* (1872).

54 (left): *In the Woods at Giverny: Blanche and Suzanne Hoschedé* (1887), Los Angeles County Museum of Art, Los Angeles, California, USA.

71: *The Garden Path at Giverny* (1902), Kunstmuseum, Vienna, Austria.

75 (left): *The Boat* (1887), Museé Mormatton, Paris, France.

76 (left): *Camille Monet at the Window* (1883), Argenteuil, Paris, France.

79: *Three Pots of Tulips* (1883).

84: *The Tulips* (1886), Gemeentemuseum, The Hague, Netherlands.

92 (top right): *Irises* (circa 1914–1917).

95: *Monet's Formal Garden* (1895), Willard Metcalf, courtesy of Derek Fell.

108 (bottom): *Bridge Over a Pond of Water Lilies* (1899), Metropolitan Museum of Art, New York, New York, USA.

112: *Water Lilies* (1916), National Museum of Western Art, Tokyo, Japan.

113: *Water Lilies* (1904).

114 (top): *Water Lilies Red* (circa 1914–1919).

114 (bottom): *Water Lilies* (circa 1897–1898), Los Angeles Museum of Art, Los Angeles, California, USA.

126: *Still Life with Flowers and Fruit* (1869), J. Paul Getty Museum, Los Angeles, California, USA.

130: *Bouquet of Sunflowers* (1881), Metropolitan Museum of Art, New York, New York, USA.

131 (top left): *Jerusalem Artichokes* (1880).

131 (top right): *Gladiolus* (1881).

131 (bottom left): *Bouquet of Gladiolas, Lilies and Daisies* (1878).

131 (bottom right): *Chrysanthemums* (1882), Metropolitan Museum of Art, New York, New York, USA.

132 (left): *Portrait of Suzanne Hoschedé with Sunflowers* (1890).

132 (right): *The Artist's Garden at Vétheuil* (1880), National Gallery of Art, Washington, DC, USA.

138: *Vase of Tulips* (1885).

148: *The Luncheon* (circa 1872–1876), Musée du Louvre, Paris, France.

153: *Cap Martin, near Menton, Côte d'Azur* (1884), Museum of Fine Arts, Boston, Massachusetts, USA.

155: *Luncheon Under the Canopy* (1883).

157: *Apple Trees on the Chantemesle* (1878).

158: *Luncheon on the Grass* (1865), Musée du Louvre, Paris, France.

172: *Madame Monet and Her Son* (1875), National Gallery of Art, Washington, DC, USA.

index

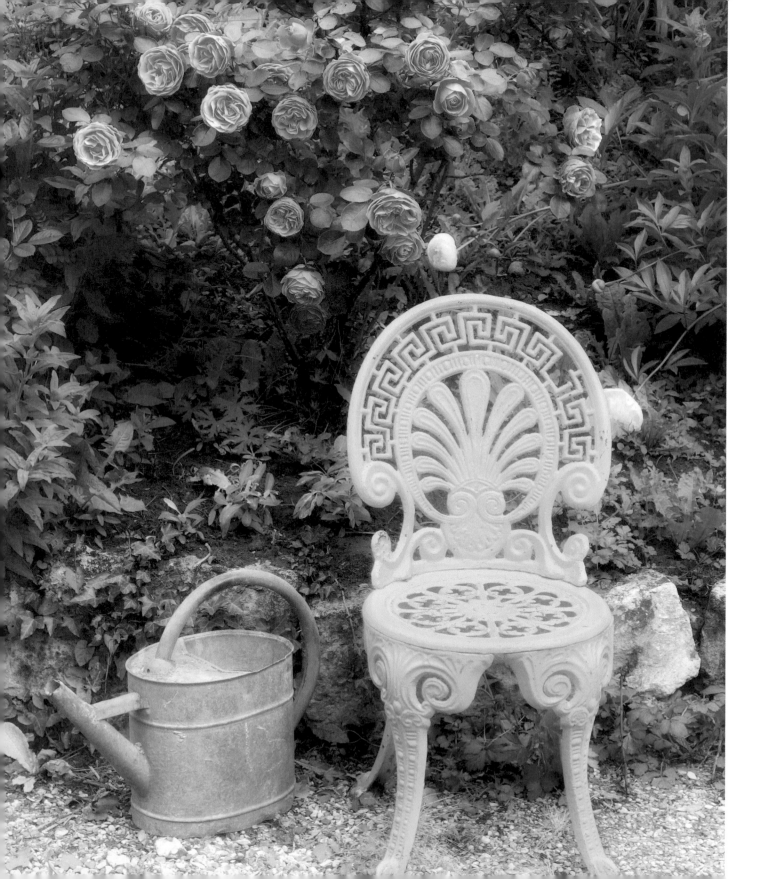

about the author

Aileen Bordman is a filmmaker, author, photographer, and the president and founder of Monet's Palate, Inc., a company dedicated to sharing the world of Claude Monet. She is the coauthor (with Derek Fell) of *Monet's Palate Cookbook: The Artist & His Kitchen Garden at Giverny*. Aileen is also the creator, writer, and producer of the acclaimed documentary film *Monet's Palate: A Gastronomic View from the Gardens of Giverny*, which was narrated by Meryl Streep. She lives in New Jersey.

HarperCollins books may be purchased for educational, business, or sales promotional use. For information, please email the Special Markets Department at SPsales@harpercollins.com.

FIRST EDITION

Water lily stamp on case © BORTEL Pavel - Pavelmidi/ Shutterstock, Inc.

Endpaper image of *Water Lilies* (1914–1926), Claude Monet, Museum of Modern Art, New York, New York, USA.

Designed by Renata De Oliveira

Library of Congress Cataloging-in-Publication Data has been applied for.

ISBN 978-0-06-269297-9

18 19 20 21 22 QG 10 9 8 7 6 5 4 3 2 1